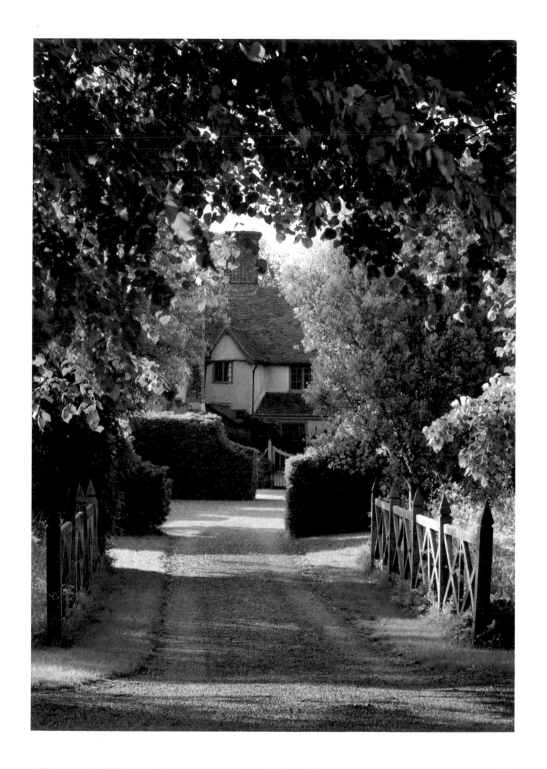

SECRET GARDENS
OF EAST ANGLIA

SECRET GARDENS
OF EAST ANGLIA

A PRIVATE TOUR OF
22 GARDENS

BARBARA SEGALL

PHOTOGRAPHS BY
MARCUS HARPUR

FOREWORD BY
BETH CHATTO

F

FRANCES
LINCOLN

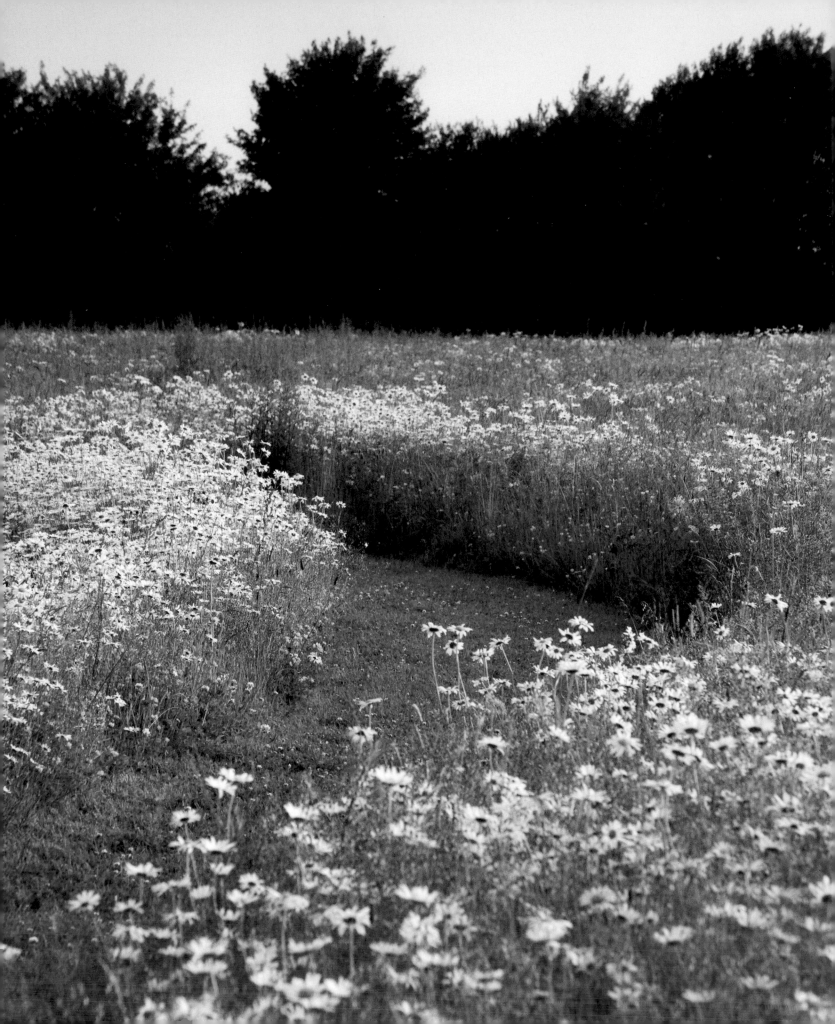

Frances Lincoln Limited
A subsidiary of Quarto Publishing Ltd
74–77 White Lion Street
London N1 9PF

Secret Gardens of East Anglia
Copyright © Frances Lincoln Limited 2017
Text copyright © Barbara Segall 2017
Photographs copyright © Marcus Harpur 2017
Edited by Sarah Zadoorian
Design by Anne Wilson
Map on page 140 by Sarah Allberrey
First Frances Lincoln edition 2017

A catalogue record for this book is available from the
British Library.

978-0-7112-3859-6

Printed and bound in China

9 8 7 6 5 4 3 2 1

Quarto is the authority on a wide range of topics.
Quarto educates, entertains and enriches the lives of
our readers – enthusiasts and lovers of hands-on living.
www.QuartoKnows.com

MIX
Paper from
responsible sources
FSC® C104723

HALF-TITLE Down a lane and across the moat, the hedged
gardens of Columbine Hall, Suffolk, await your arrival.
TITLE Veiled in early morning mist, these vibrant flowers
at Ulting Wick, Essex, glow as if lit from within.
OPPOSITE At Wood Farm, in Suffolk, mown paths lead
through ox-eye daisies in a meadow where bees and
butterflies abound.

Contents

Foreword
by Beth Chatto

FOR *SECRET GARDENS OF EAST ANGLIA*, Barbara Segall and Marcus Harpur have visited gardens across the region, and offer a selection of distinctive large and small privately owned gardens. While some may be familiar to those of us who live in East Anglia, for anyone coming to our region for the first time there are many delightful places that await your discovery. Barbara and Marcus invite you to follow in their footsteps to see our garden bounty.

In my gardening life I have always welcomed visitors to my garden in Essex, and enjoyed their comments and thoughts. I have rarely had enough time, though, to get out and visit other gardens. It is a pity, since we can all learn from one another. Learning what to do is important, but learning what not to do is equally important.

I learned so much in my early days from several charismatic and interesting gardening characters. Cedric Morris, who made a garden at Benton End, in Suffolk, was as selective about his plants as he was about his friends. I learned from him about life and gardening. Through his own generosity in his lifetime and later through Boxford plantswoman Jenny Robinson, who was his horticultural executor, many of his plants have been passed on to other dedicated gardeners in the region.

The other influence for me was, of course, Christopher Lloyd of Great Dixter, in Sussex. He was a gregarious man, who kept an open house. Like Cedric, he did not suffer fools gladly, but if he saw that you understood plants or shared his love for them, he was generous and welcoming. Both Cedric and Christopher were consummate artists in their gardens. Each of us, in our own gardens, are artists. In East Anglia, we are fortunate in being able to take advantage of the wide views and huge skies that this region offers us. And then there is the light: in these eastern counties it seems more luminous and beautiful than elsewhere.

Beth Chatto, plantswoman extraordinaire, sees gardens as a form of art. Her own garden near the village of Elmstead Market, in Essex, is world-renowned.

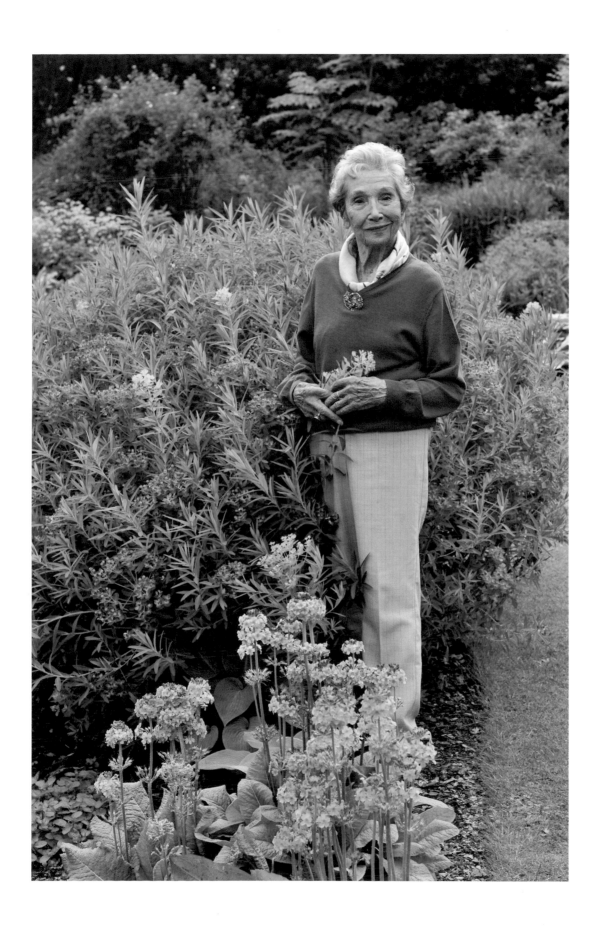

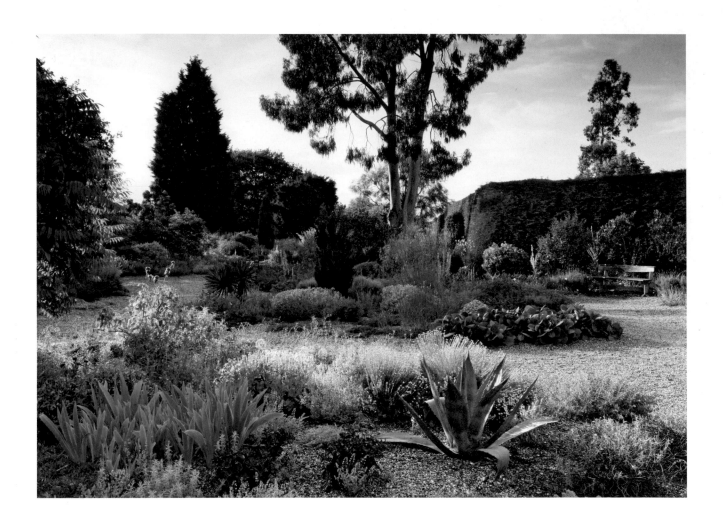

ABOVE The Gravel Garden, where heat-loving plants bask in the sun, has inspired countless gardeners.

OPPOSITE Beth's approach is always to match plants closely to their situation, and in this way she has harnessed the site's variations in soil and light to create a rich tapestry.

It is only by walking in a garden, whether private or public, large or small, that you can really appreciate the picture that has been created there. Garden owners who open their gardens and encourage visitors offer people a valuable opportunity, and in many cases inspire them to go home and paint a picture of their own.

In *Secret Gardens of East Anglia*, Barbara Segall and Marcus Harpur have combined words and photographs to put before readers the artistry of gardens in Cambridgeshire, Essex, Suffolk and Norfolk. Enjoy the gardens on the page and in person. Visit gardens to keep in touch, as well as to see how 'garden artists' in our eastern region have responded to the challenges of weather, site, light and space.

Beth Chatto

Introduction

THE WHOLE OF EAST ANGLIA is a rather secret, unsung place, off most people's beaten track. I have come to know it well since I moved here in 1986, not least because my garden-writing life has taken me to gardens great and small, private and public, across the counties of Suffolk, Norfolk, Essex and Cambridgeshire. I fell instantly under the spell of this magical region and its idyllic landscapes, the spirit of which is captured so remarkably in the paintings of Thomas Gainsborough (1727–88) and John Constable (1776–1837).

The four counties have their individual charms, yet are sometimes dismissed as flat and therefore possibly a little dull. In fact, the wide horizons and huge skies, the light, the sea, the farmlands and gently undulating countryside combine to provide a rich background for garden-making. Visitors to the region can find every sort of garden inspiration here, be it bravura herbaceous borders, tongue-in-cheek topiary, sensitively sited artworks, ornamental kitchen gardens, romantic wildflower meadows or lovingly crafted detailing.

East Anglia has a great tradition of creative horticulturists, whose skill and artistry in planting their own gardens resonates in many others in the region. These influential figures include the painter and iris enthusiast Sir Cedric Morris, who made a garden at Benton End, in Suffolk, after settling there in 1938; legendary nurseryman, the late Alan Bloom (founder of Blooms of Bressingham, Norfolk), and his son Adrian Bloom; and, of course, plantswoman Beth Chatto, who has shown us how to use plants that do well in particular environments.

In East Anglian counties this includes summer droughts, windswept locations, dry sandy soils, or, just as problematic, clay soils that crack in summer then become muddy impasses in winter. Each garden in this book is an example not only of how to meet the physical challenges a site presents, but how to turn them to advantage. In these pages you will also find the ingenious ways in which garden owners have responded to various design challenges, ranging from tiny domestic spaces to grand, historic settings. Some have created a garden from scratch. Several have started small, then been driven by their gardening ambitions to expand into the surrounding land.

In the gardening world nothing is secret or unknown for long, since we are all keen to tell someone about a place that we think is wonderful. Some of the gardens included in this book, such as Hunworth Hall and Winterton Lighthouse, both in Norfolk, are largely unknown and open infrequently, or not at all, while others, such as Helmingham Hall Gardens and Pensthorpe Natural Park, in Suffolk and Norfolk respectively, have a higher profile. While some might be familiar to those who live nearby, they remain perhaps undiscovered by garden visitors from further afield. And indeed, some that may appear too prominent to call secret have, at their heart, some quiet, unsung space.

Here are 22 gardens that characterize the region's varied styles, and whose stories I have discovered and wish to share with you. They are all privately owned, all inspire and entrance, and that there is so much to enjoy when you visit them is testimony to the owners' personal passions for garden-making. One of the greatest pleasures in preparing the book has been the time spent exploring and musing in the gardens that make up this personal selection. I have enjoyed getting to know the owners who have all taken time to show me their gardens, to tell me how they started, what they like to plant, and to reveal in detail their particular way of gardening. I have also been fortunate to revisit each garden retrospectively, through the lens of photographer Marcus Harpur: his intuition and expertise make the gardens glow off the pages of the book.

Barbara Segall

TOP LEFT East Anglia's four counties boast gardens large and small that embrace houses of varying architectural styles. In Cambridgeshire, Elton Hall's towers and crenellations look well against the garden's hallmark hedging.

TOP RIGHT At Tinkers Green Farm in Essex borders bursting with colour and contrasts epitomize the generosity of a country garden.

BOTTOM LEFT Winterton Lighthouse in Norfolk towers above the garden thoughtfully designed to allow the building pride of place.

BOTTOM RIGHT In Suffolk, Polstead Mill blends formality with pastel borders that appear to hover at the water's edge.

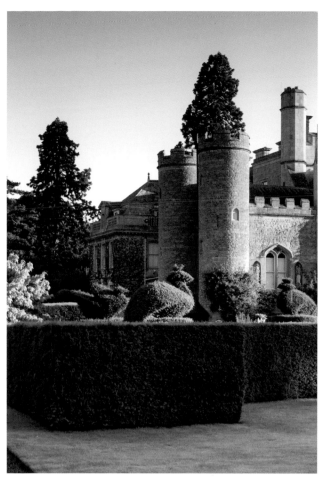

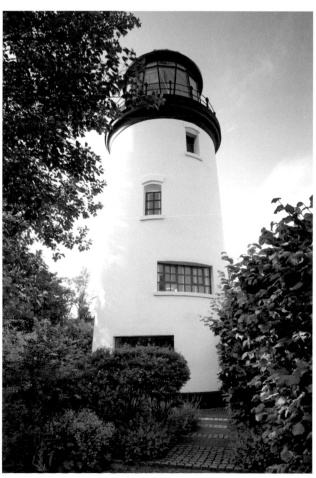
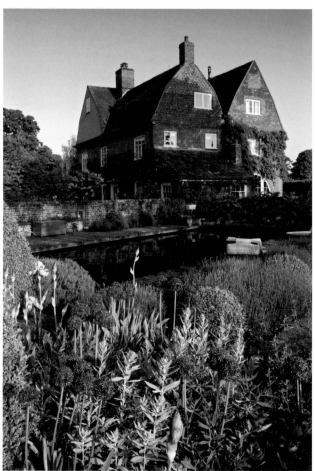

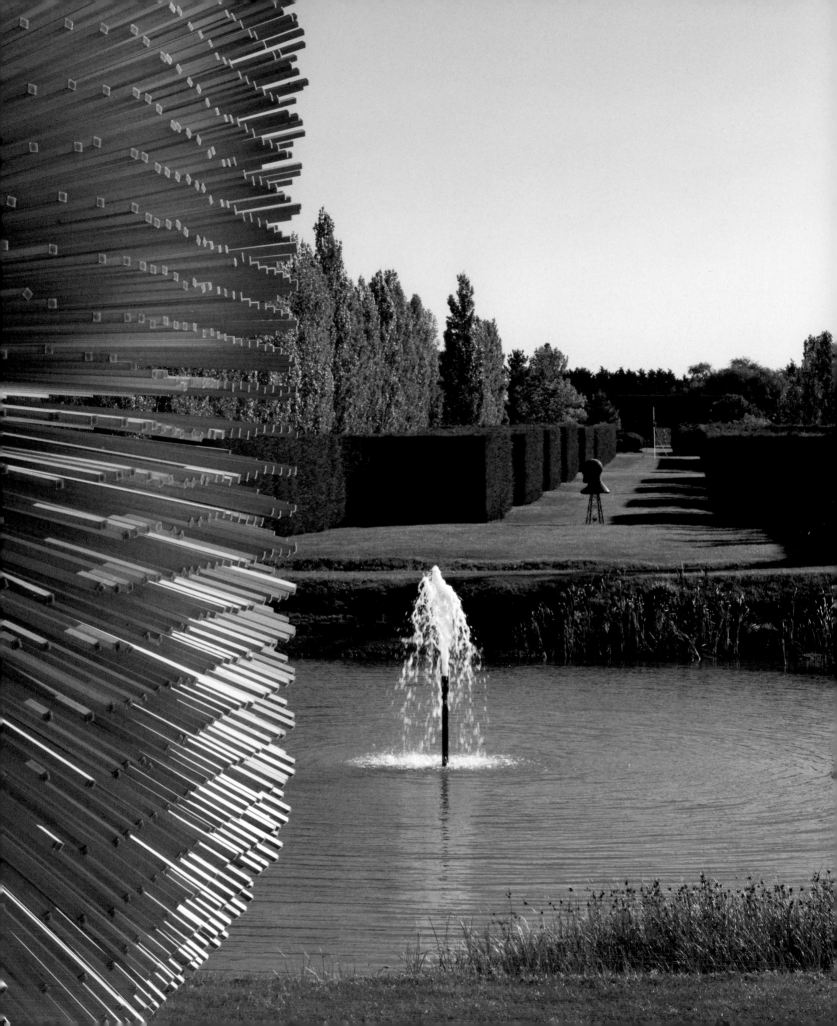

1
Barnards Farm

West Horndon, Essex

MOST OF US have 'borrowed' landscape. We are usually pleased and quite smug if this includes a church steeple, say, or a magnificent oak or copper beech within sight but beyond the perimeter of our garden. Usually less pleased if we have huge electricity pylons with high-tension cables as the long-term loan from the neighbours.

But the fact that they had several pylons in their borrowed landscape, as well as one on their own property, has not deterred Bernard and Sylvia Holmes. In fact, Bernard used the two main pylons as his reference points when developing their garden's design. And when one of the pylons on the nearby railway site was taken down, he recycled much of it to form an eerie sculpture, reminiscent – although on a larger scale – of Derek Jarman's iconic beach garden at Dungeness, Kent. Entitled *A Binary Insulated Warm Welcome*, the glass insulators from the former pylon spell 'welcome to Barnards Farm' in binary code.

Creative streak

Bernard and Sylvia found Barnards Farm in 1975, fell in love with the Georgian farmhouse surrounded by 1,000 square metres/¼ acre of garden, and moved in during 1978. The house needed much attention, and that saw the start of an enduring relationship with the person who is now the estate manager, Barry Dorling. With his father, Barry restored and decorated the house, and as Bernard and Sylvia expanded their land and activities, he became their right- and left-hand man.

'I based the design on symmetry and tried to embrace the unwieldy surroundings, such as the pylons and nearby railway.'

BERNARD HOLMES

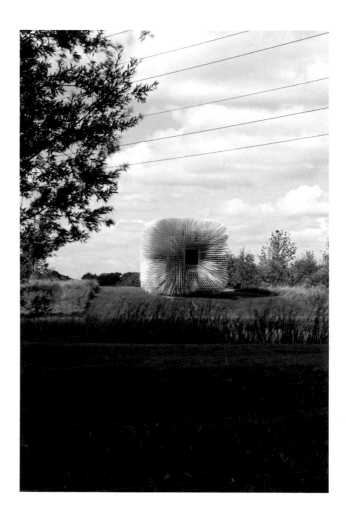

LEFT AND RIGHT Thomas Heatherwick's spiky *Sitooterie*, a place to 'sit out' in, is the perfect hideaway for views across the lake to the vista formed by closely clipped Leyland cypresses. Aligned with the central jet of water is one of the monumental bronze heads from Elisabeth Frink's *Desert Quartet*. At ground level, bays in the hedge create a play of shadows on the grass.

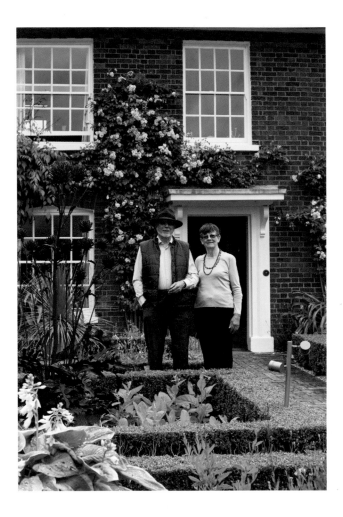

stream and lake, with interesting and quirky attractions that include a collection of gleaming vintage automobiles (housed in the restored barn), a 1920s cycle shop that pays homage to Bernard's father, a miniature railway (the longest $7\frac{1}{4}$ gauge track, end to end, in the United Kingdom) and a working runway. Running parallel to this expansion was the desire to open to visitors under the National Gardens Scheme, something they have been doing since 1983.

Bernard began his horticultural journey by taking a course at Wisley, the Royal Horticultural Society (RHS) garden in Surrey. He and Sylvia visited other gardens in their local area to find out what grew well – always a good way to find your gardening feet – and for landscaping and design ideas the couple travelled to see lots of European gardens.

They began by modifying the original small garden around the house, which was the easy part, according to Bernard. Suiting the Georgian style of the house, the front garden is laid out as a parterre with, instead of infill planting, some large-scale metal sculptures of a stylized fern and a spiky dahlia. In the back garden, hedges offer shelter for the borders and lawn.

One of the existing plants that had to be moved, as it blocked out light, was a crab apple. This had all the ornamental attributes that Bernard and Sylvia both liked: blossom, colourful and useful fruit, and a good shape. They decided to plant more crab apples, and just at this time the collection at what was to become RHS Hyde Hall was disbanded. Bernard transported all 40 trees the 50 kilometres/30 miles to Barnards Farm on a low-loader, and all but one survived the move. This was the basis of what grew into the Plant Heritage National Collection of *Malus* (crab apples). Now it consists of some 250 species and varieties, including many US specimens. In blossom and fruiting seasons the collection offers great ornamental interest.

Airborne design

Given that Bernard's initial need for more land was to accommodate a runway for one of his many transportation enthusiasms (cars, planes, bicycles, motorbikes...), it is only natural that he did much of his garden planning from the cockpit. 'I based the design on symmetry and tried to embrace the unwieldy surroundings, such as the pylons, the nearby railway and even the sound of the A127,' he says.

So it is no wonder that the snaking sinuous conifer hedge (thought to be Europe's longest serpentine hedge

The land surrounding their property had been intensively farmed, and next door was a Marshall aid barn, a relic of the post-war programme to help agriculturists back into production. It had fallen into disrepair, so Bernard decided to go ahead and restore it. Over time he and Sylvia were able to purchase more and more of the land around the farmhouse (it now stands at 17 hectares/42 acres of garden and woodland), including the now pristine Marshall barn.

And that – the acquisition of the land – set the pair off on a seemingly unstoppable streak of creativity resulting in a landscape sculpture garden, collection of crab apples,

ABOVE Bernard and Sylvia Holmes in front of their Georgian home. The parterre was one of their first projects, when the garden was still small.
OPPOSITE The couple gradually acquired more land, including space for a runway. Bernard has a pilot's licence and designed much of the garden from the air.

of Leyland cypress), the Euro Wood (with a clearing in the shape of a euro sign) and many other features are best viewed if you fly down to Essex for a visit. Bernard and Sylvia would not be at all fazed by this: just phone before you fly in is their only plea.

Near the main house Bernard and Sylvia enjoy the precise detail and calm atmosphere of a Japanese garden, with a large and noisy fountain that goes a long way to outcompete the roar of traffic on the busy road nearby. The parterre, kitchen and cutting garden, the latter punctuated by standard specimens of *Rosa* 'Iceberg', make up the domestic part of the property.

To gain height and variation in the landscape beyond the domestic gardens, Bernard and Sylvia planted hundreds of trees and the formal serpentine Leyland hedge. They also used the diggings from the lake to form a mini-ziggurat, called the belvedere, one of the highest points at Barnards Farm. Its sides densely planted with roses and topped out with a stainless steel sculpture, *The*

Analemma by Charmaine Cox, it offers stunning views across the property and beyond.

The Barnards Farm belvedere was inspired by a French one the couple saw in Granville, Normandy. Although belvederes were once an important feature of Elizabethan gardens, the only local example Bernard and Sylvia have been able to trace is the remnants at Lyveden, a National Trust site in Northamptonshire.

European inspiration

Following visits to the Middelheim Sculpture Garden in Antwerp, and to the inspirational French landscape show at Chaumont-sur-Loire over numbers of years, they realized that Barnards Farm was the ideal setting for sculpture. Their first purchase was a granite bust of a woman, which they spotted at an amateur exhibition while on holiday in Spain. Now there are 79 numbered artworks on the Sculpture Trail, some kinetic, others static, some of Bernard's making (mostly from found and

abandoned engineering or transport components), but largely the creations of internationally acclaimed artists.

Bernard and Sylvia take great care over the placing of each sculpture. Usually they make the decision together with the artist and are always willing to move a piece if it is felt that it would work better in a different setting. Many artists are represented, including Elisabeth Frink, Jean-Marie Fondacaro, Antony Gormley, Nicolas Lavarenne, Bob Waters and Monica Young.

Thomas Heatherwick's *Sitooterie* made its way to Barnards Farm via its first outing at Belsay Hall, Northumberland. That version was constructed of wood, but the piece for Barnards Farm was custom-made in aluminium, complete with over 4,000 angled aluminium tubes that give it the look of a geometric teasel seed head. By day each tube conducts sunlight into the *Sitooterie* – the name derives from the Scots for a place for sitting out – while at night internal lighting makes the structure glow as if with a thousand moonbeams. On special occasions the garden is open after hours for visitors to enjoy the light spectacle.

Bernard likens his reworking of these Essex flatlands to the terminal moraine landscape created by the action of a retreating glacier. Indeed, he might well be classed as a force of nature in view of all the developments at Barnards Farm over the last 40 years. Except that would be to focus too exclusively on the large scale. For this original garden has many hidden delights and interesting details just waiting to be discovered.

LEFT ABOVE *The Rowers* by Bob Waters, formed by acetylene welding industrial scrap metal, sits beside a stream.
LEFT BELOW With a backdrop of mature birches, *Fluide* is one of three massive bronzes by French artist Nicolas Lavarenne.
RIGHT The garden provides varied settings for work by both internationally known and up-and-coming sculptors. Bernard and Sylvia Holmes spend time with artists deciding on the best site for each work.

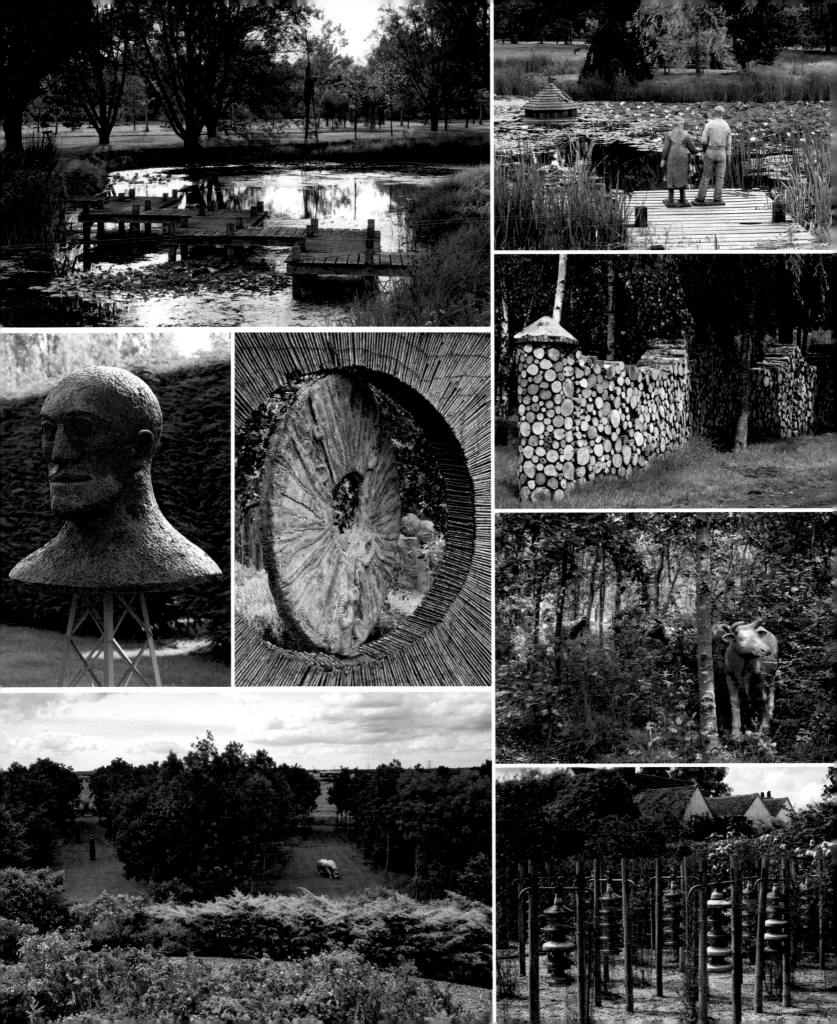

2
Columbine Hall
Stowupland, Suffolk

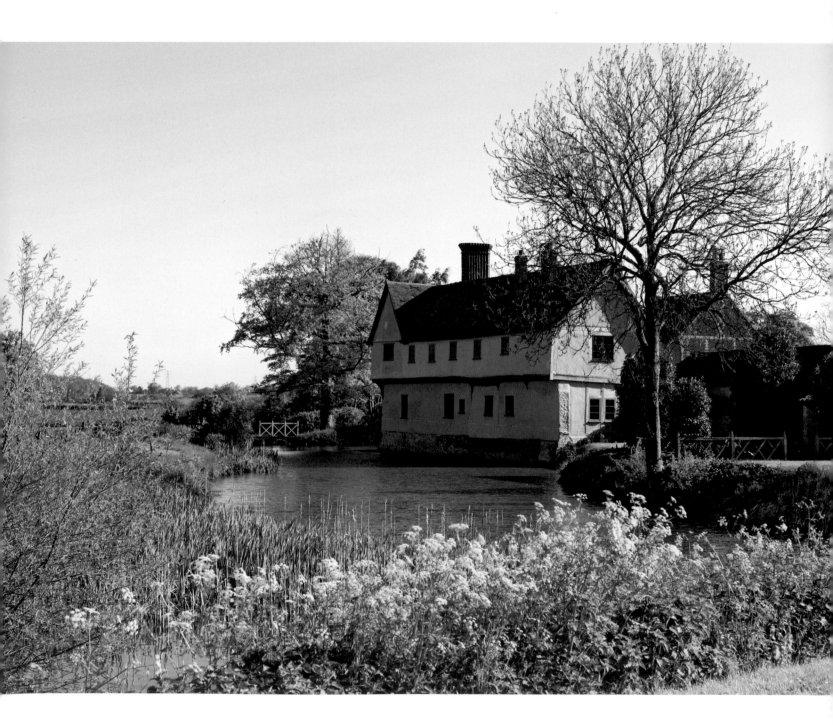

COLUMBINE HALL and the stylish garden that envelops it often feature in magazine and newspaper articles. That house and garden appear to vie with each other in garnering column inches seems entirely appropriate, since owners Leslie Geddes-Brown and Hew Stevenson have hands covered – as it were – in printers' ink.

Leslie is a journalist and author, while Hew, also an author, is a newspaperman through and through. A scion of the Tyneside family who owned the *Shields Gazette*, Hew became managing director of the *Yorkshire Evening Press* and on his retirement in 1996 was chairman and chief executive of the Westminster Press Group.

Leslie and Hew moved from Halifax to London in 1988, and then in 1993 discovered and bought Columbine Hall, a fourteenth-century Grade II* listed gatehouse wing situated near Stowmarket. It was the surviving part of a larger property that had been empty for several years. 'There are few fancy beams here: it is graded because a gatehouse wing is an unusual survival,' says Leslie. They did not have to do much structurally as the building was in sound condition, even if in need of a little restoration. Judicious work and the understated colours of Farrow & Ball paint soon transformed the interior. The garden, though, was another matter, according to Leslie: 'At that stage I hadn't worked out how to read and organize the garden, or how to unify it with the house and wider landscape.' The garden presented a particular challenge as the house is surrounded by a moat 9 metres/30 feet wide and up to 4.25 metres/14 feet deep.

Element of suprise

In 1994 Leslie was asked to write an article for the *Telegraph* about how to deal with a moated garden. When it was suggested that she ask a designer for advice, she turned to George Carter (see pages 84–9). 'He understood immediately that it was a walled garden without the walls,' she says. 'The stretch of water formed a clear break and it felt to me as if there was nothing to anchor the garden.' George's advice, swift and sure, and almost on the back of the proverbial brown envelope, was to treat the moat as if it were a ha-ha and use whatever lay beyond in sight lines or vistas, and thus bind the garden of 2 hectares/5 acres and the parkland of 11.7 hectares/29 acres into a cohesive unit.

George pointed out that the approach to the hall lacked a sense of anticipation. The drive was then a straight, open track. So Leslie and Hew bought a strip of adjacent land that enabled them to hedge it on one side. They also added a right-hand bend, so it is only when you turn the

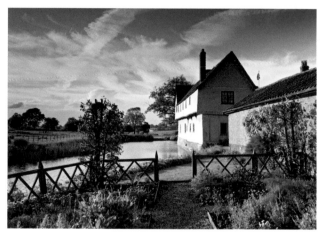

corner that you glimpse the arched gateways, clock tower and then finally the house and its moated garden. By then, you know that an adventure is waiting ahead. The next step is to cross the one and only bridge over the moat – which is in fact a cleverly created illusion. Another of George's suggestions, it is simply a pair of wooden railings on a causeway between two arms of the almost horseshoe-shaped moat.

A moat brings with it responsibilities, not least of which is that you have to maintain the water. So about 20 years ago Leslie and Hew dutifully had the moat dredged,

OPPOSITE Sitting comfortably in its landscape, Columbine Hall gives no sign of being the remnant of a once larger building.
TOP On the carefully controlled approach to the hall, wooden railings create the illusion of a bridge. Ahead, staggered hedges prevent the house being revealed too soon.
ABOVE The Herb Garden is a handy source of sage, thyme and fennel.

a task that needs doing once a century. While the work was undertaken they needed extra insurance against the house falling into the water. 'Sadly, we found no Roman artefacts, only a wealth of Marmite bottles left over from the wartime billeting of land girls at Columbine Hall,' says Hew. The moat here would originally have served for defence, but experts are unable to determine its date.

Green rooms

In around 1995 George suggested dividing the area between the hall and moat into a series of separate spaces. At first the scheme had to be taken on trust, since the hornbeam and yew hedges that would become the 'room dividers' were so small – like boundaries for a doll's house. Now these hedges are at their final height, at around 3 metres/10 feet, and are cut annually by an arborist working from scaffolding.

Leslie calls these lawned, hedged areas the 'platform'. In fact, George has divided the space in such a way that

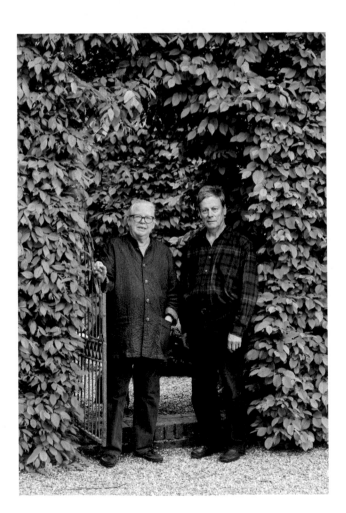

the hall, which clings to the far edge of the moated land, seems more at the heart of the garden. Through the strong hedge-lines of the Allée and the Bowling Green, as well as vistas and focal points, house and moat also appear more symmetrical than they are. Among the 'green rooms' is a long, wide corridor that echoes one side of the hall, becoming in essence an extra wing and balancing the timber structure with an element of living architecture. 'George's design has anchored the house, where before the hall seemed just to be a random fragment of an earlier property,' says Leslie.

The hornbeam corridor, its essential function being to provide a sense of symmetry, is unadorned: it is simply a gravelled space with two clipped, flat, box squares set within the high hedges. It is a secluded place where you can take a deep calm breath before stepping off the 'platform' to explore new projects such as the Bog Garden, Mediterranean Garden and Flowery Meadow. These are elements of the garden as it continues on the other side of the moat.

Pride and joy

In 1997, a year or so after the hedges were planted, Kate Elliott came to work as a gardener at Columbine Hall. She was 16 years old. Now, 20 years on, she is the garden's keeper and the creator of a decorative yet productive walled vegetable garden. It is on the site of a former farm building that was found to have an asbestos roof. With great respect for health and safety, they took the roof off but kept the walls. The concrete floor was excavated, drainage put in, and much of the silt that had been dredged out of the moat was laid in to form the basis of the garden's soil. These alterations also revealed more fully the adjacent eighteenth-century building known as the West Barn, which is used as the venue for weddings and other events.

The highly ornamental Kitchen Garden is Kate's pride and joy. She has arranged the four beds with great

LEFT Leslie Geddes-Brown and Hew Stevenson have found an elegant solution to the challenges set by their moated garden.
RIGHT Trees and a clock tower punctuate the framework of clipped hornbeam hedges in this essentially green garden. Blue-grey paintwork, used for bridges and these obelisks in the Kitchen Garden, complements the muted tones of variegated ivy, hostas and purple bearded irises. As an ensemble, the garden has been designed to meld in seamlessly with the surrounding countryside.

The answer was to treat the moat as if it were a ha-ha and use whatever lay beyond in sight lines or vistas.

sensitivity to colour. Purple kales such as 'Cavolo Nero' (also known as black Tuscan kale), 'Redbor' and 'Rouge de Russie' offer, with cabbages and globe artichokes, a silver and blue-mauve through to pink theme. Swiss chard and tomatoes dominate the red bed, while dahlias and sweet peas on obelisks provide cut flowers for the party vases. Orange highlights from pot marigolds and nasturtiums spill out along the edges of the beds.

Roses, including 'Blairii Number Two', *Rosa gallica* 'Versicolor' (rosa mundi), 'Charles de Mills', 'Penelope' and many other fragrant and repeat-flowering varieties line the walls of the Kitchen Garden and grow against the black wood of the West Barn. Kate raises most of the plants for the kitchen and separate herb garden, as well as the wider garden, in the lean-to greenhouse here or in a polytunnel out of sight, where she also grows replacements for any veg that dares to fail or is eaten by rabbits – or reckless human beings. 'We pick from the Kitchen Garden only with Kate's permission, so as not to upset the colour coordinations or symmetry,' says Leslie.

The garden at Columbine Hall has more than fulfilled Hew and Leslie's expectations, yet continues to develop. When he was 18, Hew lived with a family in Belgium as an exchange student. It was during this stay that he first saw a garden with vistas and parklands, and it became his ambition to create a garden like the one held in his memory. Now he enjoys walking with the dogs to the far extremity of their land, immersing himself in the 'wilderness' and looking back to the created garden, while Leslie loves the closer views of the seemingly floating and secretive garden that wraps itself around the hall.

In summer, cow parsley floats beneath pleached limes that frame a view of the parkland on the other side of the moat. Ornamental vines on obelisks offer a more formal counterpoint.

3
East Ruston Old Vicarage
East Ruston, Norfolk

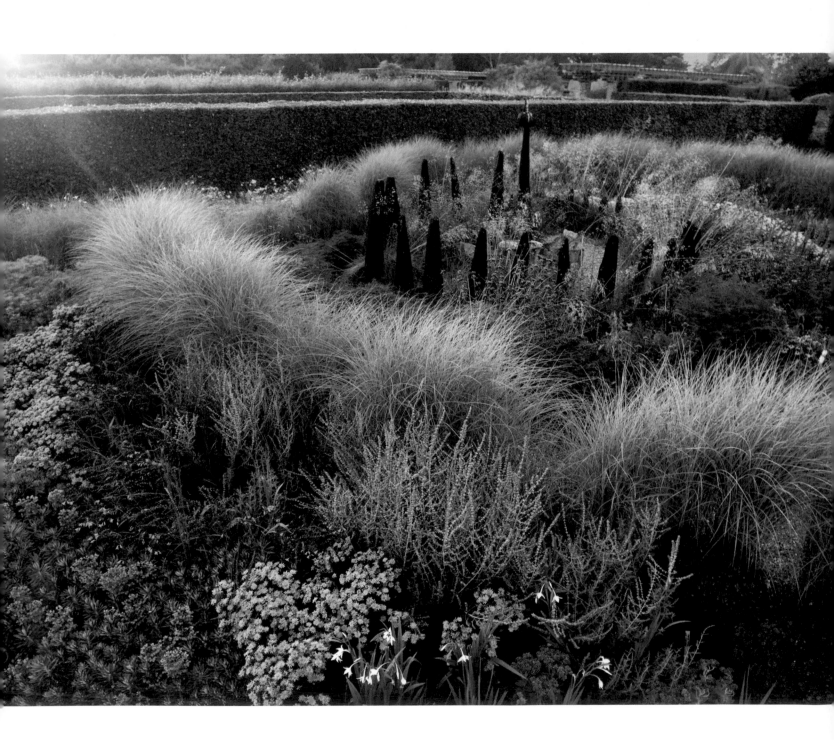

UNLESS YOU ARE A GARDEN VISITOR of a fairly determined nature, East Ruston Old Vicarage might not be on your radar. You may not have considered travelling almost to the outermost bulge of East Anglia, to a spot about 40 kilometres/25 miles north along the coast from Great Yarmouth, but if you do, you will find an oasis of horticultural excellence, full of inspirational details as well as broad brushstrokes.

Close to the house are intimate, enclosed areas, such as the King's Walk, Green Court and Dutch Garden; while further away, leading towards the boundaries, there are sweeping, more expansive plantings in the Mediterranean Garden, Desert Wash and the breathtaking Cornfield. Colour in the borders and containers, and in the extensive vegetable garden, provides seasonal interest, as does foliage shape and texture. Statuary and borrowed features, such as the Happisburgh lighthouse and church, offer stunning focal points at the end of long vistas.

Taming the wind

When they began the garden, the owners were both working in London, Alan Gray in antiques and Graham Robeson in property. They had family connections in Norfolk – Alan was born and brought up here and Graham spent summer holidays with his grandparents just a mile away from East Ruston Old Vicarage – so it was only natural that they gravitated to this part of the county.

The site originally covered just over 0.8 hectares/ 2 acres when Alan and Graham bought the vicarage in 1973. In 1989 they had the opportunity to acquire more land, took the plunge and over time extended the garden to 13 hectares/32 acres. When looking at an old Ordnance Survey map from the 1880s, they realized that this land was once divided up into much smaller fields. 'We thought of all the cover that had been destroyed to make bigger fields for larger yields,' says Alan. 'Our aim then was to put back as many of these field boundaries as we could, to give us, the wildlife and our original garden more shelter.'

In fact, that there is any garden here at all is a testimony to the benefits of shelter belts. Most gardens hold some challenges, and here the 'Goliath' that Alan and Graham battle against is the wind. 'It sweeps across what is essentially a prairie landscape. If there is a breeze in Norwich, you can be sure there is a gale here,' says Alan.

Now there are several layers of shelter belts that provide vital cover for the garden. They slow the wind down, push it up and away. The big guns on the outer boundaries are Monterey pines (*Pinus radiata*), Italian alder (*Alnus*

cordata) and Tasmania snow gum (*Eucalyptus coccifera*), with inner defences of evergreen shrubs including hawthorn, holly, phillyrea, olearia and phormium. Once the main shelter was in place, Alan and Graham planted interior hedges, often of hornbeam and beech, to form more intimate, enclosed garden rooms. In all, there are some 5–6 kilometres/3–4 miles of hedging on the property.

Next they made several ponds in various parts of the garden, some formal and others informal in style. Together, the ponds and hedges offer habitats attractive to wildlife, and the garden is now a haven for a wide range of birds, amphibians, insects and mammals, including newts, toads and frogs, and a pair of kingfishers that frequent the wildlife pond.

OPPOSITE The 'wood henge' or *Hortus Spiralis* combines the tarred and blackened remains of a group of Monterey pines with soft, flowing grasses.
ABOVE Flamboyant brugmansias brighten the entrance to the new Diamond Jubilee Walled Garden, designed for producing plants, fruit and vegetables.

ABOVE LEFT Alan Gray's (left) knowledge as a plantsman complements Graham Robeson's (right) skills as a draughtsman. Together they contribute to a constantly evolving garden.

ABOVE RIGHT Windows, doors, paths, entrances: all are opportunities waiting to be decorated with seasonal delights, as here with violas and *Rosa* 'Pompon de Paris'.

OPPOSITE Alan and Graham's garden empire has grown in size and scope, and now consists of distinct areas each with their own plant identities. These range from the Mediterranean Garden, with free-form aeoniums and euphorbias, to the clipped pyramids of the King's Walk. Vistas, such as the borrowed view of Happisburgh church, connect the various spaces and lure the visitor onwards.

The second major challenge Alan and Graham faced was a water table some 5.75 metres/19 feet below the soil surface. This means that any new plantings, especially of trees, need regular irrigation while they establish. 'Luckily the soil here is a light, sandy loam with a neutral pH known in farming terms as grade one, so it's pretty good,' says Alan. Nevertheless, they continually improve it with compost and well-rotted farmyard manure.

In 1992 a local friend asked Alan and Graham if they would open the garden for members of the Norfolk Gardens Trust. They agreed, but wondered if anyone would actually turn up. Well, 1,200 people came that day and they have been coming in their droves ever since. 'I love socializing with our visitors as we already have a common bond, a love of plants and gardening,' says Alan. Yet the garden is large enough to be peopled without ever feeling crowded.

Garden ambasssador

Alan's garden adventures spread far beyond his own plot: he is a broadcaster, writer and ambassador for the National Gardens Scheme. His influence on other gardeners is certain, but he is quick to acknowledge the horticultural figures who have inspired, informed and guided him, including Beth Chatto, Christopher Lloyd, Rosemary Verey and John Treasure. He also draws on the

The Desert Wash is filled with drought-loving plants from California, Mexico, South Africa and Australia.

legacy of Gertrude Jekyll, particularly her use of hostas and yuccas (exotic stuff in the late nineteenth century). Graham, as the garden's architect, is interested in the Arts and Crafts work of Edwin Lutyens and Charles Voysey.

Gulches and gullies

One of Graham's most ambitious creations at East Ruston has been the Desert Wash, filled with drought-loving plants from California, Mexico, South Africa and Australia. Over 450 tonnes of flint were brought in, with great care not to shatter them, and built into gulches and gullies reminiscent of an Arizona landscape. To achieve this natural look, the engineering began some 1.5 metres/5 feet below soil level. Alan and Graham broke up the subsoil, adding copious amounts of gravel to increase drainage. Above this base layer, gravel and grit were mixed with the existing soil, with a final dressing of gravel on the surface. As a result, the soil was raised by some 30 centimetres/1 foot above its original level, and held in place by Norfolk flints. Every year more gravel is added as a top dressing, which gradually becomes incorporated into the soil.

The aim is to keep the Desert Wash's half-hardy plants as dry as possible in winter, as many will stand cold temperatures as long as they are not also wet around the roots. 'Here in East Anglia we have a relatively low rainfall, some 20 inches [50 centimetres] a year, but unfortunately most of that falls during winter,' says Alan. He and Graham continually experiment with new plants to test their hardiness.

Stream of ideas

Although both have great plant passions, essentially Alan is the plantsman, while Graham is more in tune with the structure of the garden. 'We are lucky – we share ideas and bat them around before we put them into play in the garden,' says Alan. Graham derives great satisfaction from designing the latest areas that they decide to embark on, such as the Fruit Garden (with flowers, of course, and a fruit cage 'like a Mogul palace'). Other recent developments include the Diamond Jubilee Walled Garden, complete with stylish glasshouse, an orchard of heritage fruit trees and extensive planting in the East Field.

As the garden matures, decisions about cutting back or removing overgrown plantings have to be considered – hence the many woodpiles, all attractively arranged in house-like shapes (known in Germany as *Holzhaufen*). Spent wood also features in a new installation dubbed *Hortus Spiralis*. A sort of wood henge, its uprights were cut from a group of Monterey pines that had become overly large and shade-casting. A tree surgeon carved and blackened them using a gas blowtorch. The planting, mainly grasses, including *Stipa gigantea* (giant oat grass) and *Miscanthus sinensis* 'Morning Light', radiates out from the central spiral, like the sparks of a Catherine wheel firework.

There is no denying it, East Ruston Old Vicarage is a high-maintenance garden, and there is not a single day in the year that Alan is simply at leisure here. But his is a philosophical approach: 'Give yourself ten jobs to do in one day and if you complete five of them well, you are winning.' Visitors frequently ask why they do it. 'Overall, we both gain so much pleasure from our garden because it is our joint creation, one that we have fought over, argued about and definitely love.'

OPPOSITE The intentionally free-draining soil of the Desert Wash is ideal for yuccas. This area was engineered to mimic landscapes in Arizona where drought and flash floods alternate. ABOVE Even the woodpiles at East Ruston are redolent of the owners' attention to detail, creativity and unfailingly high standards.

4
Elton Hall
Elton, Cambridgeshire

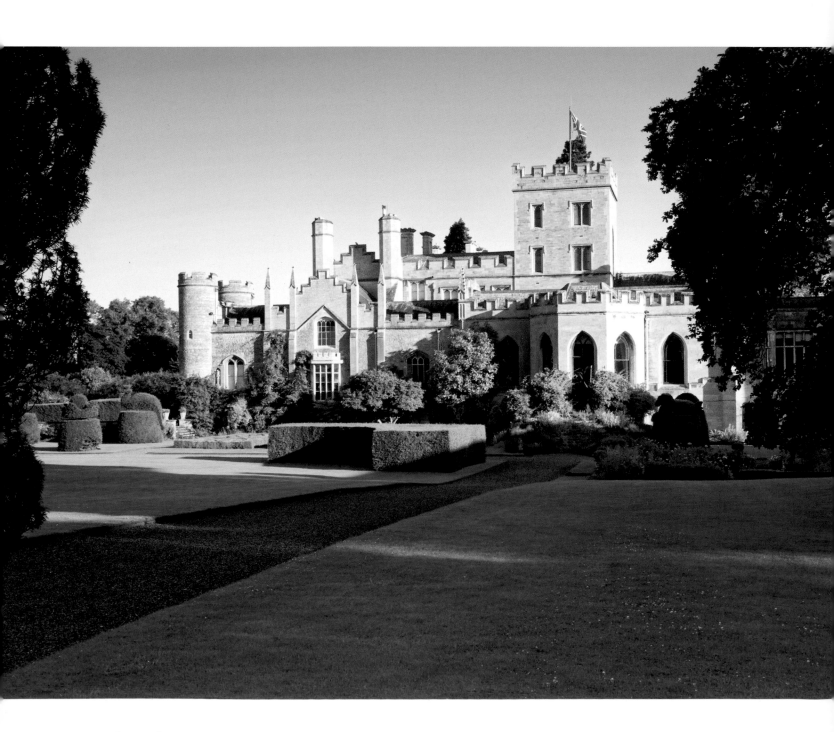

SIR WILLIAM AND LADY PROBY are the modern, pragmatic, yet undeniably creative custodians of Elton Hall, a stately Cambridgeshire house that (apart from a brief period during the Second World War) has been in continuous Proby family occupation for more than 300 years. When, in 1980, William and Meredyth moved to Elton Hall, it had been empty for four years, having already become very run down in the post-war era. They took on the challenges of this historic home with the insouciance of youth and over the ensuing decades have done much to put things to rights.

Marriage of styles

The Proby family connection with Elton goes back to the late fifteenth century, when Sir Peter Proby acquired the lease of the manor of Elton for the sum of £850 – that was for the land but not the hall. The buildings here date from the reign of Henry VII and were the home of Sir Richard Sapcote. After the Sapcotes sold the property in 1617 its history is uncertain until it appears in the ownership of Sir Thomas Proby by 1664. He restored some of the medieval buildings and added, to the west, a fine house in Restoration style. These elements were later joined together by an extension, resulting in an L-shaped building.

Elton Hall has undergone numerous architectural changes over the last 350 years. By 1815 it had been transformed by extensive alterations in a romantic Gothic style, featuring castellations and turrets. These details were removed in around 1855 to restore the western block to its classical origins, but the Gothic extravaganza remains on the southern front.

It has been a daunting task to create a modern garden that accommodates the hall's two distinct faces – also one that matches the Grade I listed building for grandeur and at the same time offers a feeling of warmth and intimacy. Meredyth has accomplished it all with brio. And yet she started out with no special knowledge of design. 'In that first summer I used to look out of the window thinking what am I going to do?' she says.

The last formal design for the garden had been made in 1913 by A.H. Hallam Murray, but only vestiges remained by 1980: the gravel paths, lawns, well head and lily pond all to the south of the house. (The box parterre and four yew cones by the drawing room steps date from the late

nineteenth century.) The main problems facing the Probys at the start were the weed-infested rose garden, the vast and flat empty space in front of the house, and the 150 dead and dying elm trees in the park.

Although Meredyth had access to Murray's original plans and other documents relating to the garden's history, she did not feel inclined to revert back – plant for plant – to what had once been there just for the sake of it. After all, Murray's garden had been designed when there were 13 gardeners, while she had a team of two. So, early on, the garden was reduced in size from 10.5 to 7 hectares/ 26 to 17 acres, to fit around the L-shaped house and cut down on maintenance.

Finding out about flowering plants was a steep learning curve for Meredyth, she remembers: 'My knowledge gradually accumulated, through conversations and initially through moving plants around myself, as they did or didn't do well on our predominantly clay soil.' She discovered how to use plants architecturally to create strong shapes that

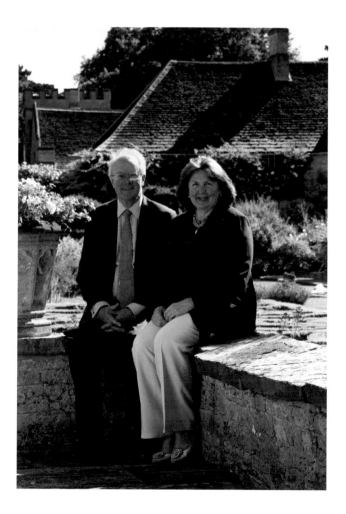

LEFT Elton Hall's south facade retains the Gothic detail incorporated by earlier Proby generations.
RIGHT Sir William and Lady Proby chose to make a modern garden rather than recreate the past.

Statuesque hedging complements the scale of the house.

lend height and distance, bringing a sense of perspective and depth to a relatively flat piece of Cambridgeshire.

Books were also an important resource in those early days. Meredyth's garden bible was David Hicks' *Garden Design*, as it introduced her to the importance of structure. The yew and hornbeam hedges she planted in the first years at Elton now define various garden areas and protect plants from the sharp winds that prevail in the eastern counties. Statuesque in size, the hedging complements the scale of the house.

In addition, by planting different species either as secondary hedges or as sentinel repeat specimens of great size, Meredyth has achieved a layered effect, of hornbeam against box or yew against hornbeam. The conical shapes make wonderful shadows across the grass.

Circular motif

The problem of the rose garden, waist-deep in thistles, was solved in 1983 with the help of rose specialist Peter Beales. For the next 20 years the new rose garden looked wonderful. Unfortunately, rose replant disease increasingly caused the plants to sicken so in 2006 all the roses were removed and 500 tonnes of soil were dug out and replaced. The site was given a new lease of life as the Flower Garden, created by Suffolk designer Xa Tollemache. Set into an immaculately kept lawn, large corner beds mark out a circular space at the centre of the garden, a motif reinforced by four narrow bands of planting forming an inner circle. Bold, expansive plantings of tall perennials combined with roses such as 'White Flower Carpet' have been refined over the years by Meredyth, working with freelance gardener and plantsman Mark Todhunter.

The aim is for an unfaltering succession of flowers from June through to August, to coincide with the period when the garden is open to visitors. Asters, echinacea, nepeta, lavender, veronicastrum, phlox and thalictrum offer a range of heights, spires, fluff and colour, and are offset by the box balls and cones that punctuate the beds.

To one side of the Flower Garden is a raised gravel path shaded by a series of eight metal arches, each holding a number of wisteria and clematis. From this slightly elevated

The contemporary fountain central to the Flower Garden boldly counterbalances the turrets, towers and chimneys of Elton Hall.

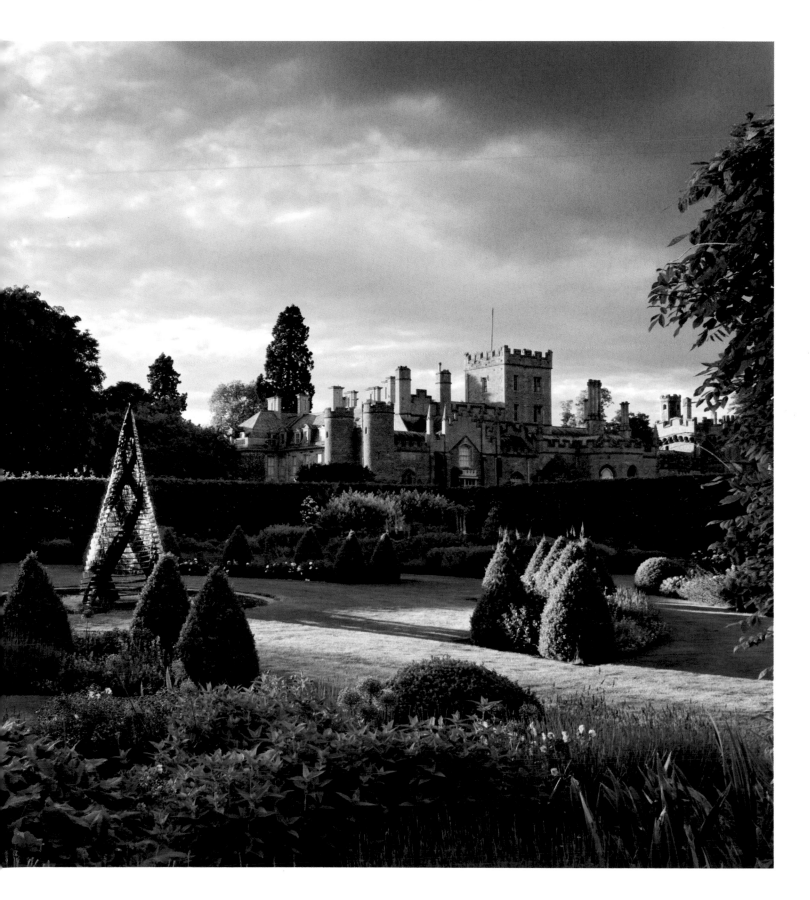

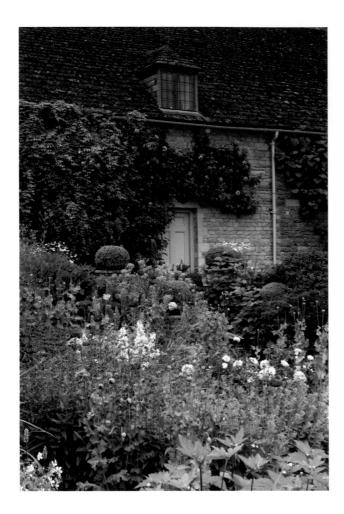

many trees planted in this area since 1980 are still relatively young, including weeping silver lime (*Tilia tomentosa* 'Petiolaris'), the foxglove tree (*Paulownia tomentosa*) and *Acer negundo* 'Variegatum'. The Shrubbery's winding paths and cool glades, Meredyth suggests, offer the change of pace that is absent in the surrounding landscape, where no hills or dells are to be found.

Rhythm in the garden is also provided by extensive use of topiary. The conical shapes lining the hornbeam walkway that leads to a view of the park, the central box and yew planting that makes sense of and anchors the well head in the vast front lawn, and the humorous topiary forms (Bertie the Norfolk terrier, a crown, some bobbles) and flat piano shapes showcased near the house, are all kept in check either by head gardener Steve Simpson or James Crebbin-Bailey of Topiary Arts. James visits the property twice a year, ready with shears to trim and manipulate. A hairdresser in a former career, he is now a sought-after topiary artist and has a gift for cutting plants into shape by eye without the need for guide lines.

Lily pond

The Orangery Garden was William and Meredyth's millennium project. They wanted somewhere to overwinter plants so asked architect Christopher Smallwood to design an orangery. With its own run of crenellations, obelisks and Gothic windows, it perfectly reflects the Gothic facade of the house. In front of it is an enclosed garden that shelters a collection of heat-loving plants and a row of Italian cypresses (given to the Probys for their 25th wedding anniversary).

Closer to the house is a sunken lily pond that formed part of the 1913 design, to which four corner beds and a low, enclosing wall have been added. The original planting called for bedding plants such as ageratum, salvias and begonias. Mindful as she is of the garden's history, Meredyth was quick to ditch the bedding in favour of a larger, lusher planting scheme with campanulas, poppies and *Aruncus dioicus*. 'The house itself is layered with different styles, and I didn't feel bad in abandoning features of the 1913 design that no longer worked,' she says. 'I think that with the immaculate lawns and formal hedging, a burst of wild colour and texture around the lily pond is much more exciting.' An awareness of this unspoken dialogue between house and grounds, past and present, makes for a rich experience when exploring the newly revived garden.

vantage point, the Flower Garden's central pool and water sculpture are seen at their best. *Coriolis*, by Giles Rayner, is a shapely modern metal structure that echoes the Gothic obelisks and turrets of the south facade. Water spirals down the 4.2-metre/14-foot sculpture, giving an illusion of twisting; when agitated by the wind, droplets fly outwards.

Near the Flower Garden, and providing a contrast to it, is the Shrubbery, which was laid out with the advice of designer Rupert Golby. Intended mainly as a spring garden, in summer it becomes a restful oasis of green. The

ABOVE Poppies, delphiniums and campanulas form a brightly coloured surround to the sunken lily pond.
OPPOSITE Elton Hall garden is characterized by expanses of emerald lawn and perfectly clipped formal hedging. The green architecture, which adds pace to what is a relatively flat site, is balanced by touches of topiary humour and discrete spaces dedicated to colour (such as the Orangery Garden, pictured top left).

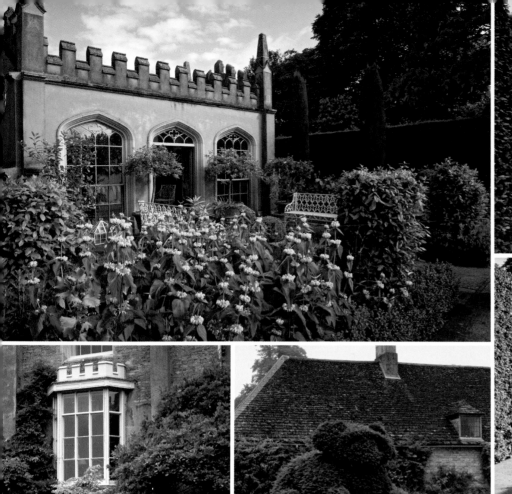

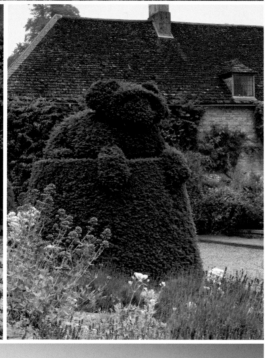

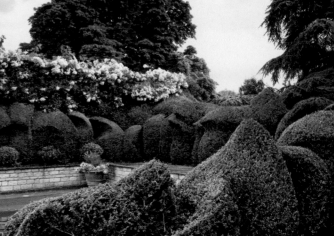

5
Helmingham Hall Gardens
Helmingham, Suffolk

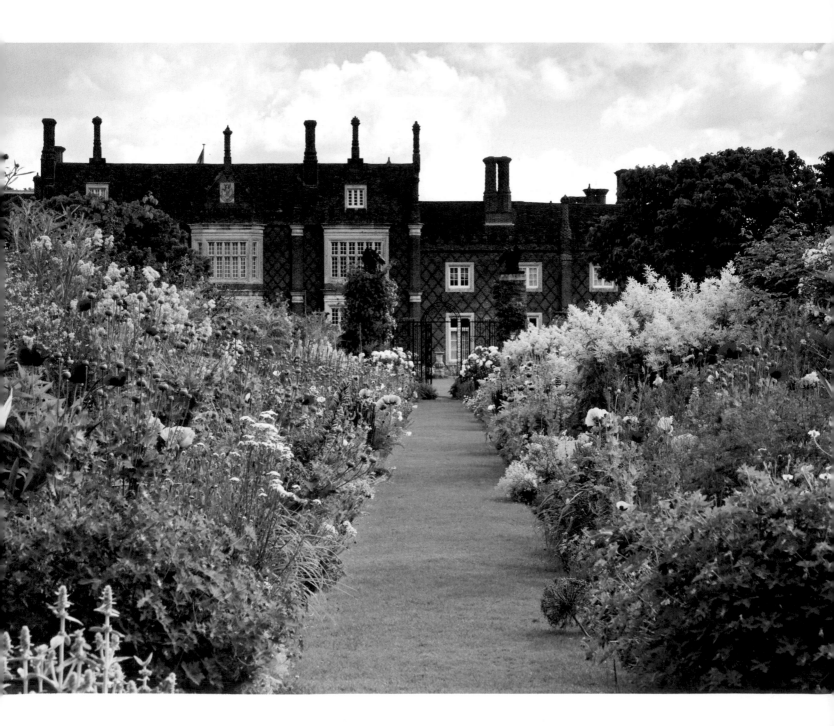

HOME TO the Tollemache family since 1510, Helmingham Hall appears to float on the surface of its broad, rectangular moat, surrounded by the green expanse of a deer park. There are many garden delights at Helmingham, but perhaps most enticing is the walled Kitchen Garden, complete with ample herbaceous borders and tunnels covered in climbing vegetables and flowers. Hidden away on its own moated island, this gem of a garden sparkles like a box of bright jewels throughout summer and autumn.

As in any garden that has been in the hands of one family for centuries, there are echoes from the near and far past. Lady Tollemache, who has lived at the hall with her husband Timothy, Lord Tollemache, since he inherited the title in 1975, has succeeded in melding these older garden forms into a harmonious whole. In the early years Alexandra (or Xa, as Lady Tollemache prefers) redesigned existing features, later moving on to incorporate creations of her own. Head gardener Roy Balaam, who arrived as a garden boy in 1956, has worked with Xa to realize new plantings and projects.

Form and fragrance

At the entrance to the moated walled garden is a rose garden surrounding a formal parterre. This was laid out in 1965 by Xa's mother-in-law, Dinah, the late Lady Tollemache, and has been developed to hold a comprehensive collection of over 200 hybrid musk roses. Here you will find favourites such as 'Buff Beauty', 'Felicia' and 'Cornelia', all underplanted with London pride saxifrage and edged in 'Hidcote' lavender.

The parterre was redesigned in 1978, when its box-edged beds were infilled with cotton lavender (*Santolina chamaecyparissus*). Two circular spaces with central stone urns are bedded out seasonally with wallflowers in spring, followed by petunias and nicotiana. The low box pyramids that punctuate the parterre echo brick obelisks on the bridges over the moat.

These two areas, the parterre and the Hybrid Musk Garden, as it is now known, face the Grade I listed hall on its west side. In 1982 Xa complemented them with new elements across the moat to the east. At this point, Xa was still cutting her garden-design teeth and turned for advice to the Dowager Lady Salisbury, renowned for the Old Palace Garden at Hatfield House. The result of their collaboration was a knot garden, overlooked by the upper rooms of the hall, and beyond it a second rose garden.

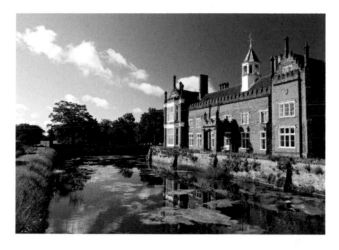

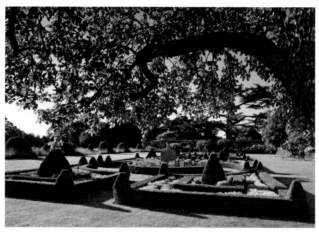

OPPOSITE Dazzling herbaceous borders are a sight to behold in the walled Kitchen Garden.
TOP The hall becomes an island every night, when the drawbridge is raised.
CENTRE The box-edged parterre, filled with cotton lavender.
ABOVE Roses in the Hybrid Musk Garden.

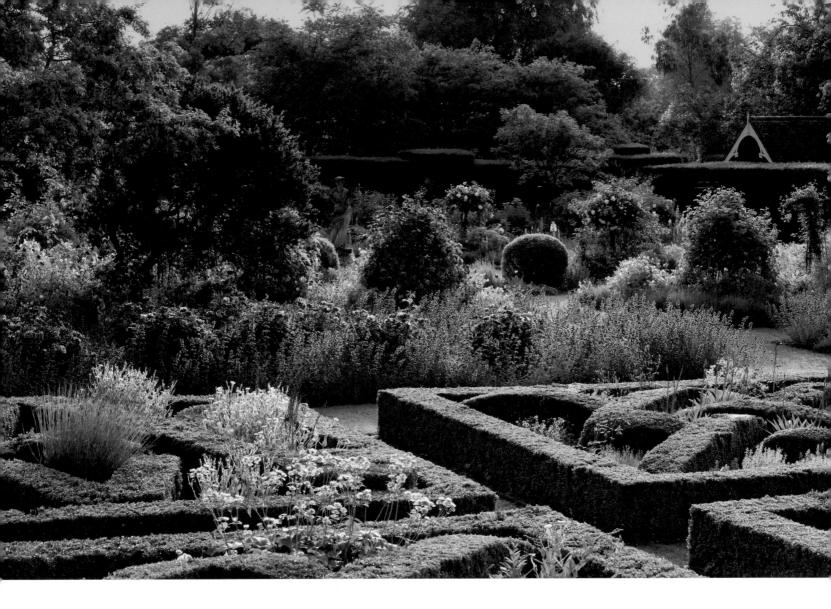

ABOVE Between the Knot and Rose Garden is a double row of striped *Rosa gallica* 'Versicolor' almost lost in the blue of *Nepeta racemosa* 'Walker's Low'.

RIGHT Xa and Tim Tollemache, here in the Apple Walk, intend to make a new garden after handing Helmingham Hall safely over to the next generation.

OPPOSITE Roses such as 'Ispahan' and 'Jacques Cartier' are supported on large metal hoops.

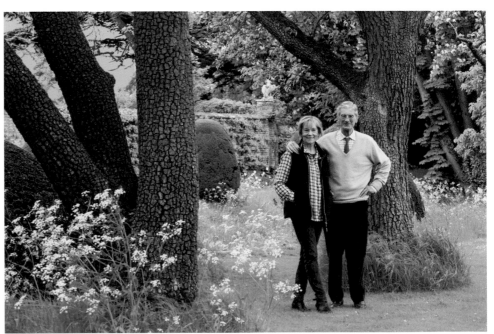

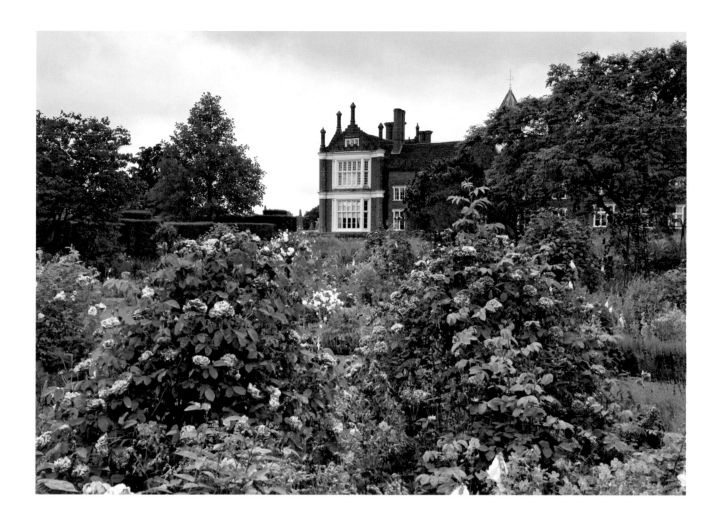

The Tudor-style knot incorporates one of the Tollemache family's heraldic motifs, as well as Alexandra and Timothy's initials. Its intricate pattern of ribbon-like box hedges is filled with annual and perennial herbs. From here, a grass path lined either side with a hedge of white-and pink-splashed *Rosa gallica* 'Versicolor' leads into the splendid Rose Garden, with its collection of old-fashioned roses and underplanting of white foxgloves, sweet Williams, campanulas and hardy geraniums. The roses, in blending tones, are trained up metal supports and tied to a network of umbrella-like wires. This encourages more buds to break along the stems and also supports the roses in wet and windy weather.

Design skills

The garden at Helmingham Hall remains a source of inspiration for Xa, and is where she feels free to experiment with different ideas. In the late 1990s, equipped with the plant knowledge acquired through her hands-on approach and the skills assimilated on a course run by garden designer Jill Fenwick, she began her own career as a garden designer. Now with numerous projects in her portfolio, for gardens large and small at locations across Britain, including several award-winning designs for the Chelsea Flower Show, her reputation is well established.

The greatest transformation at Helmingham has been to the walled garden. The island site of almost 0.8 hectares/ 2 acres is probably Saxon in origin, and would have been used as a cattle stockade. By the mid-eighteenth century, though, the walls were in place and the land intensively cultivated to supply the house with fruit and vegetables. Old plans show how it was divided into eight sections. Xa and Tim decided to follow the same configuration, with eight large plots divided by grass paths, to create an ornamental yet hard-working kitchen garden.

Deep herbaceous borders flank the main path leading from the entrance gateway down the centre of the Kitchen Garden, while running crosswise are long iron tunnels to

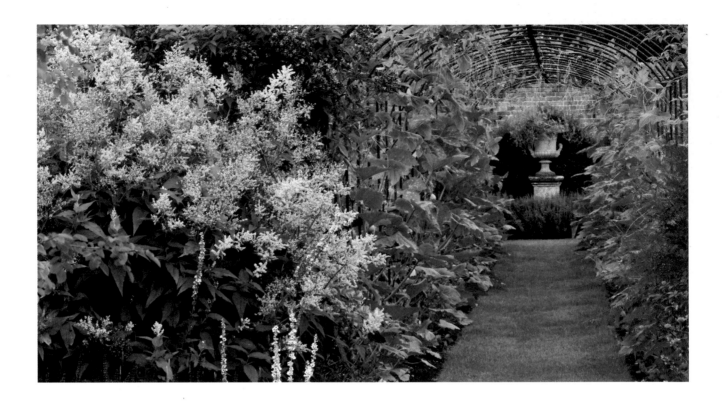

support early and late-flowering runner beans, ornamental gourds and sweet peas. Along the walls themselves are small 'chambers' divided by clipped yew buttresses and filled with herbs, colourful salads and colour-themed plantings. The circuit of wall borders is completed with unusual shrubs, grasses and a collection of topiary.

New era

Until fairly recently each vegetable bed was a picture of perfect row gardening, with long, straight lines of crops. But there are changes ahead. By the end of 2017 Xa and Tim will have moved to another house on the estate so that Helmingham Hall can become home to their elder son and his family. Xa's priority before leaving is to make the garden easier to manage. She is also looking ahead: 'I want to move while I am full of energy and ready for the challenge of making a new garden for myself.'

ABOVE Long iron tunnels are planted with sweet peas, runner beans or ornamental gourds, depending on the year. In the foreground is a giant persicaria, one of Xa's 'muscular' plants. OPPOSITE The Kitchen Garden walls provide warmth for cherries and other fruit to ripen. Around the perimeter of the garden is a set of borders where Xa tests out plant associations, as well as a series of light-hearted topiary figures.

Together with Roy, who now works part-time, Xa has found various strategies to reduce labour without diminishing the garden's interest. For a start, two items of high-dependency horticulture have been dispensed with – 100,000 wallflowers and masses of brassicas. Another device is to divide plots with a simple design in turf, which allows for shorter rows of vegetables. This minimizes the impact of bare earth where crops have either been sown or harvested. 'Immediately it went down to green I knew it was the right thing,' says Xa. 'It gave the garden a breathing space.'

Shrubs and sculpture are included in the design, to offer an additional dimension. At the centre of one grassy rectangle, its corners marked by four *Prunus fruticosa* 'Globosa', stands a flighty metal sculpture by Bristol-based artist Pete Moorhouse, circled by silvery *Lavandula angustifolia* 'Hidcote'. In another rectangle Xa has used a low-growing mixture of 'pictorial meadow' annual wild flowers, this time planting *Prunus* 'Amanogawa' at the corners.

While the vegetables follow their own timeline of growth and decline, an exuberant wave of colour rises and falls in the Kitchen Garden's herbaceous borders from spring into early autumn: purple drumstick alliums, pastel oriental poppies, sky-blue delphiniums and

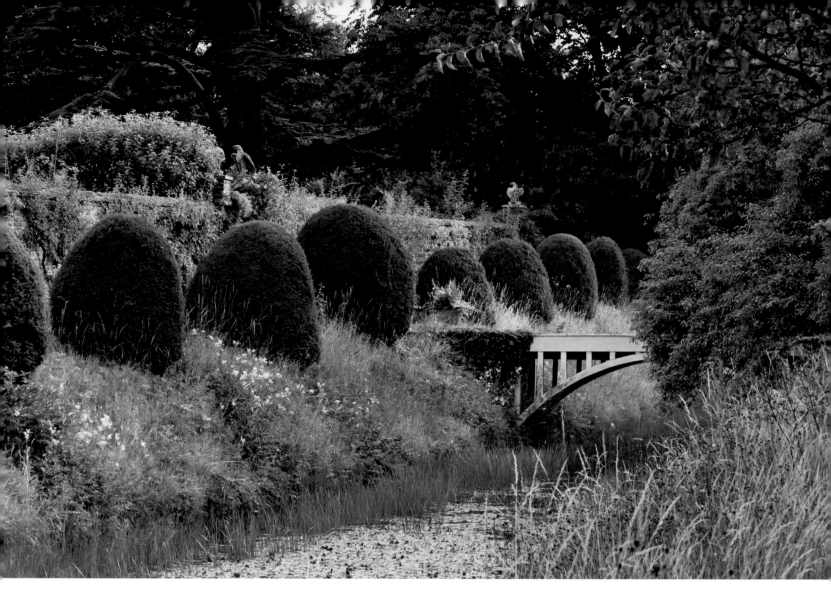

As in any garden
that has been in
one family for
centuries, there
are echoes from
both the near and
far past.

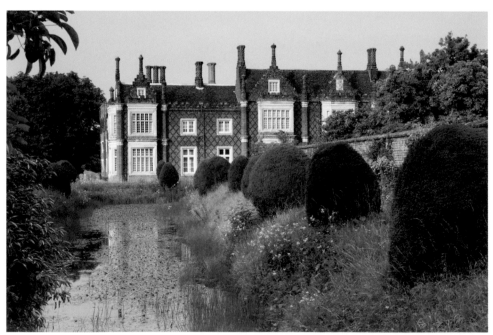

metallic orange tiger lilies. Xa has placed key structural plants rhythmically along the borders, choosing *Persicaria polymorpha* (also known as *P. alpina*), silvery leaved cardoons and neon-flowered euphorbias for 'muscle'.

Near the Kitchen Garden, on the mainland side of the moat, is a new woodland garden set to become another significant part of Helmingham's landscape. This area, which has moved the garden out into the parkland currently grazed by deer and cattle, is also a relatively low-maintenance addition for the hall's future custodians. Xa has planted elder, oaks and liquidambar, as well as glades of *Malus* and *Prunus* for seasonal ornament. Wild flowers and mown paths add texture at a lower level. Completing the garden are two landforms, a Yin Yang Mound and Turf Spiral, shaped by Xa herself at the controls of a digger.

One of Helmingham's signatures is the way formal and informal plant arrangements mingle so successfully. The loveliest example is the moat itself, sown at the edges with ox-eye daisies and wild grasses. These flow softly around the base of repeated clipped yew cones marching steadily along the waterside. Simple but very beautiful.

OPPOSITE ABOVE Along the edge of the moat, uniformly clipped yews are softened by a skirt of wild flowers and grasses.
OPPOSITE BELOW The hall and walled garden each occupy their own island.
ABOVE The old and the new (clockwise from top left): a carved stone apple beside an aged apple tree; recently created landforms; grazing deer in the park; and the timeless sight of gardeners going about their work gathering windfalls.

6
Hoveton Hall
Hoveton, Norfolk

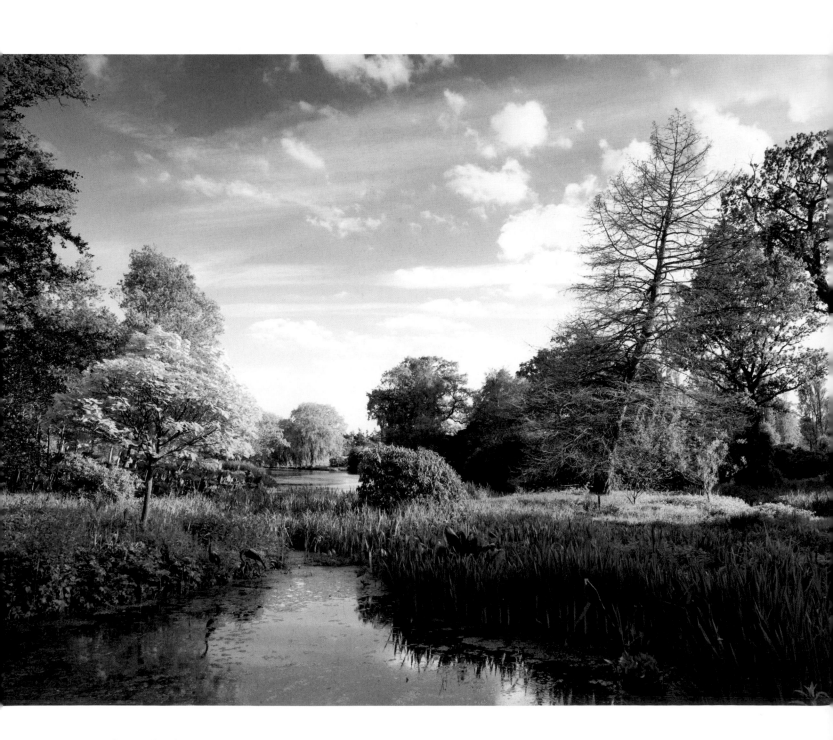

WATER, WILDLIFE AND WALLED GARDENS holding dramatic seasonal blooms in plantation-like stands are among the attributes that sing out at Hoveton Hall in Norfolk, situated about 16 kilometres/10 miles from Norwich, at the juncture where the Broads and flatlands meet and mingle.

Hoveton Hall is a fine Regency survival, built between 1809 and 1812 to replace an earlier residence, and is thought to be the work of Suffolk-born Humphry Repton (and his son John Adey), arguably the last of the great English landscape designers of the eighteenth century. Commissioned by Mrs Christabelle Burroughs, Hoveton Hall has echoes of Repton's work at Sheringham Hall, also in Norfolk.

If Hoveton was indeed a 'Repton', then he surely had a hand in designing the landscape park surrounding the house. However, no iconic Repton 'red book' – a sketchbook of meticulous detail showing his suggestions for improvements to gardens, parks and houses – exists to prove his involvement. There arc, though, plans of the house; and cartographer William Faden's county map of the 1790s shows the 1.6-hectare/4-acre lake formed by damming the River Ash (a feature that would have been dug by hand). Also extant are plans showing a glasshouse on the site, and records of an ice well built during the eighteenth century. (The Grade II* listed glasshouse was recently restored and the ice well still exists.)

Great outdoors

Hoveton Hall's history is worn lightly by its present custodians, Harry and Rachel Buxton, who formally took up the baton from Harry's parents in 2013. They now offer 'homestay' accommodation and host weddings and other events. Essentially, though, this is a family home, surrounded by 250 hectares/620 acres of parkland, gardens, woodland and farmland.

Harry grew up on the estate. 'My parents always encouraged us as children to enjoy the great outdoors. We would walk out the door at 8.30 a.m. after breakfast and not come back until lunchtime. It was a wonderful playground,' he says. Harry has memories of making camp in the woods and boating on the lake – and now it is the turn of his own children to experience the same sense of adventure. 'They are particularly keen on the Kitchen Garden in autumn, with its abundance of fruit, a lot of which doesn't ever make it to the house,' says Rachel.

The present-day Buxton links to the Hoveton Hall estate and garden start in 1919, when it was owned for a decade by a cousin, Geoffrey Buxton. It was he who created the

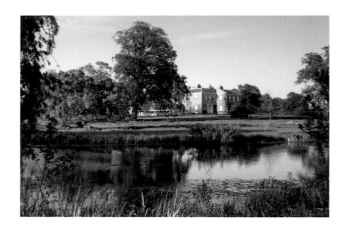

large Water Garden at the northern end of the main lake and around the small kidney-shaped lake (hand-dug in the 1920s) in Ashmanhaugh Wood. Streams and pools criss-cross the woodland beneath a canopy of silver birch, sweet chestnut and Scots pine, where Geoffrey transformed the understorey with colourful waterside planting. His plants of choice were rhododendrons, in their thousands, all supplied and planted for him by Waterers Nurseries (a famous family-owned Surrey nursery, specialist hybridizers of rhododendron, now part of Notcutts).

Douglas Clark, Hoveton's next owner, added walls to the existing eighteenth-century Kitchen Garden, as well as constructing several other walled enclosures. For one of these he commissioned an unusual circular gate in the form of a spider's web. Made in ornamental wrought iron by Eric Stevenson of Wroxham, it has become one of Hoveton's signature motifs and is a favourite of family and friends.

In 1946 Harry's grandparents, Desmond and Rachel Buxton, bought the hall, bringing it back into the Buxton family. They carried out major works to the woodland, and it remained a family home with occasional open days for charity, particularly in aid of the local St Peter's Church.

Harry's parents, Andrew and Barbara Buxton, took the property on in 1987 and embarked on a sustained programme of restoration and improvement. The key for them was to ensure the gardens could be enjoyed throughout the year, as well as being their own personal

OPPOSITE The main lake, formed by damming the River Ash, is one of many watery features at Hoveton Hall. Reflections of trees and sky heighten the beauty of the hall's setting and contribute to a sense of peace.
ABOVE The Regency hall and landscape park are thought to be the work of Humphry Repton, who was born in Suffolk.

Fresh initiative

Among their projects was to further enhance the Spider Garden, for which they referred to a layout pre-dating the gate itself, shown on maps from the 1840s. The Buxtons reinstated formal herbaceous borders, introducing colour and aromas that lift the spirits on a warm summer's evening. They also added a central feature formed of a circular flint-stone mosaic depicting a spider's web, set within a frame of box hedging. Completed in 1998, the planting and mosaic are the work of Ipswich-based landscape garden designer, James Smith. The garden's walls, inside and out, are the support system for trained fruit trees, as well as climbers such as clematis, wisteria and honeysuckle.

Close by the main lake Barbara and Andrew created the Magnolia Garden, which holds not only magnificent magnolias but also camellias, rhododendrons and weeping willows, adding colourful reflections at the waterside. Another of their initiatives was to plant hydrangeas to follow the rhododendrons in season along the wide, road-like Back Drive. This route allows for a less moist wander in the Water Garden.

As Harry recalls, 'guests and family members always traditionally deadheaded the hydrangeas at the appropriate time of year. People who stayed understood they had a role to play in keeping up the standards of the gardens, so weeding, bonfires and ground clearance were all part of a country weekend to my parents.'

Among the particular seasonal highlights of Hoveton Hall are the masses of daffodils widely planted in the grounds. One of these has a special resonance with the family. Harry's great-grandfather, Edward Buxton, who lived nearby at Catton Hall, was the manager of Barclays Bank in Norwich. In 1929, during a lunch-time break, he visited the Norfolk showground to look at the new bulbs on offer and commented on an attractive orange-centred daffodil. He then returned to the bank – and died of a heart attack. The owner of the daffodil named it for him, and naturally there are many, many clumps of 'Edward Buxton' that bloom in spring at Hoveton.

In the 1940s the parkland had been put to the plough for increased food production, but since 1993 it has been restored to grass under the Countryside Commission Scheme for the Restoration of Historic Parks. The iron railings have been re-established, giving a sense of light enclosure to the hall, and Harry continues to add to the tree collection in the parkland as well as the one established by his father. In conjunction with various government-sponsored woodland schemes, he planted some 500 trees in 2016.

stamp on the landscape. Trees were Andrew's main horticultural enthusiasm, while Barbara was instrumental in reviving the Water Garden and walled Kitchen Garden, with the help of designer Tessa Hobbs. Tessa's contribution included brick-edged curved beds that pick up on the circular design of the Spider Garden. In 1992 the Buxtons officially opened the 6-hectare/14-acre garden at Hoveton Hall to the public.

ABOVE The recently restored listed glasshouse was originally used for growing grapevines. Today it displays a collection of pelargoniums and exotic plants.
OPPOSITE ABOVE In late spring, the herbaceous borders in the Spider Garden are full of fresh greens, with the promise of flowers to come. This walled garden, complete with cottage, takes its name from a wrought-iron gate with spider's web motif.
OPPOSITE BELOW The current custodians of Hoveton Hall, Harry and Rachel Buxton, stand alongside Harry's parents, Barbara and Andrew.

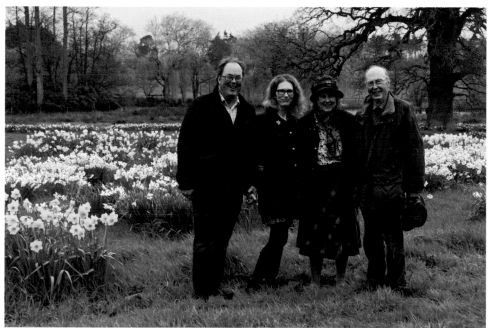

*One of the daffodils
widely planted in
the grounds has a
special resonance
with the family.*

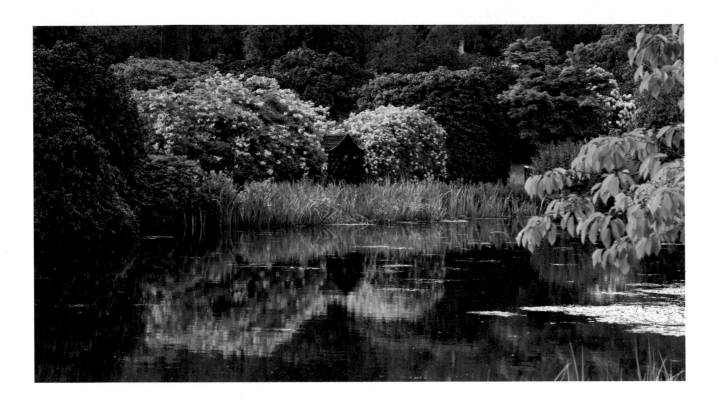

Wildlife award

Harry has observed how certain changes made by his parents to reduce upkeep have resulted in increased wildlife activity. It is a trend that he has been monitoring and consolidating for more than a decade. In 2012 Hoveton Hall Garden's contribution to conservation was acknowledged by the Royal Society for the Protection of Birds, with their Stepping up for Nature award for 'best garden for wildlife'. Head gardener Stewart Wright, who has been at Hoveton since 2002, has driven the garden's environmental initiative forward as part of a mixed approach to managing the garden for both ornament and wildlife.

In the past the watercourses were 'cromed' annually with a special tool to remove all vegetation. Now native species have been replanted to provide a variety of habitats. Aquatic water soldiers, for instance, provide breeding grounds for Norfolk hawkers, just one of 21 types of dragonfly found here. The increase in vegetation has enabled water voles and water shrews to colonize, while an abundance of sticklebacks has attracted nesting kingfishers.

Now that grass cutting and strimming have been greatly reduced, there is a wider range of wild flowers to support insects and birds. Borders with nectar-rich plants play a role in this, as do nesting boxes and bird feeders. As a result, more than 1,000 invertebrate and 142 bird species have been recorded here. Muntjac deer live among the rhododendrons, and the lake attracts otters and Daubenton's bats.

The Buxtons are justifiably proud to have arrived at a garden that is part-managed and part-wild, one that offers variety and an air of mystery from the historic connections of the listed glasshouse and ice well. They plan to protect and conserve the garden for the future, both as an enchanting place to visit and one ever-richer in wildlife.

ABOVE AND RIGHT Winding between the main lake and smaller kidney-shaped lake in Ashmanhaugh Wood is an extensive system of water gardens with bankside plantings of gunnera, primulas and ferns. Thanks to the passion for rhododendrons of a Buxton cousin in the 1920s, the woodland dazzles with colour in May and June.

7
Hunworth Hall
Hunworth, Norfolk

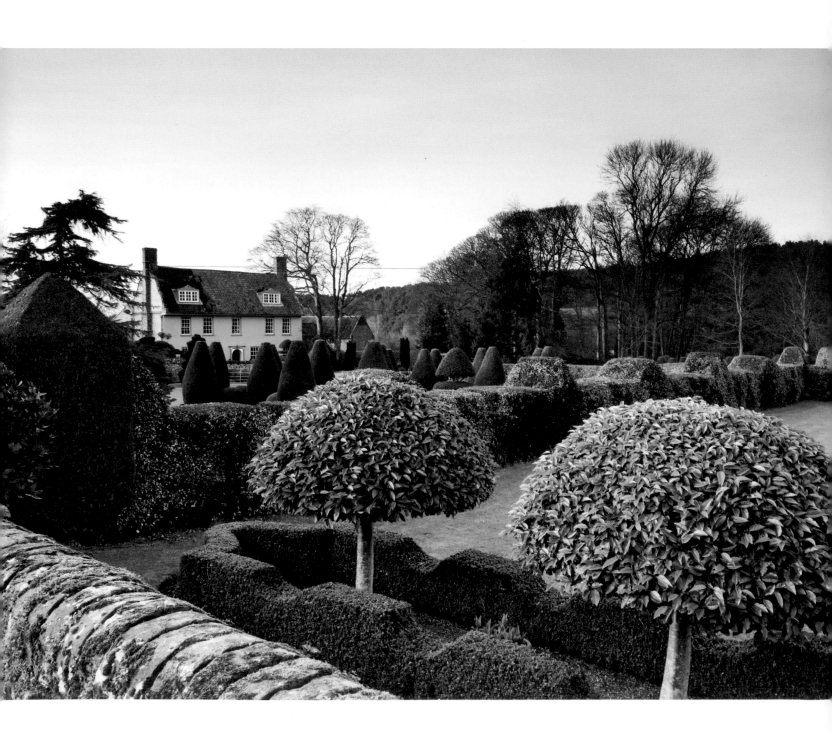

THE GENTLY WINDING tree-arched lanes of the Glaven Valley, in the heart of Norfolk, do not prepare you for the formal garden that lies behind high hedges at Hunworth Hall, the home of Henry and Charlotte Crawley. The garden has evolved 'piecemeal' over the past 25 years, as Henry puts it, and is a homage to the Anglo-Dutch formal style that was favoured in the late seventeenth century.

The Crawleys moved here in 1983, but previously this had been Henry's parents' home. Clipping the beech hedge that separated the house from the vegetable garden was one of Henry's chores as a teenager. Little did he know that in his adult life he was going to be forever shaping and clipping hedges, or that he would some day create a geometric garden within the empty paddock once grazed by his mother's goats. Back then, the hedge was cut in traditional straight lines; but now that it has a more prominent role to play as the boundary of a designed space, it has been given a crenellated top edge, with alternate sinuous curves and triangular peaks.

Pleasure garden

The present Hunworth Hall, complete with Dutch gables, dates back to around 1726 and incorporates part of an earlier, larger house. That house was the home of Edmund and Rebecca Britiffe, members of an old north Norfolk family. Edmund Britiffe's 1726 probate inventory, together with a detailed plan of the estate by a local surveyor, James Corbridge, offer clues as to the character of the garden that was once here.

The plan shows that a formal pleasure garden with avenues of trees and regular paths had been laid out in front of and beside the old hall – it also shows that on high ground there was a garden building furnished with leather chairs and a writing desk. Formal gardens such as this were popular in the late seventeenth century due to the influence of William of Orange (who reigned 1689–1702), and many manor houses in East Anglia had small formal gardens featuring hedging, topiary and canals.

When the Crawleys took over the house they had no clear plan for creating a garden, especially as Henry was a doctor in a busy local practice and had little spare time. However, he and Charlotte, who is an art historian, began

to research what the garden would originally have looked like. They wanted to tie the garden's design in with the house, which was when their thoughts turned to the Anglo-Dutch formal style.

Few examples of this style remain, as Lancelot 'Capability' Brown (see pages 96–9) and the landscape movement he inspired swept away this sort of formality in the later eighteenth century, and introduced a style that was easier to maintain than all the clipped hedging and topiary work. The difficulty of looking after a formal design probably explains why the original garden at Hunworth disappeared, 'especially since at that time the house was occupied by tenant farmers, who had no wish to follow garden trends,' says Henry.

At the far end of the paddock he planted a number of exotic trees, such as the tulip tree (*Liriodendron tulipifera*), roble beech (*Nothofagus obliqua*), oriental plane (*Platanus orientalis*) and Tasmania snow gum (*Eucalyptus coccifera*). Then in 1988 he began creating his formal garden in

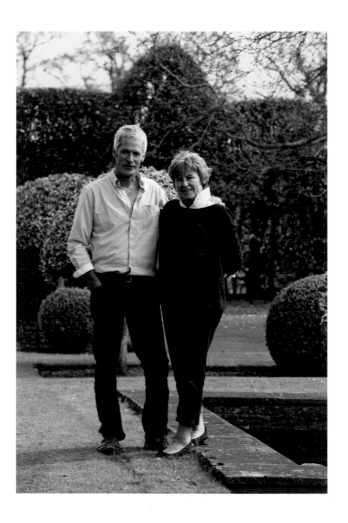

LEFT The crenellated beech hedges, parasol trees and all the other shaped plants at Hunworth Hall take around three weeks to trim.

RIGHT Henry and Charlotte Crawley enjoyed researching the garden's history.

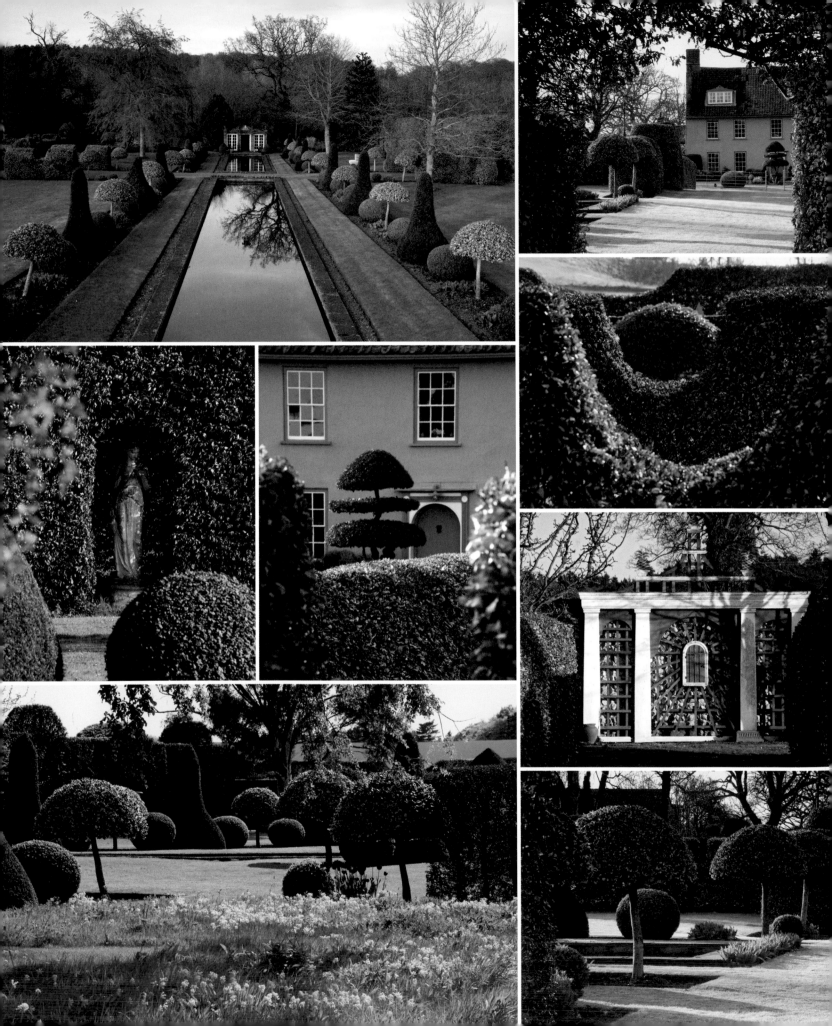

earnest, planting the beech hedge that now divides the former paddock in half horizontally.

Next Henry laid out two large circular beds either side of the central axis leading out from the front of the house. In the middle of each circle is a ring of lavender surrounding a 'Ham House' pedestal urn. These were made by Whichford Pottery, whose founder, Jim Keeling, was one of Henry's fellow archaeology students at Cambridge University. Many other pots at Hunworth, including a giant urn placed in the turning circle of the drive, are Jim's work.

The circular beds were originally designed for 'plat band' planting, popular in Dutch gardens of the period, where a pattern is formed using isolated specimen plants. Henry decided to embellish the feature with a collection of topiary trees – skittles of *Juniperus chinensis* 'Keteleeri', box balls, potted bays and holm oaks shaped into layers – and these eventually overwhelmed the earlier interplanting of flowering plants. Even so, once set on this trajectory of shaped specimen plants and hedging, there was no way back for Henry.

In the 1990s he planted the beech hedges either side of the broad grass walk that runs from the house across the former paddock and right up to the hedge Henry used to cut as a teenager. This forms a central axis of focus, leading from the front door down to the far end of the garden, where the path passes through an archway into the Kitchen Garden. The space between the twin hedges narrows until it reaches a vanishing point at the end of the vista. At this furthest point, on the back wall of the Kitchen Garden, Henry has created a *trompe l'oeil* that makes further play of perspective and reveals a view out on to the fields beyond.

Twin canals

Although plants provide the structure of this atypical country garden, buildings and water features reinforce its formal layout. Henry describes their construction as a leap of faith. A canal, which runs at right angles to the main axis and is divided in half by the central broad walk, was completed in spring 1993 under the supervision of local landscape gardener Russell Wright. The folly and orangery were created to the Crawleys' design by local builder Syd Lubbock. Sited at opposite ends of the canal, the two buildings are linked visually by the channel of water.

If it followed the natural lie of the land, the garden would slope gently down the valley edge, but it was landscaped to almost level in the seventeenth century. This made the canal possible, and also means that the

upper wall sits 1.8 metres/6 feet above the garden. The folly is perched astride the wall at this highest point, raised up on a supportive portico, from where you can look down on the canal tracing a line across the garden. As Henry says, 'by Norfolk standards it's a view.'

The inspiration for these architectural features came from a trio of gardens: Westbury Court Garden in Gloucestershire (now owned by the National Trust), images of the Privy Garden at Hampton Court Palace,

OPPOSITE Holly, box, beech and juniper are used to form the geometric lines typical of a garden in the Anglo-Dutch style. The central axis leads from the house down to a trellis-work *trompe l'oeil* on the boundary wall, while a stepped canal provides a cross axis. This strict formality is softened by patches of long grass dotted with spring bulbs.
ABOVE Perched at the top of a wall, the folly offers a view across the garden towards the orangery at the opposite end of the canal.

which was painstakingly restored by 1995, and the reconstructed Het Loo gardens near Arnhem, in the Netherlands. Westbury is generally considered the best of the Anglo-Dutch formal gardens to survive in England from the reign of William and Mary.

In many seventeenth-century Dutch gardens, existing canals were incorporated into the design, and thus were often at odds with the axis of the house. 'At Hunworth we have mimicked this with the canal hidden from the main sight line from the house, partly dictated by the lie of the land, but also to present an element of surprise,' says Henry.

Framing the canal on opposite sides are two parallel beds of topiary holly, yew and box. Henry used *Buxus sempervirens* 'Handsworthiensis', described by specialist grower Elizabeth Braimbridge as the toughest against box blight. Completing the canal plantings are ribbons of English lavender (*Lavandula angustifolia*) and cool white-flowered native water lilies that float serenely on the canal's surface, the whole creation shimmering at the centre of this shapely garden.

It takes almost three weeks to cut all the hedges and shape the parasols, balls and cones (which have morphed into medicinal flasks). Henry spreads the work out from late July through August, and finds that all goes smoothly with the right equipment, sharp cutting edges and reliable ladders.

Over the years Henry kept on planting hedges – 'as if I didn't know when to stop' – but that impetus has changed; and although the formality of the seventeenth-century pleasure garden is still paramount, there is an informal feel in the meadow-like grass established more recently in between some of the hedged areas.

This is essentially a green garden, where the emphasis is on form and structure, but there are flowery interventions in season. Spring sees tulips and other bulbs on the sloping banks in front of the house, and later wild flowers bloom in the informal unmown grass. In winter and by moonlight the garden at Hunworth Hall becomes quite other, adding to the pleasure that the Crawleys have had in creating it. Cushioned and blanketed in snow, the topiary shapes and hedges are transformed into sugar-icing coated confections, while moonlight adds shadow and glistening water to the picture.

Winter light and snow paint an otherworldly scene, changing the garden's many greens to white.

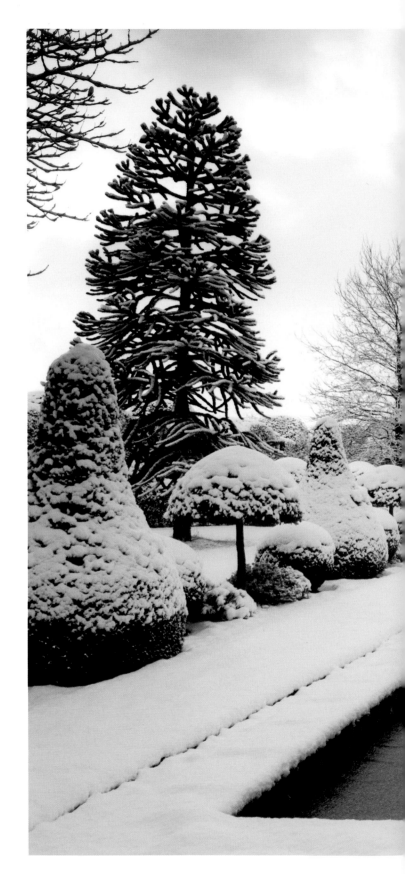

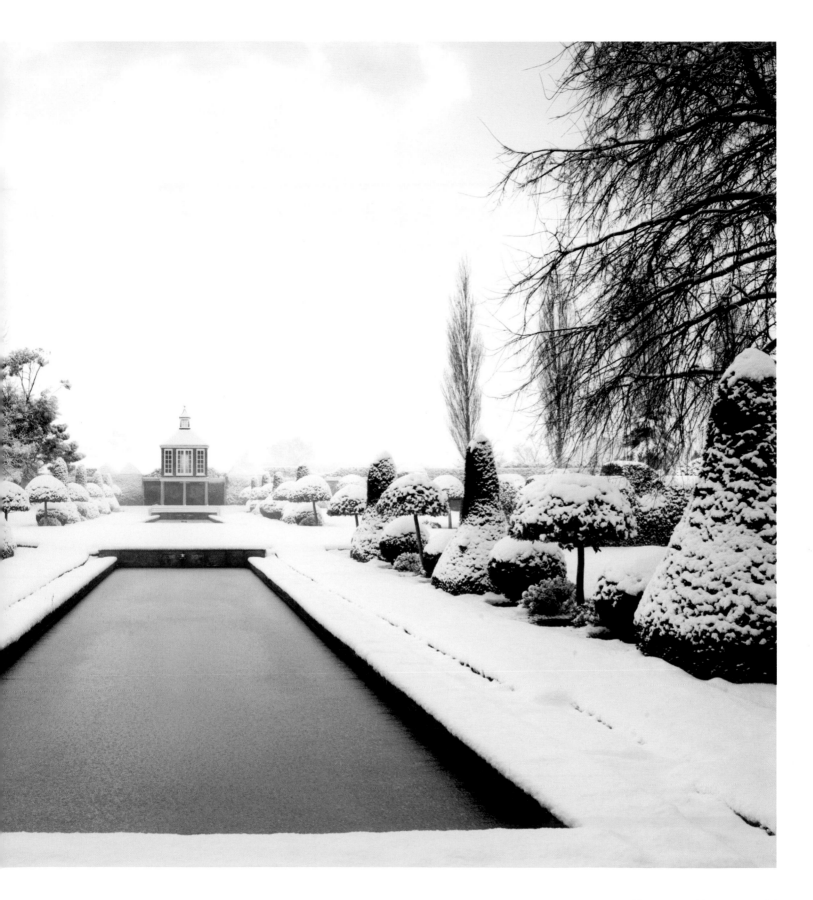

8
Kirtling Tower
Kirtling, Cambridgeshire

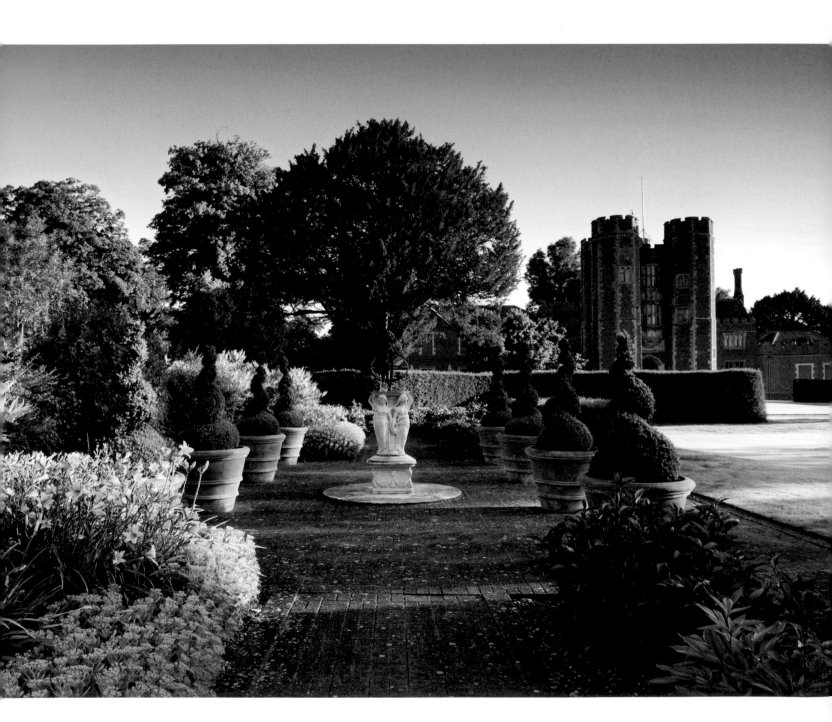

LORD AND LADY FAIRHAVEN moved from Anglesey Abbey, just outside Cambridge, to nearby Kirtling Tower, a Grade I listed Tudor gatehouse with Victorian additions, with the intention of downsizing to a small, low-maintenance garden. That was in 2004, but the Fairhavens' natural enthusiasm and determination have prevailed. They were soon garden-making, first by planting hedges to shelter and divide a site that presented various design challenges. Today, the varied, harmonious and ever-developing garden spreads out over 6.5 hectares/16 acres.

The Kirtling estate, near Newmarket, was a royal deer park for hundreds of years. After the Norman Conquest in 1066, William I passed the land to his niece, and it went down that family line until 1530, when Henry VIII gave it to Edward North. An adept politician, North served as a royal official under Henry VIII, Edward VI and Mary Tudor. In 1540 he built Kirtling Castle, which, with its four-towered gatehouse, was the first private brick-built property in Cambridgeshire. North may have arranged for Elizabeth I to spend time here, as a 'guest', during Mary's reign; and in 1578, after her own accession to the throne, Elizabeth journeyed to Kirtling with an entourage of 2,000.

Most of the original Tudor hall was demolished in the late eighteenth and early nineteenth centuries, leaving only the gatehouse towers, to which two Victorian wings were added. Tricia, Lady Fairhaven used her own company, Kirtling Construction, to build a library and a west wing four years before moving in. The Fairhavens were not, at that point, optimistic about the garden's potential. 'It was a mess,' Tricia recalls. There was a walled garden, but it had to be left covered with polythene for two years before attempting to grow anything in it.

Yew structure

Many people have played their part in transforming the gardens around Kirtling Tower. In the 1990s the Fairhavens turned to garden designer and author Penelope Hobhouse for advice, particularly on hedging. 'We couldn't afford walls, so the next best thing is yew,' Tricia recalls. They wanted to establish windbreaks and 'rooms' to enhance and add interest to the front of the property, which was very open and windswept.

LEFT Curving yew hedges create enclosures in front of the Tudor gatehouse.
RIGHT Lord and Lady Fairhaven, with their enthusiasm for garden-making, have overseen the transformation of this historic site.

Penelope Hobhouse's knowledge of history and plants proved invaluable when in discussion with the National Trust, English Heritage and Historic England (which monitors nationally important archaeological sites), as there were many constraints imposed on what could or could not be planted or disturbed on this ancient site. Later, the Fairhavens decided to reshape the front drive and move some 300 of their yews in order to alter the layout of hedging. This was achieved with the help of landscape architect Chris Carter of Colvin & Moggridge. The aim was to screen parked vehicles from the house.

The Octagon Garden, adjacent to the dining room, was designed by Tricia's friend, the late Rose Parker-Bowles, and echoes the shape of the towers. Rose gave Tricia the design as a birthday present in 2003. It is a soft garden in shades of pink, cream and blue, backed by good foliage. 'It is my sort of gardening, nothing ferociously acid or yellow,' says Tricia.

Of all those who have played a part in the garden, the person with the most input over the longest period is

Richard Ayres, former head gardener at Anglesey Abbey. His expertise was needed when finally the polythene came off the Walled Garden and it was ready to be replanted. Tricia claims to 'know nothing about plants' but is clear about the shapes and colours she likes, and Richard was swiftly able to come up with the ideal plant combinations. Among his selection are *Aruncus dioicus*, astrantia, *Geranium* 'Patricia' and *G.* 'Rozanne', with delphiniums and *Eremurus robustus* for height.

Tricia did not want a garden arranged in squares, so Richard planned for four long and deep borders to run from corner to corner, with a circular hedge of lime occupying the space in the middle. Still awaited is a suitable central water feature, a position held for now by a box plant. There are also mophead specimens of *Crataegus orientalis* to reflect Ailwyn, Lord Fairhaven's interest in trees.

Near the Walled Garden is the main lawn, used for croquet, with the Victorian Garden beside it. This holds many different herbaceous and tree peonies. The lawn is enclosed at its lower end by one of the oldest hedges on the property, a box hedge that is more 'cloud' than formal in look. Two impressive gates set by the Fairhavens into the hedge lead your eye down to an avenue of 150-year-old walnuts (*Juglans regia*).

It was problematic knowing what to align the gates with since, as Tricia explains, this is a garden where 'nothing lines up with anything'. It later transpired, however, that their choice could not have been more appropriate – an old painting sent off for cleaning revealed a previously unseen detail: that gates had originally stood on this very spot.

Bulb planting

In spring, Rupert's Garden draws visitors to Kirtling. This space is a memorial to the Fairhavens' second son, who died in 2000; and although Tricia dislikes yellow flowers in other parts of the garden, especially in summer, here she is happy to admit the yellow springtime promise of hope and joy. So, after Richard had planted out large swathes of *Narcissus* 'King Alfred', the Fairhavens called on help to complete the task. They sent out invitations to friends, family and neighbours, and about 80 people turned up, each with a trowel in hand.

OPPOSITE The scene at Kirtling Tower changes through the seasons, but the tones remain soft. In spring massed daffodils are followed by camassias in Rupert's Garden, while muscari line the grassy path along Church Walk. Irises, lavender, roses and the brimming herbaceous borders of the Walled Garden are the mainstay of the summer show.

'We gave everyone hot drinks and cake on arrival, and then we set to planting thousands of bulbs,' says Tricia. Now there are some 80,000 narcissus, and around 3,000 camassia that flower later in the same field. The Fairhavens have also planted 5,000 tulip 'Georgette', each of which produces three to five heads in scarlet, in lieu of poppies that will not grow here.

Between Rupert's Garden and the Walnut Avenue is a hidden space known as the Secret Garden. It boasts deep, curving borders of shrubs and trees, as well as *Alchemilla mollis*, *Lavandula angustifolia* 'Hidcote' and *Nepeta* 'Six Hills Giant'. There is a grove of Himalayan silver birch (*Betula utilis* var. *jacquemontii*), and sweeping hedges of *Elaeagnus* × *ebbingei* and copper beech, that skim and dip below each other's rims.

It is not surprising given Ailwyn's love of trees that the Secret Garden also holds numerous specimens of fastigiate oak, dawn redwood (*Metasequoia glyptostroboides*) and a rare alder, *Alnus glutinosa* 'Imperialis'. Rambling roses such as 'Wedding Day' and 'Kiftsgate' have space to grow large here; suspended on ample wooden supports or on old trees, they become clouds of bloom in early summer. More tree treasures are to be found in the two arboreta in another part of the garden, one devoted to conifers and the other to oaks.

The garden team at Kirtling Tower consists of three gardeners and an extra person to cut the grass. There is also the estate's legendary digger-driver, Ray Day, who carved out the large pond at the centre of the Secret Garden. It was he who did battle with the brambles that had been left undisturbed for years on the banks of the Tudor moat. Church Walk, alongside the moat, is now one of the spring highlights at Kirtling, with ribbons of some 36,000 bulbs, including chionodoxa and muscari. Tricia herself is known as the 'phantom gardener', for the huge heaps of prunings that mysteriously appear here and there around the garden.

Gardens, however we may wish to control them, often provide the greatest surprises, especially if some part is left undisturbed for a season or two. When the ground under a spreading purple beech tree was left unmown, a few wisps of foliage surfaced from some long-forgotten plant lying dormant beneath the soil. More appeared – flowered for the first time and were identified as *Tulipa sylvestris* – and now there is a colony of thousands. This yellow-flowered tulip was introduced from Turkey in the later sixteenth century, so might it be the remnant of a Tudor pleasure garden that once flourished here?

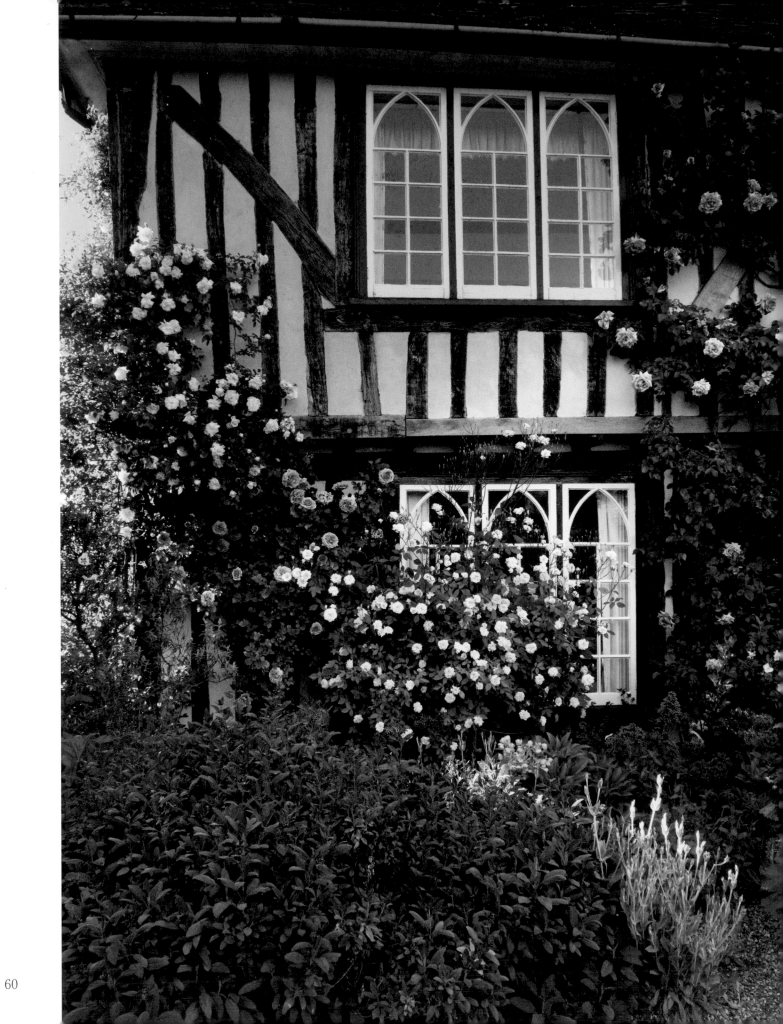

9
Parsonage House
Helions Bumpstead, Essex

ANNIE TURNER has gardened all her life. She finds it endlessly fascinating, especially the way it combines art and science. For her, though, the plants are paramount. She and her husband, the Hon. Nigel Turner, have been living at Parsonage House since 1990. Around their fifteenth-century Grade II* listed home they have created a quintessentially English garden, with mixed borders that hold low-growing sparkling jewels in spring, and tall, thrusting perennials that rise like an ever-flowing floral tide in high summer.

Their kitchen garden, small and productive, is close to the house, while the 1.2-hectare/3-acre field across the lane is the setting for an orchard of heritage apples. The main garden radiates out from the house over 1.2 hectares/3 acres, with a further 1.2 hectares/3 acres of wild flowers and trees.

Parsonage House is a timber-framed property dating from 1450, once owned by St Paul's Cathedral and later leased to Hatfield Priory. Following the dissolution of the monasteries in the sixteenth century it became a domestic residence, and was once divided into four cottages. Fast-forward to 1945, when the building's front door was immortalized in a clip from the film *The Seventh Veil* – cast members Ann Todd and James Mason stayed at the house during filming.

The Turners feel fortunate that the new buildings they have added – a pool house, the garden-room extension, and the flat and potting shed – were all designed by their friend, architect Charles Morris, who is known for work in many gardens but notably for the Orchard Room at Highgrove House. These alterations replaced unsympathetic or derelict features dating back to the 1950s and earlier.

Plan and prepare
For Annie, the move to Parsonage House, very near the Suffolk border, marked a return to the countryside where she had spent many happy childhood years: 'I was born in my grandfather's house in Suffolk, and in my memory I see a lovely garden sweeping down to a large lake. I

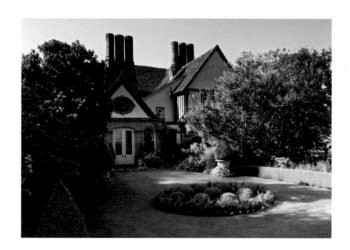

OPPOSITE The front garden at Parsonage House is a gravelled suntrap, perfect for purple sage and self-seeders such as grey-leaved campions.
TOP An oval bed in the lawn mirrors the gable window of the garden-room extension designed by architect Charles Morris.
ABOVE This terrace is a favourite place for outdoor meals with family and friends.

RIGHT Annie and Nigel
Turner have created a
picture-perfect English
garden around their timber-
framed home.
OPPOSITE Mown paths curve
out into the wildflower
meadow from a central circle
of Turkey oaks.

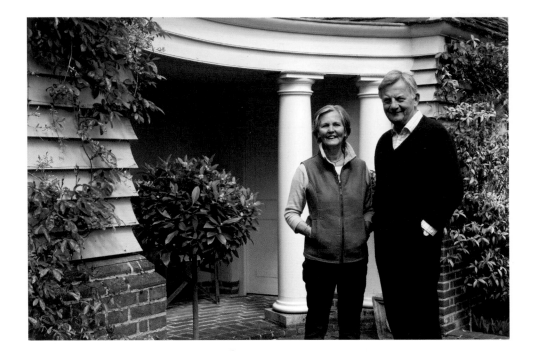

earned my pocket money pricking out plants, weeding
and edging, and by the time I was ten I was responsible
for the rose pruning.'

Even though raring to go, Annie could not launch
straight into making a garden around her new home.
Preparation and patience were keywords at the outset.
As recent storms had felled a number of mature trees,
extensive clearing and assessing occupied the couple
in the early weeks. After that, the focus shifted to
eradicating ground elder and bindweed – a phase that
lasted five long years. Annie reined in her creativity,
knowing that she would be wasting her energy while
the perennial weeds persisted.

'Having the discipline not to do too much too soon
has its rewards,' says Annie – like time to think and plan.
Her thoughts turned to the existing herbaceous border
and remaining mature trees. She started planning a way
to move around the garden that would involve both an
easy passage and an interesting journey, and imagined the
views from different windows of the house.

The wait also allowed her to see how frost rolls in to
various places in the garden, and how the wind blows.
Parsonage House is on a hill, which is fortunate in many
ways, since there is good drainage and the frost tends to
dissipate, but it is exposed to wind from the west and
north-west. An important first step was to create shelter,
which the Turners did by planting a ring of 300 trees in

a former crop field at the garden's furthest edge – mainly
native species nearest the farmland, becoming more exotic
towards the formal garden. They planted a hawthorn
hedge all the way round the roughly diamond-shaped
site – some 3,500 saplings in all – and sowed a fine grass
mix that they would develop over time into a wildflower
meadow. Spires of rich blue *Camassia leichtlinii* and three
species of orchid can now be seen here in their hundreds.

Memories of friends and family occasions live on in
some gardens in the form of plants that are gifted or 'passed
along', as is the case for certain special trees in the Turners'
meadow. There is a cedar of Lebanon planted for Nigel's
mother, Lady Netherthorpe (a rose named for her is also in
the main garden) and a potted walnut tree given to Annie
by a friend, which now grows unfettered in the woodland
fringe to the meadow. The paths mown through the grass
lead out in swirling curves from a central circle of Turkey
oaks (*Quercus cerris*).

A secret revealed

Finding out what secrets a garden holds is often a
wonderful voyage of discovery for a new owner, and the
find in one of the Turners' forays was a 1930s swimming
pool. It came to light when they cut down an old hedge.
English Heritage described it as a very interesting
early domestic example, and there were people in the
village who still remembered the pool from that era, but

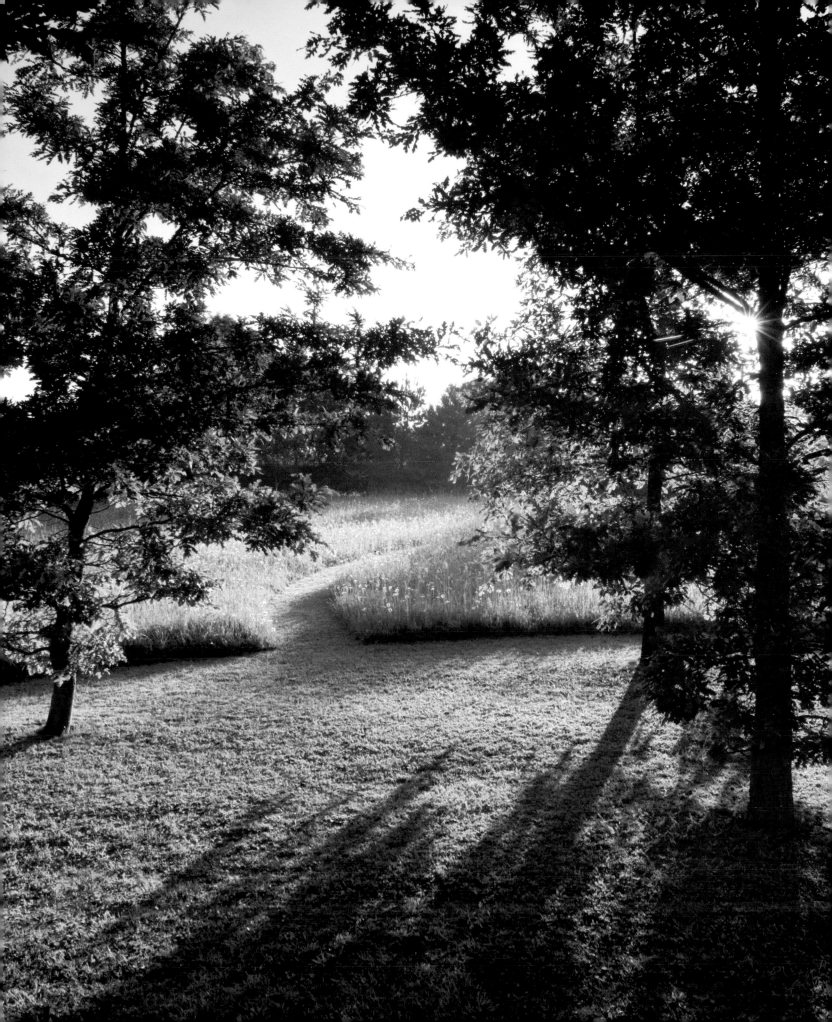

TOP LEFT The site of the old swimming pool is now a tranquil spot to sit amid white-flowered shrubs and roses such as 'Pearl Drift'.

TOP RIGHT Across the road, the Turners have planted a field with 'Sturmer Pippin' and other East Anglian apples.

ABOVE LEFT Box topiary by the tennis court, providing an ever-ready set of 'new balls' for the players.

ABOVE RIGHT Rhubarb lines the Kitchen Garden, sited conveniently near the house.

OPPOSITE One of two long borders framing the lawn, skilfully planted to knit together and provide a long season of interest.

unfortunately it was in a poor state. Constructed of concrete and reinforced with scaffolding poles, it had no heating, nor any filtration, and poplar roots were causing cracks in its base and walls.

The Turners eventually got planning permission to build a new pool, and used the spoil to fill up and turf the old one. That part of the garden is now a tranquil green space, with white-flowered shrubs against a backdrop of ivy. The bench that sits atop the old swimming pool is centred on the door out from the drawing room.

Annie and Nigel have added a terrace by the house, as a place to sit out and enjoy meals. An immaculate lawn rolls out from here. 'It is like a green lake,' says Annie, 'a breathing space that enables you to take in the drama of the borders on either side.' The main border, backed by the yew hedge that encloses the new swimming pool, is an eye-catcher in every season. Low-growing spring bulbs including snowdrops, *Crocus tommasinianus* and tulips, complemented by hellebores, can be viewed from the house on cold days.

Team Turner

Plants always hold the foreground in Annie's designs, and she is well supported in this by head gardener Andrew Bond (who has worked for the Turners for 15

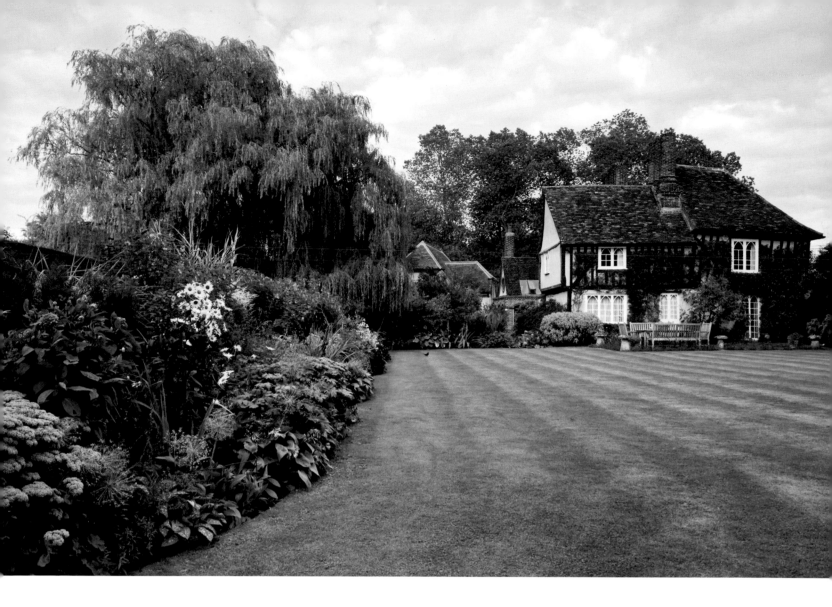

years) and his wife Sharon. All three can 'talk plants' for hours and have similarly skilled green fingers, being able to propagate almost anything with leaves and conductive tissue. Robert Andrews, who mows the orchard and other grassed areas, and keeps all the machinery in working order, is another vital member of the team. Nigel has a free hand in the garden but limits himself to the pool, tennis court and gravel, lest he 'cause damage', as he puts it.

The garden itself is an effortless blend of formality and relaxed flowing informality. The massed plantings of perennials in the long borders, where colour flows from foliage to flower and forward to seed heads and rose hips, is counterbalanced by clipped box and yew hedges, with one or two separate topiary set-pieces. The numerous box balls that tumble alongside the tennis court add a touch of humour – and are perfect for Annie and Nigel's grandchildren to leapfrog over. Another topiary feature, a rotund yew shape that dominates the main lawn, has always been known fondly as Cyril.

To keep the massed perennials and climbing plants in place, and give them additional support, Andrew creates wonderful supports from whippy hazel twigs, which he weaves and twists together. He also uses hazel poles to make rectangular, tiered supports for perennials, and is adept in using string to make neat and tidy latticework supports for sweet peas, beans and other climbers.

Colour flows from foliage to flower and forward to seed heads and rose hips.

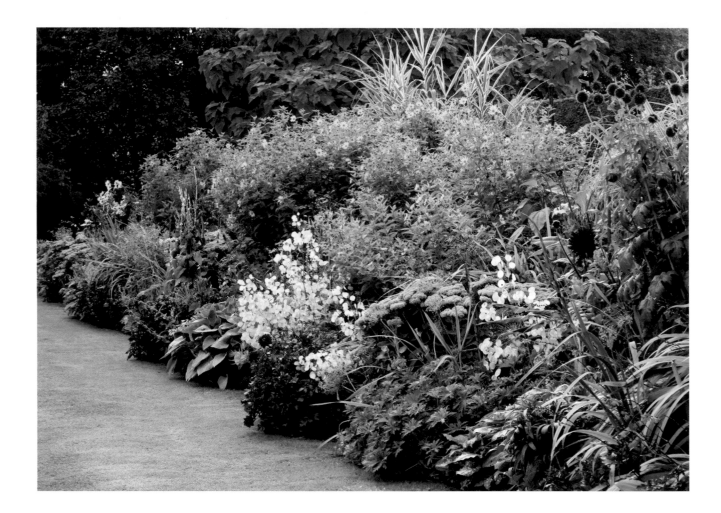

Annie is happy to accommodate self-seeders such as *Verbena bonariensis*, *Papaver somniferum* 'Lauren's Grape', holly-leaved hellebores, snowdrops and various geraniums. Many are allowed to grow to maturity or else are potted up and moved to other parts of the garden. But performance, rated in terms of foliage, flower colour, shape and texture, is a requisite for continued inclusion.

Perfume is another important element, and nowhere more so than within the tall yew hedges that surround the swimming pool. Scented *Trachelospermum jasminoides*, honeysuckle and roses such as 'Rambling Rector', 'The Garland' and 'Sombreuil' sweeten the air on a summer's day. The new pool lies next to the remnant of the moat, which, dominated by the soft flowing lines of an ancient willow, is the most perfect contrast to its functional neighbour.

The garden at Parsonage House is always on the move. Annie and the team often take plants to the limits of hardiness by trying them out in different situations.

'But you have to keep your experimentation within the bounds of practicality,' she says. 'I try not to make life too hard for us with changes that mean extra maintenance.' You get the feeling, though, that Annie's creativity takes some reining in.

ABOVE In spring this border is filled with tulips, wallflowers and honesty, but in summer it rises as high as the yew hedge behind. Tall *Helianthus* 'Lemon Queen' benefits from head gardener Andrew Bond's hand-crafted staking.
RIGHT Annie sees the walls of any building as the natural support and backdrop for her elegant combinations of climbers and perennials, including apricot *Rosa* 'Meg', dark dahlias and (top right) frilly-flowered *Clematis* 'Purpurea Plena Elegans'.

10
Pensthorpe Natural Park
Fakenham, Norfolk

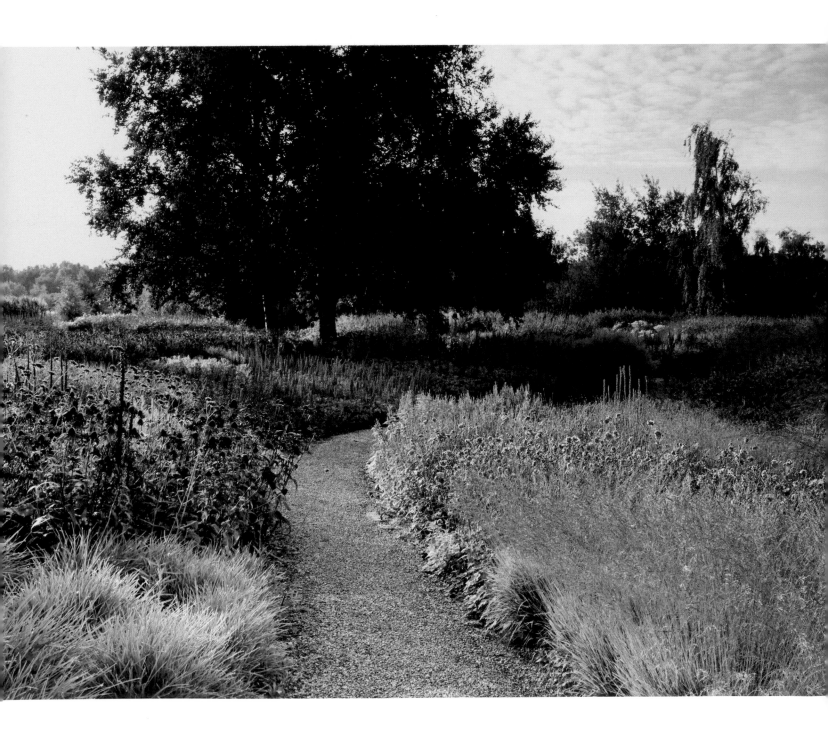

PENSTHORPE NATURAL PARK has been a magnet for wildlife enthusiasts ever since it opened to the public in 1988. This large nature reserve set in the Wensum Valley in north Norfolk is a must for anyone interested in waterbirds. But the story does not stop there, as Pensthorpe also has much to offer garden-lovers. The unexpected horticultural jewel at the heart of the 120-hectare/300-acre site is the Millennium Garden created by Dutch horticulturist and designer Piet Oudolf. Bold and colourful, this tour de force of naturalistic planting is at its peak from June through to August, followed by rich autumnal tints.

Wildlife haven

The site was originally a mixed farm and quarry owned by Bill and Francesca Makins. After the extraction of more than 2 million tonnes of aggregates had been completed in the 1980s, Bill dedicated his time to creating a haven for wildlife. As well as planting woodland and wildflower habitats, he used the former gravel pits to make eight large freshwater pools fringed with reed beds. In winter these attract large numbers of migrating birds heading south from their breeding grounds in Scandinavia and the Arctic Circle, such as pink-footed geese from Greenland and Iceland, as well as many other ducks, geese and swans.

In 2003 Bill decided to sell Pensthorpe. The bureaucracy that went along with the park's great popularity had become a burden, and he wanted to pass it on to 'safe hands'. He was fortunate to find buyers in the shape of Deb and Bill Jordan of the Bedfordshire family firm Jordans Cereals, who made contact after visiting Pensthorpe one day. 'We had no idea at the beginning of what a mammoth challenge it would be,' says Deb. 'But waking up to the dawn chorus, or wandering through our own reserve after the visitors have left, is always an amazing experience.'

The Millennium Garden was part of the Makins' legacy. Bill Makins was particularly enthusiastic about exotic waterfowl, whose plumage is at its most vibrant in the winter months. It struck him that a well-designed, vivid garden at its peak through the summer would help provide all-year colour and interest for visitors to the reserve. The idea was that visitors should discover the garden at the centre of the reserve as a surprising, almost secret entity.

LEFT Dutch designer Piet Oudolf's signature palette of perennials and grasses includes echinaceas and Japanese anemones.
RIGHT Deb and Bill Jordan, who took the park on in 2003, value its tranquility.

The Makins approached Piet Oudolf in 1997, aware of the extraordinary talent of the Dutch plantsman and garden designer who was beginning to make a serious name for himself on the world's gardening circuit. According to Deb, when Bill Makins received no reply to his letters he decided the only way forward was a more personal touch. He picked up the phone to Piet on Christmas Day and was surprised not only to find him in, but also receptive to the idea of coming to England to discuss the project.

Piet's design for Pensthorpe would be the first public garden of his in the United Kingdom to showcase the concept of prairie planting. Over the next year the ground was prepared and the plan finalized. In May 1999 Piet visited to lay out the garden, in readiness for the 12,500 plants needed to complete it. Finally, in August 2000 the Millennium Garden, composed of the drifts of clumping perennials and softly moving grasses for which Piet is renowned, was opened by plantsman and broadcaster Roy Lancaster.

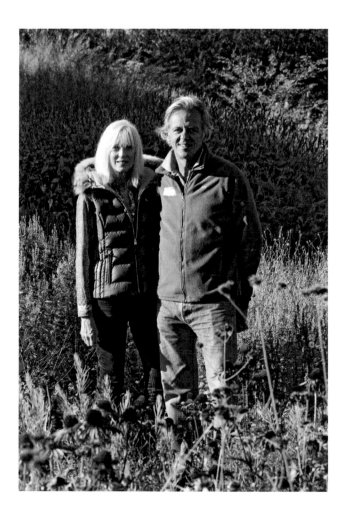

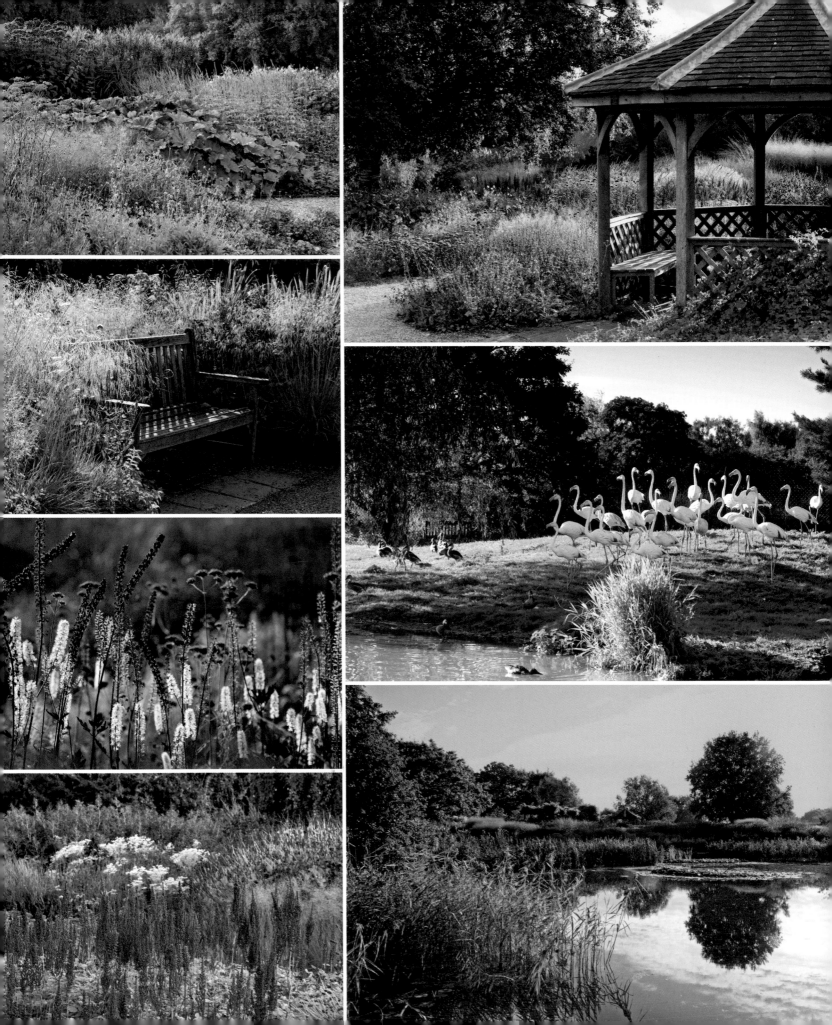

New Millennium Garden

Time went by, and when this influential garden was in its ninth year, the Jordans felt some replanting was needed in order to keep it looking at its best. Neither Deb nor Bill profess to have a deep knowledge of horticulture. 'Until we came to Pensthorpe our own gardening experience revolved around a great deal of raking leaves, mowing and tidying,' Deb says.

Pre-Pensthorpe, Deb and Bill had a close friend who invited them regularly to the Chelsea Flower Show for their yearly fix of specialist gardening. Here they gathered ideas and made plans for the future should they ever have the opportunity to create a garden of their own. It never occurred to them that some day they would be watching one of the most talented designers of the time working out of the small gazebo at Pensthorpe to redesign the Millennium Garden.

This was in 2008, when Piet returned for a two-day visit to formulate ideas for the replanting. At this stage the garden was beginning to show signs of overcrowding, and some of the original plants had been lost. During his visit Piet reviewed what was out of scale and what needed to be replaced. Then from March through to September 2009 the team at Pensthorpe began the necessary task of lifting, dividing and replanting. It took two full-time gardeners and three loyal volunteers a total of 2,000 hours to complete the transformation. Around two-thirds of the garden was replanted with divisions of the original stock, and the remainder replenished with 4,000 new plants (representing 32 per cent of the initial Millennium planting). The refreshed and renamed New Millennium Garden opened in 2011.

Overseeing all the horticulture at Pensthorpe is head gardener Jonathan Pearce. He came to Pensthorpe in 2014, having worked on many large-scale European horticultural projects, most recently in France, where he ran his own garden and landscape company. At Pensthorpe he is delighted to be in close contact with the plants and maintenance of such varied gardens – although, as the prolific wildlife tends to undermine his handiwork, this is a relationship that needs constant fine-tuning…

Sculpture Trail

The Jordans have added to the park's attractions since they took over, notably with the Wave Garden, designed by Chelsea medallist Julie Toll. This cool and green garden under a canopy of mature oaks provides spring and early summer colour, as well as rich autumnal tones, and is the perfect foil for part of the Jordans' sculpture collection. The first piece was a flock of birds by local artist Ros Newman. Feedback was so positive that the Jordans decided to add at least one new artwork each year to the evolving sculpture trail, all with a nature or wildlife theme. The most popular piece is *Wild Boar* by George Hider. Deb finds that sculpture brings the garden to life, especially in the depth of winter when the plants are less showy.

Also in the Pensthorpe portfolio is the Wildlife Habitat Garden, offering many pointers on how to attract more insects, birds, amphibians and mammals to home gardens. Opened in 2009 by BBC *Springwatch* presenter Chris Packham, it demonstrates simple ways in which to merge ornamental with wildlife-friendly gardening.

The newest horticultural development is a courtyard garden near a group of flint farm cottages, now Pensthorpe's administrative centre. Known as the Five Cottages Garden, it was created by Jonathan and his team in 2015. It features architectural plants such as *Paulownia tomentosa* and aralia, along with drought-tolerant monardas, sunflowers, cosmos and vibrant orange-red flowered *Salvia confertiflora* for dramatic effect. The courtyard floor is gravelled and the planting is confined in places by waves of Corten steel sunk into the ground. Made in Pensthorpe's workshops, the steel waves were designed to Deb's specifications by landscape architects Sheils Flynn of Docking.

It will soon be 15 years since Pensthorpe came into their lives, and the Jordans have no regrets. As Deb explains: 'One of the greatest rewards of living on the site is having that opportunity to soak up the atmosphere of the park after hours. The peace and tranquility pervading the reserve and gardens is incredibly therapeutic. It also gives us the perfect time to think about future improvements that will benefit both visitors and wildlife.' And so, it seems, the Pensthorpe adventure is set to continue.

OPPOSITE The Jordans were delighted to welcome Piet Oudolf back to Pensthorpe to formulate plans for the refreshed and replanted New Millennium Garden, which opened in 2011. This burst of colour at the heart of the park complements the surrounding freshwater pools, which provide a sanctuary for exotic and migrating birds. A wooden gazebo and grass-veiled benches invite visitors to sit awhile.

11
Polstead Mill
Polstead, Suffolk

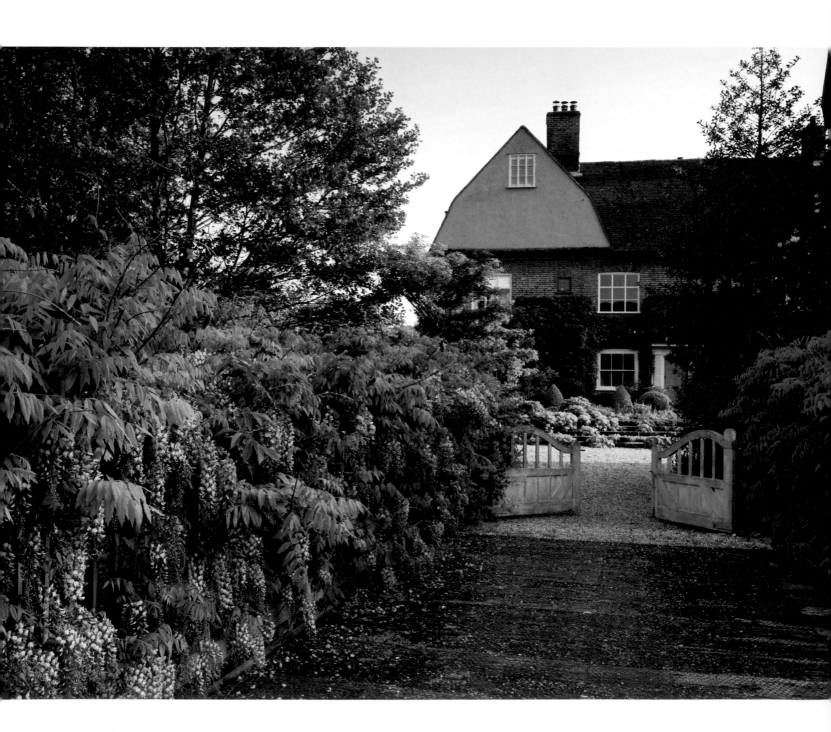

LUCY BARTLETT began her gardening life in mellow and moist South Wales. When newly settled in Suffolk, she thought she had moved to a desert. Now it feels like her *terroir*, but in the beginning it was a real journey of discovery. 'I learned that going east means you actually have to water plants,' she says. Lucy and her husband Richard found Polstead Mill in 2002. The house dates from 1785 and was incorporated with the adjacent mill in 1947. Up until then, this was a working mill, complete with a mill race, weir and pool leading off the River Box, which runs through the garden.

Features such as the swimming pool, built over the former mill race, and the terrace, path and steps in front of the house, were put in by their immediate predecessors. By the time the Bartletts arrived, however, there was plenty of scope for renewal and expansion. The garden at Polstead Mill covers around 4.5 hectares/11 acres and now includes a tree-fringed lawn and herbaceous borders near the house, and a kitchen garden, woodland and wildflower meadow reached by crossing either of the two bridges over the river.

Plant palette

The garden is very much Lucy's domain. She describes herself as a selfish gardener: 'My parents were passionate gardeners, martyrs to their garden you could say. But I need the garden to do what I want, rather than it dictating how we live.' While Richard supports Lucy wholeheartedly in this, he does not intervene in the garden except to pleach the limes.

Early on, Lucy attended classes run by Frances Mount, a legendary Polstead plantswoman who when young had gardened with Cedric Morris at Benton End, near Hadleigh. It was thanks to these tutorials that Lucy came to understand the plant palette that would work well here. But first things first – and this meant doing battle with some unwanted elements.

The initial assault was on 35 overgrown Leyland cypresses (× *Cuprocyparis leylandii*) that, by dint of their girth, had effectively shrunk the informal lawn to a fraction of its size. The felled Leylands still have a place in the garden, as Lucy recycled them almost immediately to replace the old footbridge that had floated away during a storm in the winter of 2002. Freeing up the informal lawn

has made space for more shrubs and trees, which make a gentle curve along the line of the river, across the far edge of the lawn and back towards the pond. In late spring and early summer the grass close to the road and riverbank is left unmown to froth with the white of cow parsley.

The Bartletts put in a better approach to the house, replaced all laurel hedges with beech, and gave the garden a consistent look by installing wooden gates and metalwork made to Lucy's specifications by Lavenham Joinery and Gedding Mill forge. It was at this time that Lavenham garden designer Janey Auchincloss proved invaluable, for her ability to turn Lucy's 'scribbles' into workable designs.

During this rebuild time the Bartletts restored many of the walls, as well as the main bridge over the River Box. On finding the newly renovated bridge suddenly too stark, Lucy felt wisteria would be the answer and bought several. It took six years for the plants to flower, and the Bartletts trim them back quite fiercely at regular intervals, but they always make a wonderful show in early summer.

LEFT With its garlands of wisteria, this bridge connects the house and wildflower meadow across the River Box.
RIGHT The family's West Highland terrier looks out from the terrace and lime-green haze of *Alchemilla mollis*.

Foliage with texture

Once the heavy work was done, Lucy could re-garden in earnest and concentrate on the herbaceous borders. She felt it was important to give the garden a 'backbone' by using structural plants, as well as a variety of foliage and texture. 'I am relaxed about plants that become a bit wayward, provided there is an underlying structure,' she says. The view from the kitchen takes in her flamboyant new plantings alongside the pond, a relic of the mill race. Lucy admits that the mix of purples, reds and yellows 'is pure whimsy', formed exclusively of plants she likes.

Although there is an emphasis throughout the garden on foliage and a green tapestry effect, Lucy confesses to loving once unfashionable but nonetheless bright and boisterous lupins, dahlias and hollyhocks before they began 'trending'. She grows these in deep borders devoted to cut flowers in the Kitchen Garden.

This playfulness belies the fact that Lucy is secretly a 'provisional catastrophist' in the garden – she tries to

future-proof important elements of it, an approach perhaps derived from her former career as a stockbroker. Waiting in the wings is a young specimen of a rare Polstead black cherry, ready to replace the mature tree that looked about to keel over in 2002 (but which, against the odds, is still going strong). Nor does Lucy want the garden to be a burden as time progresses. She prefers to anticipate change, even if it means contemplating a reduction in size. 'At least if there is a good structure you can shrink down a border or two if necessary,' she says.

It would be a tough call, though, as each part of the garden has its own character. The Yorkstone terrace in front of the house, softened by two lozenges of closely mown lawn, is a set-piece combination of formality and gently flowing plant structure. Flights of steps with randomly self-seeding *Alchemilla mollis* sashay out from the terrace into the generously gravelled entrance court adjacent to the river. Against the house are ample borders where lines of box, shaped into cones, are softened by repeated *Alchemilla mollis*, other perennials, and roses including 'Bonica' and 'Buff Beauty'. The house walls here are clad with rambling *Rosa* 'Albéric Barbier', whose apricot to lemon blooms perfume the air in summer.

Low brick walls surrounding the swimming pool and its garden make a sheltering backdrop on the outer side for new borders to frame the Terrace Garden. These are packed with mounding plants with softly purple or grey foliage and pastel flowers. The colour scheme continues around the pool, where the shape of stately cardoons is echoed in a silvery sculpture by Tom Hitchcock of Gedding Mill.

The cook's garden

In 2009 the Bartletts began more extensive work to create the Kitchen Garden and stylish glasshouse. This plot of 0.4 hectares/1 acre is the heart of family life throughout summer, and also an enjoyable social space for entertaining friends. For Lucy, it is the least 'out-sourceable' part of the garden and is where she is at her most hands-on: 'I am the cook and therefore the kitchen gardener.' She sows and plants according to what is needed and when

LEFT Lucy Bartlett has carefully considered each step in creating the garden at Polstead Mill.
RIGHT As this was originally a working mill, water is an important element in the garden created by the Bartletts – one of their early projects was to replace the rustic footbridge washed downriver in a storm. Repeated shades of grey, pink and mauve contribute to a sense of harmony.

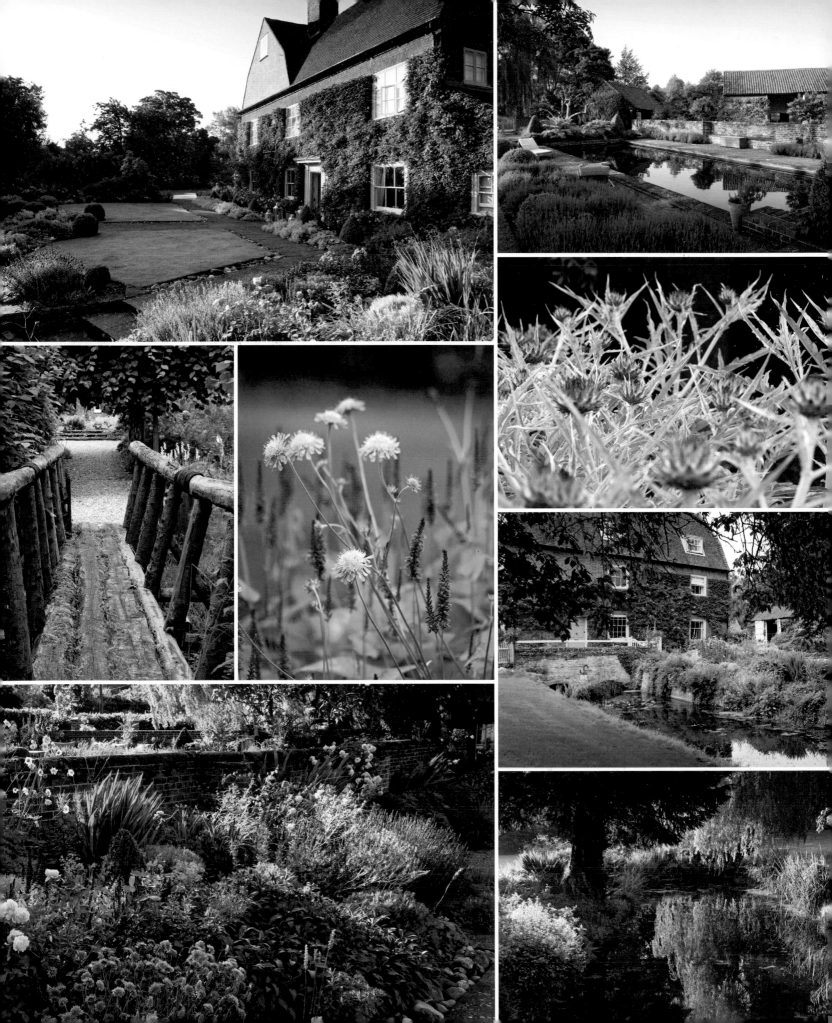

ABOVE Lucy is most at home in the walled Kitchen Garden, where herbs flourish in the giant oval containers modelled on her grandmother's baking tins.

RIGHT Pot-grown aubergines ripen in the greenhouse.

OPPOSITE The well-organized Kitchen Garden produces both staples and treats, ranging from red onions to blueberries. Tarragon is a favourite herb, and crimson sweet peas a must for cutting.

– large harvests in August and September, less in the quieter month of July. The red brick walls of the Kitchen Garden provide support for pears, apples and figs, while wood-edged raised beds arranged in clusters create an attractive area for food production. At the centre of each group of beds are custom-made metal containers inspired by the old-fashioned oval cake tins used by Lucy's grandmother. These are perfect for herbs and strawberries. The Kitchen Garden's bounty is either served up fresh or processed and preserved in various ways in the well-equipped kitchen behind the glasshouse.

Beyond the Kitchen Garden is a gently sloping wildflower meadow sown on the depleted soil of a former commercial strawberry field. The informal grove of pear trees, crab apples, nuts and apples is valued both for produce and blossom. Spring bulbs including lily of the valley, snowdrops and bluebells bloom in profusion here and in the woodland adjacent – although, as Polstead Mill lies in a frost pocket, they tend to emerge later than in other gardens.

The meadow is where the children enjoy camping and is also the site of one of Lucy's favourite garden seats, with a view across the wisteria-covered bridge to the house beyond. 'It is so important to have places within the garden where I can sit without thinking I have to pull out weeds,' she says. The temptation, though, is never to sit down.

The Kitchen Garden is the heart of family life throughout summer, and an enjoyable social space for entertaining friends.

12
Raveningham Hall
Raveningham, Norfolk

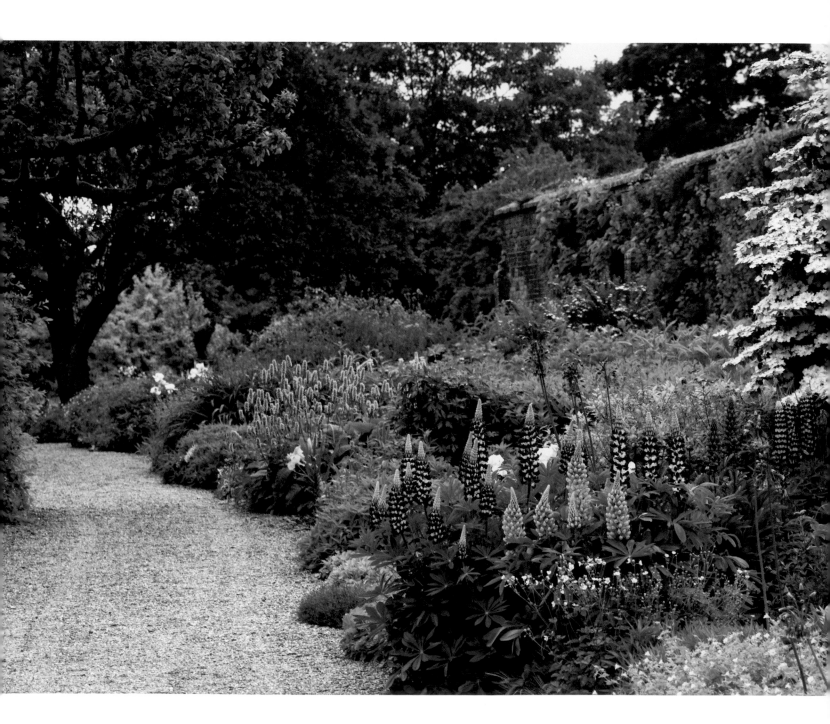

RAVENINGHAM HALL, a Grade II* listed property within a fine historic landscape, is the home of Royal Horticultural Society (RHS) president Sir Nicholas Bacon and his wife, Lady Bacon, a renowned sculptor. Traditional farming is the hallmark of this estate lying south of Norwich, which has been the seat of the Bacon family since 1735. Its once private gardens are becoming more visible and accessible, although many visitors express delight at discovering what they see as a well-kept secret.

Towards the end of the nineteenth century the original pleasure grounds were replaced by gardens of an Arts and Crafts style, including a gravel terrace that runs the length of the hall's south facade. This is flanked in places by generous herbaceous borders and leads to a rose garden. A deep ha-ha sweeps out from the perfectly mown lawn to the trees and grassland of the park.

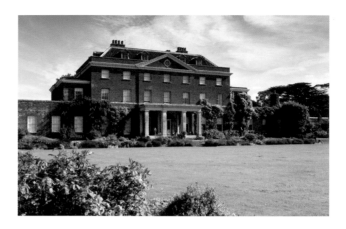

Snowdrop legacy

Much of the Edwardian planting still exists, but in the 1960s Priscilla, Lady Bacon (Nicholas Bacon's mother), a plantswoman and dendrologist of note, increased the range of shrubs, trees and herbaceous plants. Borders were extended and pathways diminished wherever possible, to make room for the numerous plants she accumulated.

Her interest in snowdrops – she was one of the early collectors – is visible in the massed swathes naturalized in various places at Raveningham. Nicholas and his wife Susie continue to add to the collection, and share their enthusiasm with visitors on special snowdrop days in February. It was Priscilla Bacon who also started the agapanthus collection, one of the garden's high points in summer.

Naturally, Nicholas's gardening education began under his mother's tutelage – and included cutting and boxing chrysanthemums, once grown in large numbers in the walled garden and taken to market. Both he and Susie are hands-on gardeners, each with their own designated areas: the Stumpery and Arboretum for Nicholas, the Herb Garden and Bacon Garden (based on the passage of time) for Susie. The couple develop the garden continually, aided by a team of four gardeners and the advice of noted horticulturist Richard Hobbs.

It was following the destruction of woodland on the northern side of the garden during the 1987 storm that Nicholas began establishing the Arboretum, to a plan designed by plantsman Roy Lancaster. The collection of trees and shrubs includes many species of oak.

Close by is the modern-day Victorian-style Stumpery devised by Nicholas with antler-like branches and roots

OPPOSITE Spilling on to gravel paths on the south side of the walled Kitchen Garden is a deep herbaceous border filled with choice perennials, including lupins in mixed colours.
TOP The symmetry of Raveningham Hall's south front is complemented by a simple rectangle of lawn.
ABOVE The entrance porch opens on to a terrace dating from the garden's Arts and Crafts era.

piled high, the ground between densely planted with terrestrial and tree ferns. Sculptor Marcus Cornish's bust of a singer from Harrison Birtwistle's opera *The Minotaur* seems to fill the air with a deep bass voice. From the far reaches of the Stumpery there is a breathtaking view down to a 2-hectare/5-acre lake. It blends naturally into the landscape and yet is a recent addition, created by the Bacons as a millennium project.

Lady Bacon chairs the RHS Herb Advisory Group and is understandably passionate about herbs and their various culinary, ornamental and medicinal uses. The Herb Garden she has created near the hall is Elizabethan in format: the squares holding culinary herbs are edged in cotton lavender (*Santolina chamaecyparissus*), while the triangles of medicinal herbs have a border of rosemary. The surrounding old yews were pollarded as pillars to give the design structure.

Melon pits

Over the past 25 years the Bacons have brought the walled Kitchen Garden, to the west of the hall, back into good working order. It now produces fruit, vegetables and cut flowers for the family and staff, or for sale on open days. Within the completely restored late nineteenth-century Boulton & Paul range of glasshouses are collections of pelargoniums, orchids and two scented tender roses, 'Maréchal

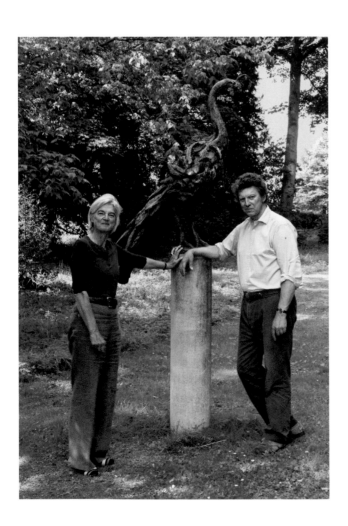

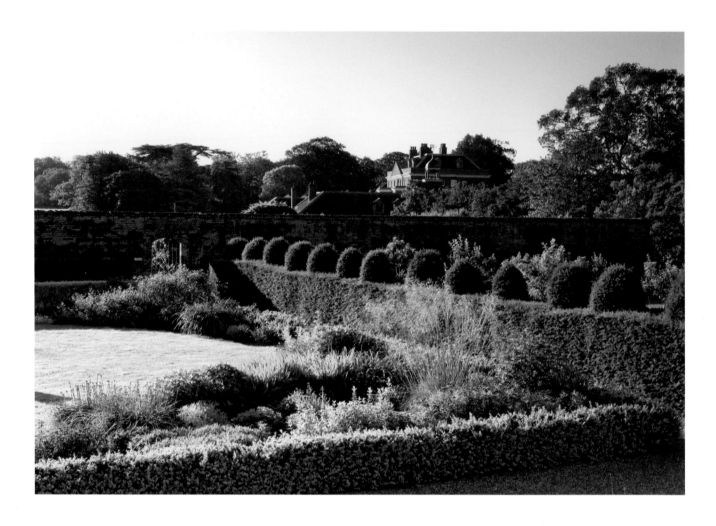

'God Almighty first planted a garden; and, indeed, it is the purest of human pleasures.'

SIR FRANCIS BACON

Niel' and a Colombian musk rose (name unknown), growing against the walls. This Victorian powerhouse of edible gardening, including fully functioning melon pits, provides annual crops of apricots, nectarines, figs and grapes.

Susie encourages groups of visiting schoolchildren to spend time in the Kitchen Garden. Here they can look at and taste different vegetables, and find out how they grow. In particular, they have a chance to see a fruit tree that is probably as old as the house. 'It is still producing good cooking apples,' says Susie, 'although we have a grafted clone as insurance in case this one declines.'

To the south of the Kitchen Garden is a fine herbaceous border 6 metres/20 feet deep and 46 metres/150 feet long, filled with a plant enthusiast's selection of perennials including lupins, aquilegias, alliums and delphiniums. Poignantly, Nicholas's grandfather and aunts can be seen in the same border in the black-and-white photographs from 1904 displayed on the tearoom walls.

Time as a theme

Step away from this packed border and you find yourself in the Bacon Garden, one of the most recent additions at Raveningham Hall. On the site of the estate's former nursery, it honours a celebrated family ancestor, the philosopher and statesman Sir Francis Bacon (1561–1626). Susie took as inspiration Bacon's essay

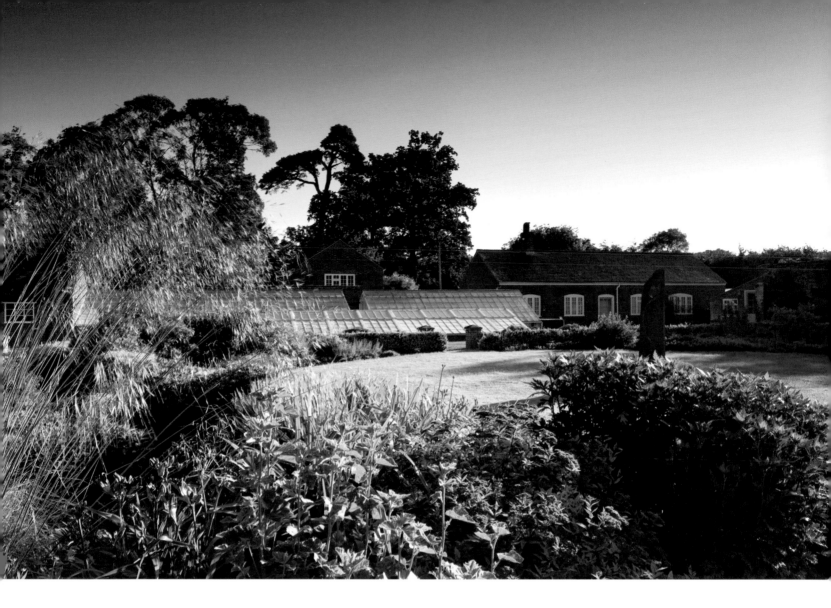

Of Gardens to create four borders around a central lawn, each shining in turn as the seasons change. The garden's most striking feature is a turf mound some 3 metres/10 feet high, similar to the one described by Bacon. Its summit provides views over the shapely yews rising above the walls of the Kitchen Garden, towards the house and its backdrop of mature trees.

In front of the mound, at the centre of the garden, is a 1.8-metre/6-foot weathered piece of Cumberland slate set upright into the lawn and inscribed with Bacon's opening line: 'God Almighty first planted a garden; and, indeed, it is the purest of human pleasures.' Designed in collaboration with letter-cutter Lida Kindersley, the words curve snake-like from the slate's perfectly cut central hole. The sculpture is in fact a gnomon (the projecting part of a sundial), and the mown circle around it forms the face of the clock.

Positioning this piece and the many other sculptures – including Marcus Cornish's portrait of her four sons as children – is something that gives Susie additional pleasure. 'I hold places in the garden in my mind,' she says, 'then, as I walk around, I see these places from different angles and at different times of day.' This was precisely how she found the perfect spot for one of her own bronzes, a peacock, which stands in a woodland glade to gleam in the setting sun.

OPPOSITE Each corner of the Bacon Garden reflects a particular season. The hall's chimneys and roofs make a pleasing rhythm viewed across the castellated yew hedge and Kitchen Garden wall.
ABOVE The central circle of grass and upright slate sculpture in the Bacon Garden together form a sundial. In the background can be seen the full extent of the restored glasshouse range.

13
Silverstone Farm
North Elmham, Norfolk

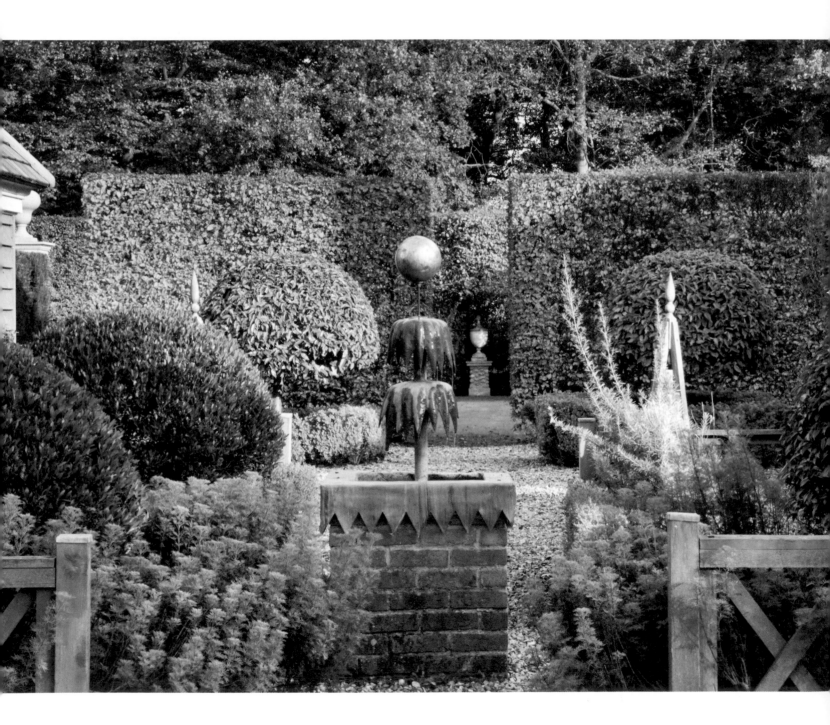

When George Carter moved in at Silverstone Farm, the house looked as if it had landed out of nowhere on a sea of gravel – disheartening, you might think. Not so for George, who saw this blank canvas as just the opportunity he needed to create a contemporary version of a traditional formal garden. The result is an elegant series of spaces that makes ingenious use of illusion and ornament, while also fitting with the modest nature of Silverstone Farm and its agricultural landscape.

An established and sought-after garden designer, George is first and foremost an artist. He studied fine art at Newcastle University, and as a sculptor found himself involved with sculptural outdoor installations. It struck him that this organization of outdoor space might be considered a form of garden design.

His design career was launched on the back of the national garden festivals of the 1980s, aimed at regenerating derelict urban sites. At the time, gardens and gardening were enjoying a revival in the United Kingdom. The work George did in creating temporary show gardens and scenes revealed an ability to combine instant planting with convincing garden features, buildings and objects that he manufactured himself. This continues to be one of his great skills. He also has a proven talent for manipulating space – in particular, making it seem larger than it really is.

Pleasing symmetry

George bought Silverstone Farm in 1990. He found the roughly symmetrical shape of the house pleasing, and the site had other satisfying aspects: 'It is a rare thing in Norfolk, a farmhouse that sits well in the middle of its 2 acres [0.8 hectares] of land. Mostly, they are alongside the road and linked physically and visually to barns and other working buildings. Here the house is detached from both.'

Not only did the house's location in the land make it perfect for gardening on all sides, but it also had mature trees that sheltered it on the north and east, giving it a settled look. In addition, there was a great deal of 'borrowed landscape'. The neighbour's woods, for example, seemed to be a designed avenue of trees, but in fact they are simply a drift of trees on a field edge.

The first thing George did was to build two wing walls with piers on either side of the house, a device to increase the apparent extent of the building, as employed in the late eighteenth century by landscape designer Humphry Repton. 'It really is a very small house and this gave it the feeling of a little more substance,' says George. 'It keyed the house into the landscape and offered a sense

of arrival.' The architecture of the house – the position of windows and doors – was the starting point for the many axial lines, frames and view-stoppers or focal points that George has designed into the garden. At an early stage he drew out a perspective view of his ideas, a plan which has held good but since been elaborated.

The next step was to plant hedges, mainly of hornbeam, beech and yew, to create a series of rooms. Paths lead from room to room, or across the whole garden, making diverse axes. As he was not in a rush to see results, and enjoys seeing plants develop over time, George chose to start with small plants rather than the larger specimens often preferred by his clients. In winter, when the deciduous hedging has lost its foliage and the evergreens take on a new, almost brighter gleam, the bare bones of the garden's architecture are revealed more clearly. Following frost or snowfall there is an even greater transformation.

Green architecture

Among George's sources of inspiration were pictures of late seventeenth- and early eighteenth-century Dutch and English formal gardens. Of particular interest are the views published in *De Vechtstroom* (1719) of small merchants' gardens along the River Vecht in Holland, as they provide a glimpse into the minds of gardeners of that period. The gardens reveal a keen interest in architectural space and are modest in scale, but sometimes make use

OPPOSITE At Silverstone Farm, space is organized using grass, topiary and hedges in much the same way as in seventeenth-century gardens.
ABOVE The lines of house and garden are interrelated. Here, paths lead from the unadorned grass forecourt in front of the house through low hedges to a wider expanse of lawn.

of elaborate detail. 'As a sculptor I am always looking at spatial organization, volume and void, and the ways wide or narrow, long or short shapes are contrasted,' says George. Hedges, grass and topiary are the main components of his green architecture. Flowers are used sparsely and there are no borders, as the structure and foliage of his chosen plants provide the required look.

At first he ruled out any plants introduced later than the seventeenth century, but over time has made exceptions. Privet, especially native *Ligustrum vulgare*, remains one of George's preferred plants, as does box. (Even though box blight has not yet appeared here, as a precaution he uses *Buxus sempervirens*, which has a larger leaf and seems less susceptible than *Buxus sempervirens* 'Suffruticosa'.) Oaks such as *Quercus ilex*, lime trees, *Phillyrea* and buckthorn (*Rhamnus alaternus*) are also included in Silverstone's restricted plant palette.

Early on, when the planting was young, George made trellis-work to the height and shape that it would reach in maturity. These structures, intended mainly as a temporary feature, added substance to the new garden. In places the trellis has now been removed, and the plants are kept clipped to the required shape and height; but in some cases the plants are so densely entwined that the trellis has become a fixture.

Cutting the huge amount of topiary and hedging throughout the garden is a serious activity, and seems to be going on much of the time. George claims his best investment is a Niwaki tripod ladder that provides the required access and stability. Its height is the determining factor for the height of all the hedges on the property.

The garden has matured over the last 25 years, and looks as if it has always been here. The back door (now the main, everyday approach to the house) is reached through a pleached lime walk that leads into a courtyard and herb garden. In front of the house there is a plain grass and gravel parterre, and then the view opens out – although the expansive lawn is still enclosed by hedges. At the far edge of the lawn a curved path weaves through shrubs and trees, planted as if in woodland.

A roughly oval-shaped area laid out behind the farmhouse holds two contrasting gardens: an orchard on lower ground and, on the level above, a formal green theatre created in homage to the *teatro di verzura* of seventeenth-century Italy. A grassed auditorium framed by hornbeam hedging is oriented towards a stage with five arches. The limit of the stage is marked with a line of low box balls, mimicking footlights.

Change of role

Some years after his move to Silverstone Farm, George purchased the red pantile-roofed barns that form part of its suite of buildings: constructed in 1830, during the heyday of British agriculture, no expense was spared on them. Today the barns are used for offices, entertaining, and lecture days run by George and colleagues. More Mediterranean than Norfolk, the courtyards of these south-facing barns boast citrus plants in faux Versailles boxes and a pool surrounded by *Hebe* 'Pewter Dome' and

LEFT George Carter takes a sculptural approach to garden design and favours a restricted palette of plants.
RIGHT ABOVE A narrow vista between high hedges creates a sense of drama. The little gate in front, one of many interesting details, is made from old garden tools.
RIGHT BELOW Clipped domes of box become the 'footlights' of this Italianate green theatre.

Paths lead from room to room, or across the whole garden, making diverse axes.

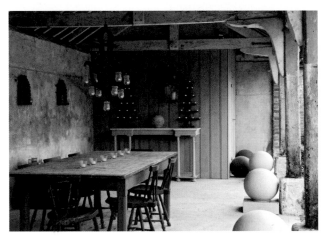

TOP LEFT The pared-down Mediterranean look of the courtyards by the pantile-roofed barns is enhanced in summer with potted lemon trees.

ABOVE LEFT The barns are now a congenial location for lecture days and entertaining.

ABOVE RIGHT A plain Norfolk red brick wall is transformed with the addition of one or two embellishments.

OPPOSITE George is a master of illusion, able to turn contemporary materials such as marine ply and resin into benches, obelisks, urns and gilded ornaments that appear more substantial than they really are.

clipped *Teucrium fruticans*. Some of the more tender plants return into the warmth of the conservatory in winter.

George's skill in refronting, repurposing and refashioning, as well as creating afresh, is legendary – and used to great effect in providing authentic-looking furniture and ornaments for the garden. Finials, facades of small garden buildings, urns, benches, chandeliers and many other decorative pieces emerge from George's studio, often made from non-traditional materials such as waterproof ply, galvanized steel or reconstituted stone. He also uses traditional oak, lead and stone, with a particular use of local flints as a building material.

That early work for the garden festivals and as a designer for exhibitions such as the now-discontinued Grosvenor House Art & Antiques Fair has practical legacies. It means that George has a kit of parts left over from events, and prototypes for objects he once designed. He calls it 'a graveyard of effects' but this is nowhere near their final resting place, as they are often recycled or used as the basis for a new creation. Be it in his own garden or those he designs for clients, the message is clear – watch this space.

14
The Manor
Hemingford Grey, Cambridgeshire

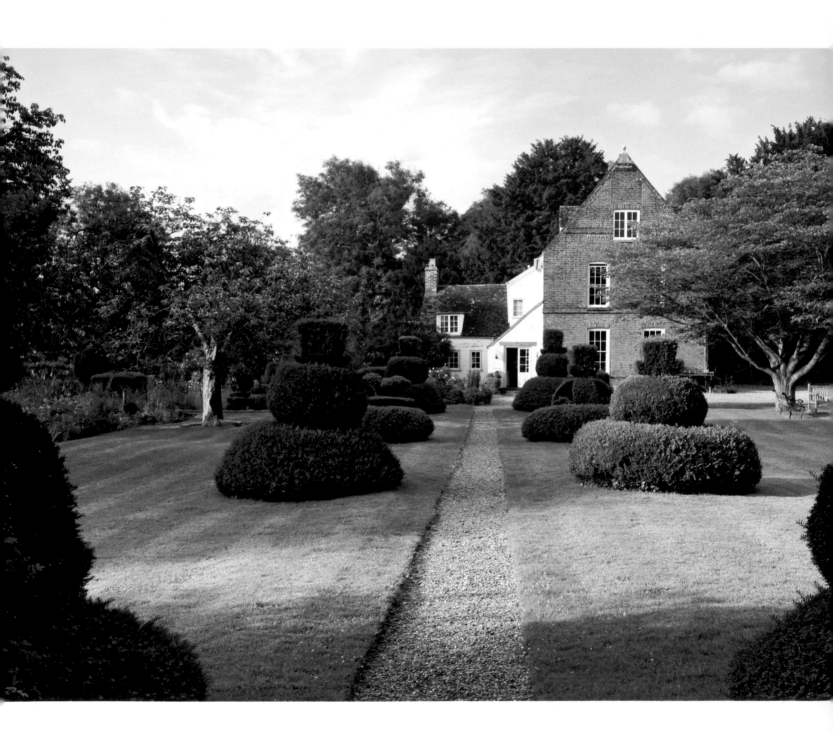

IF ONLY GARDENS COULD SPEAK. Were it so, then the garden at The Manor, Hemingford Grey, would have more stories to tell than most, for it surrounds the atmospheric home of the late Lucy Boston, an acclaimed writer of children's novels. When Lucy arrived here in 1939 she began a labour of love to restore the fabric of the twelfth-century house, described as one of the oldest continuously inhabited dwellings in Britain. In the process she and her son Peter uncovered Norman stonework, as well as Elizabethan features that had been concealed for centuries behind layers of 'improvements'. She also created a romantic, plant-filled garden, and used both garden and house as the setting for the six books in her Green Knowe series.

When Lucy died in 1990, Peter, a renowned architect, and his wife Diana took on responsibility for the site. Peter was the illustrator of the Green Knowe books as well as many others written by his mother. He died in 1999, and so now it is Diana Boston who continues to champion The Manor, keeping the flame of its long history burning, and sharing the house and garden – and their fictional inhabitants – with visitors.

Once her own grandchildren were old enough to be au fait with the stories, Diana invited them in turn (there are ten) to a 'Green Knowe tea', where she showed them the house and garden's deeper secrets. Each occasion was

OPPOSITE Topiary yews along the path down to the riverside represent orbs and crowns, in honour of Queen Elizabeth's coronation in 1953.
BELOW LEFT Diana Boston is the current custodian of the Manor House, and terrier Birkie her constant garden companion.
BELOW RIGHT A larger-than-life topiary chess set contributes to the special atmosphere of this garden originally laid out by author Lucy Boston.

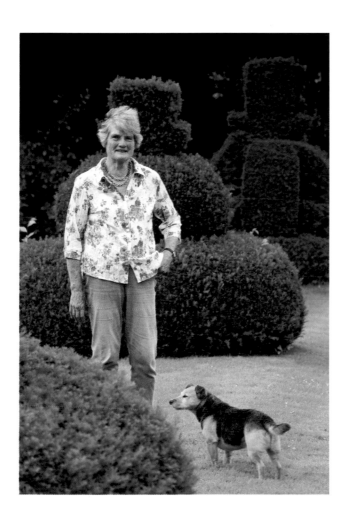

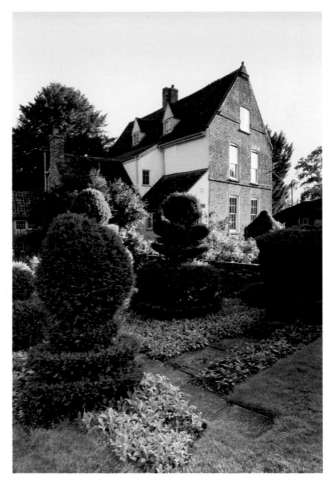

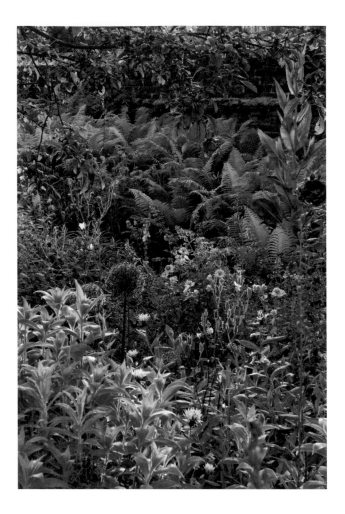

of a landscape largely untouched since the construction of the medieval house. Then, wild flowers bloomed in the meadowy expanses around the manor and massive trees laid their billowing skirts right down to the ground. Being fenland in origin, and so close to the banks of the Great Ouse, there was also regular flooding to deal with.

Little by little the garden evolved, but for ease of maintenance some of the lawns have become wildflower meadows again. Lucy would be pleased to know that orchids and snake's-head fritillaries are once more growing in places in the grass. Between the house and river springtime blossom from flowering cherries that Lucy planted still gives pleasure; the four deep borders, packed with herbaceous plants and irises, and the topiary work are also much as she originally intended.

The iris collection preserved by Diana reflects one of Lucy's plant passions. During the 1950s and 1960s she regularly acquired the varieties selected annually for the Dykes Medal. She also obtained many of the early iris introductions from America, as well as one of the darkest, 'Great Gable', and several from the Suffolk garden of artist and plantsman Sir Cedric Morris.

Royal emblems

Probably the best-known features of the garden today are the topiary yews. Lucy planted the first eight at intervals along the path to the garden's riverside entrance gate. Garden-making is often influenced by memories of places and plants encountered in earlier periods of life. For Lucy, the topiary reminded her of childhood visits to Levens Hall in Cumbria. However, instead of clipping her yews into the simple geometric cones she had initially planned, on the eve of the Queen's coronation in 1953 she decided to shape them as orbs and crowns. One recalcitrant yew would not be mastered, but no matter: ever-resourceful, Lucy saw its potential to represent instead the dove of peace, an emblem found on one of the royal sceptres.

Her next topiary work, near the house, was a chess set complete with castles and knights. The black-and-white chequerboard on which the pieces stood was achieved using the dark foliage of *Ajuga reptans* and the silver of *Stachys byzantina*.

Old-fashioned roses

Fragrance was important for Lucy and continues to be so for Diana. Aromatic herbs such as lavender and dianthus fill the borders, and there are roses all around. When Lucy began her rose collection, the old roses she preferred were

memorable, as Diana recalls: 'Suddenly they see this place that they know so well as their grandmother's home in a quite different light.'

Many visitors are devotees of the classic novels. In every room there are features familiar to Green Knowe readers, and the garden is no less a part of the story. Its strongly outlined structure, complete with topiary shapes in yew, is alive with the possibility of adventure, as well as the intrinsic beauty offered by Lucy's – and now Diana's – subtle choice in old roses and herbaceous plants.

When Lucy first turned her attention to the 1.6-hectare/ 4-acre garden, she was sensitive to its significance as part

ABOVE Alliums, centaurea and teasels thrive under the spreading branches of a crab apple. In the lee of the wall is a colony of shuttlecock fern (*Matteuccia struthiopteris*).
OPPOSITE The spontaneous look of the Long Borders is in fact only made possible by the gardener's skilful intervention. The rose seen here, *Rosa* 'Ispahan', is a double-flowered damask.

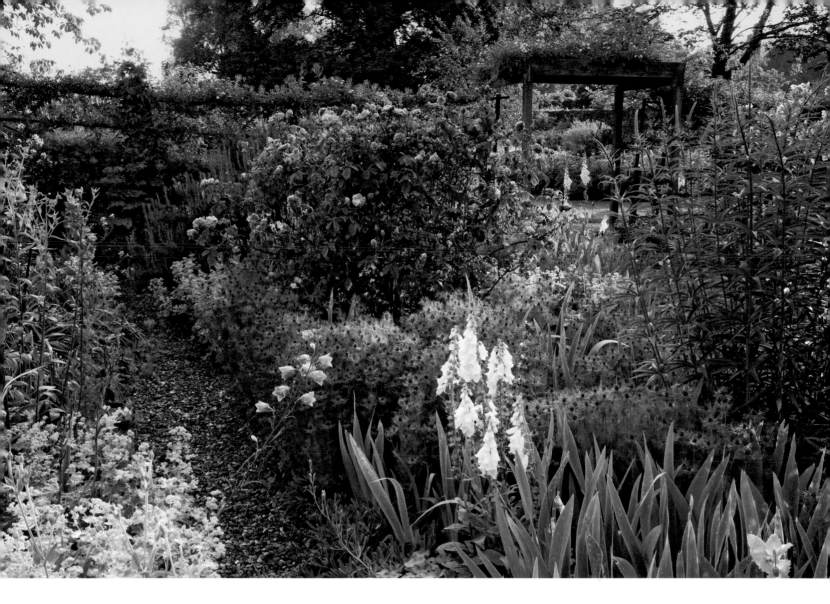

out of favour while modern hybrid teas were in demand. Thanks to her perseverance in seeking them out, the collection holds some rarities, including 'Hippolyte', 'Laure Davoust' and 'Anaïs Ségalas'. Lucy drew on the advice of three celebrated rosarians, all now deceased: Graham Stuart Thomas, then at Sunningdale Nurseries, Hilda Murrell, and later the Norfolk rose grower Peter Beales. Diana has since incorporated many roses bred by David Austin, to extend the flowering season.

Pools of colour

Patterns and colour combinations, always in Lucy's mind, have been taken up a gear by Diana and gardener Kevin Swales, who works here two days a week. Diana appreciates Kevin's ability to plant the ideas that are 'half-formed' in her head: 'It is a very good partnership and the garden benefits.' They have added azure puffs of forget-me-nots at low level and zingy citrine-yellow clouds of woad (*Isatis tinctoria*) to shine in spring. Later in the season come swathes of blue

'The garden is a magical place when poised just ahead of the fragrance and romance of summer roses.'

DIANA BOSTON

and white camassia, many umbellifers, such as *Anthriscus sylvestris* 'Ravenswing' and a giant fennel bought from Great Dixter, and drifts of white-flowered honesty. 'I love all the pools of colour in late spring,' says Diana, 'when the garden seems magically poised just ahead of the fragrance and romance of summer roses.'

Throughout the garden perennials including phlox, in particular blue-flowered 'Chattahoochee', campanulas and alliums combine well with the pastel pink to velvet-mauve and blush-white of the old roses. Poppies, cornflowers, larkspur and purple orache (*Atriplex hortensis* var. *rubra*)

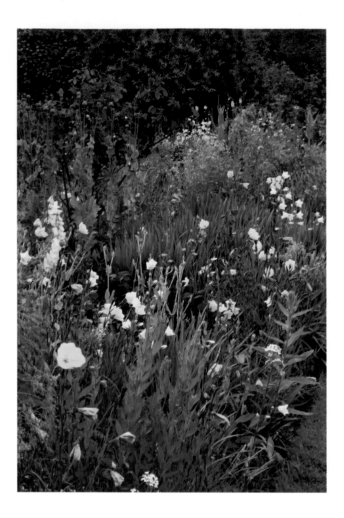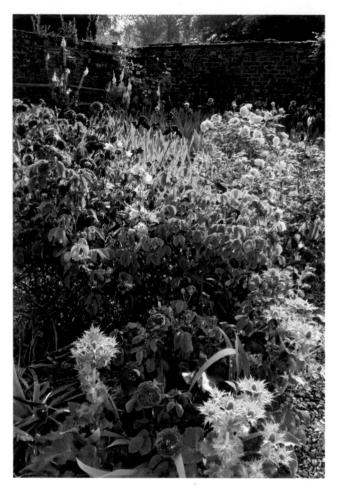

ABOVE LEFT Self-seeding evening primroses, campanulas and opium poppies create a pointillist effect.

ABOVE RIGHT *Rosa* 'Duc de Guiche', planted by Lucy Boston, is also one of Diana's favourites. Behind are the dark iris 'Great Gable' and paler 'Great Lakes'.

OPPOSITE Lucy Boston loved roses for their fragrance, and sought advice from the leading rosarians of the day. One of the rarities surviving from her collection is blush-pink 'Laure Davoust' (bottom left), a French variety introduced in the nineteenth century.

are among the annuals allowed to self-seed. The display has a certain informality and may seem to spring up at random, but much hand-weeding goes on behind the scenes. In fact, a great amount of work is needed to achieve this spontaneous look.

Although the long perennial borders, iris beds and yew topiary are among the garden's strongest features, there is more to see: a stand of dark-eyed, fragrant *Philadelphus* 'Belle Etoile', for instance, as well as a smaller rose and herb garden near the chess pieces. At the back of the house, once past massive yews and purple beech, there is a more open area bounded by the remains of the old moat and the Wild Garden. Further on, along a sunny wall, is a cottage garden border with peonies, hemerocallis and nepeta. Here the whole aspect of the garden is lighter and the sky, always dramatic in East Anglia, becomes part of the landscape.

Lucy Boston's presence is palpable at The Manor. Diana successfully treasures this heritage while continuing to make her own contribution, and by this balancing act keeps the place alive. Lucy gardened on a grand scale, whereas Diana sees herself more as a plant collector. Lucy liked scented plants, while Diana is also conscious of bees and wildlife. There is a secret conversation floating in the air, as Diana confirms: 'Every now and then, when I do something a bit differently, I nod to Lucy and hope that she will approve.'

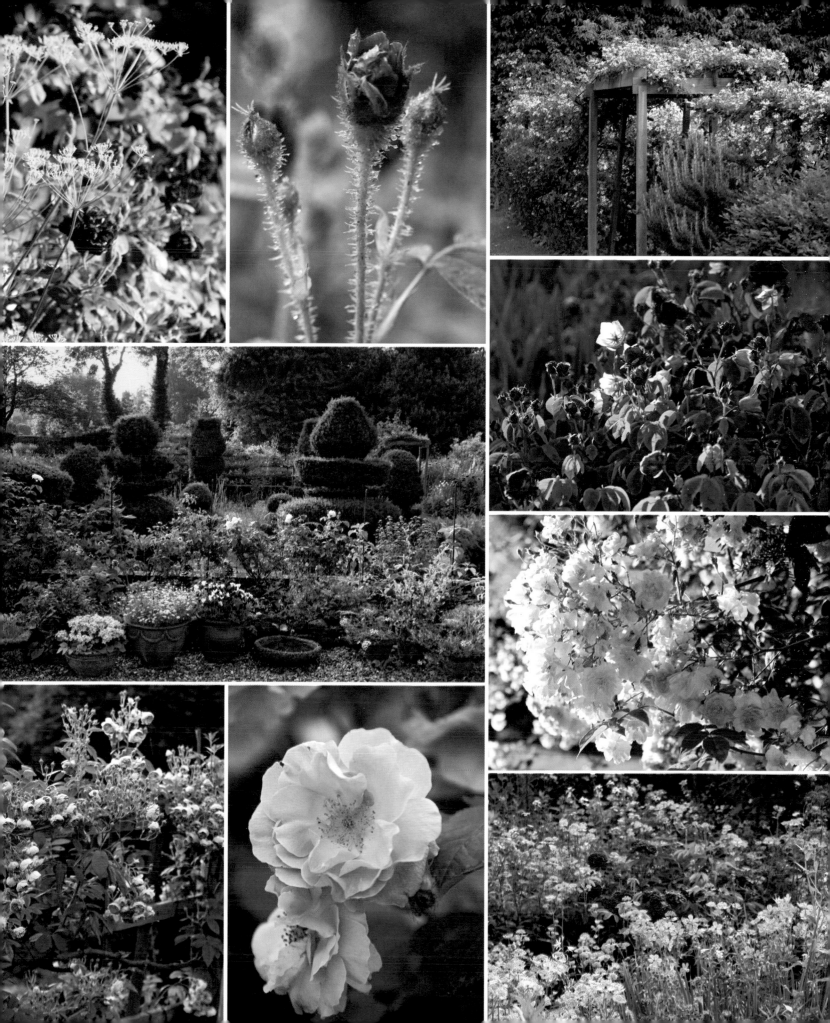

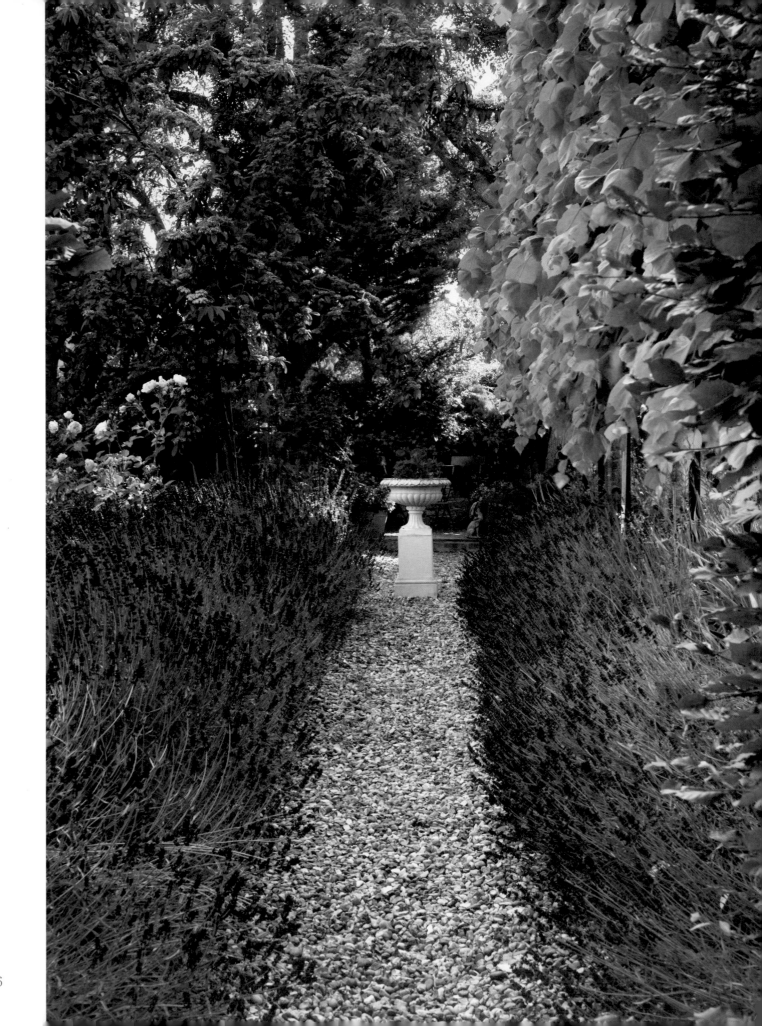

15
The Manor House
Fenstanton, Cambridgeshire

LIKE ALL OWNERS OF SPECIAL HOUSES, Nigel Ferrier and Lynda Symonds see themselves as custodians both of the place and its history. Their home, a Grade II* listed building dating from the late seventeenth century, was the estate office of Lancelot 'Capability' Brown, England's most celebrated garden-maker. The house was altered at the hands of Georgian and Victorian 'improvers', and it seems the garden was never in the running to be treated as a Brown landscape, but the association with him nevertheless remains strong.

As chief gardener to George III at Hampton Court, Capability Brown resided at Wilderness House, a property within the grounds. When the opportunity arose to buy some land of his own, he jumped at it. He purchased the manor of Fenstanton, including the Manor House and numerous other buildings, from the Earl of Northampton in 1767. The price was £13,000, with a deduction of £1,500 for work Brown had carried out for the earl at Castle Ashby.

It is thought that while Brown did not ever live at the Manor House full-time, he stayed there when visiting the estate and conducting his business in the parish as lord of the manor. Fenstanton has many Brown associations, none more poignant than his burial place and the Brown family memorial in the village church.

On two levels
Plans of Fenstanton in Brown's day show the garden at the Manor House to have been much larger than it is currently, with orchards running down to the fenland beyond. But even at around 2,000 square metres/½ acre there was still much to do when Nigel and Lynda came

to live here in 2007. The basic structure was in place: an avenue of pleached limes and gravelled paths that effectively separates the more formal upper garden from the sweeping borders of the lower level. But plants had run riot and the weeds were waist-high.

Four walk-in skip loads of plant material went out before Nigel and Lynda were able first to fully appreciate the ground plan, and then start refining it. They created a series of rooms, each with a vista through to another

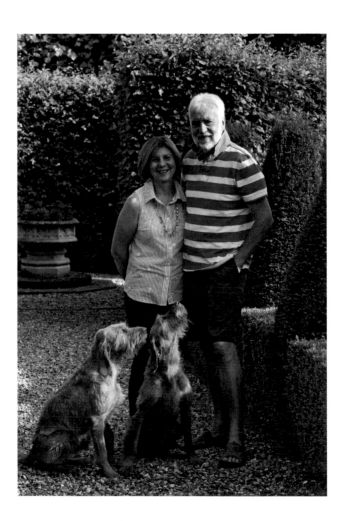

LEFT Under pleached limes, banks of *Lavandula angustifolia* 'Hidcote' release their scent to anyone brushing past along this pathway.
RIGHT Nigel Ferrier and Lynda Symonds, seen here with dogs Mollie and Radish, live in the house once owned by Lancelot 'Capability' Brown.

part of the garden. The idea was to allow views between separate spaces while also ensuring that it was not possible to see the whole of the garden from any one point.

The couple replanted most of the borders, retaining some of the original plants, moving others into more suitable beds and, of course, adding plants of their own choice. Nigel took all the irises that were in various places and grouped them together in a sun-baked setting near the house, where in late spring and early summer they give more pleasure en masse than dotted around the garden.

The top border, originally one of the most overgrown, is a shady site where lilacs and oak-leaved hydrangeas now thrive. It is dominated by a bay tree that Nigel confidently shapes into a soaring 3.7-metre/12-foot tower, working from atop a Japanese tripod ladder.

A little lower down the garden's gentle slope, and slightly hidden from view by the pleached lime walk with its underplanting of lavender, is the Mediterranean terrace. A real hotspot, this is where figs, olives and a palm flourish. Here too is a shed whose existence was revealed during the 'great uncovering'.

Let there be light

Never shirking from the garden's challenges and seeing, as Brown did, that something better could be achieved by thinking big, Nigel and Lynda embarked on their largest project – the removal of what they called the 'Berlin Wall', a hedge of Leyland cypress planted in the late 1960s. Forming a solid barrier of over 23 metres/75 feet, the hedge was brown and in its death throes when the couple arrived. It was hard manual labour but they removed the eyesore completely, and gained a worthwhile amount of space for new features. The neighbours were also pleased.

With the hedge gone, there was room for more and deeper borders for planting, and Nigel introduced an additional gravelled cross-path near the bottom of the garden, lined on each side by Himalayan birches and underplanted with a low-growing dogwood, *Cornus sericea* 'Kelseyi'. An urn and a bench offer focal points at opposite ends of the birch-lined vista.

Nearer the house, between it and the pleached lime walk, the more formal style is marked by a parterre divided into four quadrants. Each quarter is box-edged and holds a purple berberis clipped into a rounded shape. These beds present a problem for Nigel and Lynda because very little thrives here and box blight is spreading. They have tried various different plants and even replaced the soil, to no avail. However, as they have plans for an additional

building adjacent to the house, from where they will finally be able to see the garden, their battles here may soon be coming to an end.

A double line of yew cones, or as Lynda calls them 'Moomins' (after the characters created by Finnish author Tove Jansson), will remain, providing a gentle but marked edge to exuberant rose and herbaceous borders that peak in June, with cardoons, astrantia and *Aruncus dioicus*.

The path between the yews leads into a circular enclosure of copper beech hedging, complete with a central stone urn and red geranium. Red geraniums are in fact a theme, filling urns and pots around the garden. Lines of clay pots holding a single plant are used to delineate path edges. This splash of bright colour is well supported by the backdrop of textured green and purple foliage.

Nigel and Lynda open the garden every other year for a regular Fenstanton village event, and in aid of the National Gardens Scheme. In 2016, the tercentenary of Capability Brown's birth, the Manor House was high on the visiting list of anyone wishing to celebrate Brown's achievements. In the lead-up to the nationwide festival of special events, openings and exhibitions, many Brown experts, including author Steffie Shields and historic landscape advisor John Phibbs, visited Fenstanton and offered insights into this aspect of Brown's life.

Nigel and Lynda learned on this occasion that two huge, gnarled apple trees in the grounds of the Manor House could well be veteran survivors of a number of fruit trees bought by Brown in 1770. The trees, which still bear fruit, represent a tangible link with the past: the pleasure Nigel and Lynda take at seeing apples ripen on the branch is intensified by the idea that Brown once felt the same satisfaction.

Brown would have recognized a kindred spirit in Nigel. When invited to the first meeting ever to bring together all owners of Brown houses or landscapes, Nigel presented his credentials as a media, web and digital expert to Gilly Drummond, chair of the Capability Brown Festival. He suggested that the festival needed a fine website. And so, as is often the way, events came full circle: the official tercentenary website was powered from Brown's former estate office, the Manor House at Fenstanton.

A series of garden rooms is linked by gravelled cross-paths leading to vistas or seating areas. Formal features include the parterre (top right), with purple berberis and variegated holly, while the venerable apple tree that probably dates from Brown's day (bottom right) is found in the informal, lower garden.

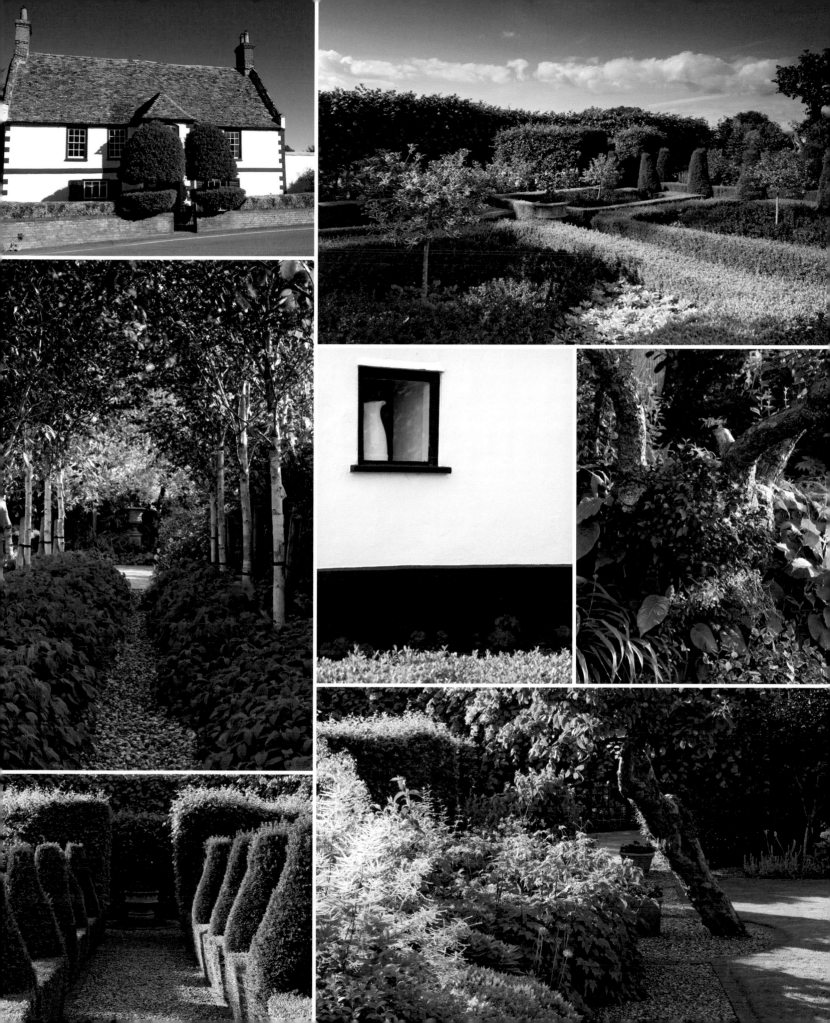

16
38 Norfolk Terrace
Cambridge

THE WALLS AT NUMBER 38 are so high and enclosing that passers-by are unaware of the intensely coloured and densely planted garden concealed within. This tiny town garden opens once a year for the National Gardens Scheme and two weekends in July, when owner John Tordoff exhibits his paintings for Cambridge Open Studios. It is hard to imagine how 79 visitors can ever have fitted in, but they did.

John Tordoff was a versatile character actor who since the 1990s has turned to art and garden design, he says, as 'an outlet for the creative energy that was not getting out on to the stage'. He developed an award-winning garden in Hackney, London, and later with his partner, retired educationist Maurice Reeve, embarked on a more ambitious garden in Umbria, in central Italy. Then in 2009 the couple decided to swap both gardens for a tiny plot in Cambridge, close to the buzz of the city's cultural centre. They found 38 Norfolk Terrace, a corner house in a row of mid-nineteenth-century artisan cottages. By the time they had made substantial renovations, they had, *force majeure*, reduced the garden's size considerably to a space of 8 by 4 metres/26 by 13 feet.

Spanish arches
Although you can see the whole place at a glance, there is more to this bright town garden than immediately meets the eye. John, who loves building structures and making the attendant space work, began to think seriously about its design in 2011. His approach is to make good use of whatever the site has to offer. In this case there was only an old elder (*Sambucus nigra*) that cast shade on one side of the garden. That, then, was going to be the spot for

hostas and ferns, the pagoda John had made for his former Japanese stroll garden in London, and for ground-covering *Soleirolia soleirolii*, one of his signature plants. There was also a derelict shed at the back, but that had to go.

In a garden where size matters, the new shed and service area had to be carefully sited and screened. John set about building a Spanish-style colonnade, with columns made from plastic drainpipes and the four arches from weather-resistant marine ply. The whole structure is painted ochre,

LEFT Columns, trellis-work and raised beds provide structure in this patio garden filled with potted plants. The display changes with each new season, or as it pleases the owners.
RIGHT The back doors fold open, so that house and garden become one.

chosen as a neutral foil for the garden's vibrant plants. The front is embellished with metal foliage-work, also painted, while ivy covers the trellis fixed between the arches.

John has never taken to grass, so it was not a hardship to pave over the existing small lawn and transform it into a patio filled with potted plants, reminiscent of those colourful, cool gardens of southern Spain or Morocco. After the digging and levelling, the main features could be fixed in place – including a small rectangular pool with decorative tiles that John and Maurice had bought in Rajasthan. Its single jet offers a soothing splash. A dark, lead container with one miniature water lily provides a second water feature.

Next they made a series of slightly raised beds, running in front of the arches and along two sides of the garden. Mirrors – three mosaic-framed by Maurice and one with Gothic curves – are used to extend the space. This trickery is also taken into the house, where the garden itself bounces off the large mirror in the living room.

Ivy clothing the wall along one side of the garden makes an ideal evergreen backdrop for the pots and planting. Shape, height and foliage are important characteristics in John's choice of plants. Among those that play their part in this setting are ornamental rhubarb (*Rheum palmatum*) and a lone specimen of *Taxus baccata* 'Fastigiata'. Above all, though, John loves colour and here can make it bright and 'even a bit brash'. There are low-growing shrubs such as spiraea, with citrine spring foliage, neatly cut box cubes (a nod to the topiary of former gardens), four roses (including 'Hot Chocolate' and 'Lady of Shalott') and numerous overflowing pots of vivid annuals that are constantly rearranged according to what looks best at the time.

Showstoppers

While John designs and does most of the planting, Maurice raises annuals such as sweet peas, coleus and nasturtiums for adding to the containers when ready. Extra annuals are bought from a stall at the Cambridge market. In the largest raised bed are three pillars reserved for Maurice's stars – seasonal pots that come out of the wings as the year progresses. Peony-flowered tulips often feature in spring, lilies in summer. Maurice chooses new bulbs each year and passes the old ones on to a gardening neighbour. Watering is another of his duties, and it is clear from the way the garden thrives that he does this with great diligence.

Number 38 is reminiscent of the garden of two halves that John made in Hackney – one side colour, the other shade and restraint. It is much enjoyed by the local birds. John would also like to have exotic breeds here, such as Lady Amherst's pheasants. You can do a lot with a small space, but there are limits. The metal cockerel and a duo of white pottery pigeons atop the Spanish arches are the best he can hope for.

Most gardens have a seat or two and Number 38 is no exception, with a table and pair of metal chairs painted the brilliant Majorelle blue of Yves Saint Laurent's garden in Marrakesh. Yet John and Maurice do not really need to sit out. The back wall of their living room is a series of folding doors: when they are fully open, it is as if the house has invited the garden in.

LEFT For John Tordoff and Maurice Reeve (behind), the fun of growing annuals more than compensates for the constraints of a small garden.
RIGHT Mirrors create an illusion of space, and the blue-tiled pool provides a focal point. There is planting suited both to sun (bottom right) and shade (bottom left), and even room in this tiny town garden for 'Lady of Shalott', a favourite rose.

17
Tinkers Green Farm

Cornish Hall End, Essex

ON THE OCCASION OF THEIR RUBY WEDDING, Peter Swete gave his wife Denny a garden shed. It was the perfect gift. Not only does it make her gardening life easier – and she spends a lot of time outdoors – but the shed, known as 'Den's Den', has become the centre of operations for the large garden she has created despite her intentions otherwise.

A dozen or more years ago all Tinkers Green Farm had by way of a garden was some dead lavender and roses in one round flower bed at the centre of the drive. The Swetes had recently moved from their former home at Shore Hall, also in Essex, having determined to scale down their gardening activities. They added two modest new borders and found to their delight that the thatched farmhouse, with its pale yellow walls, was an ideal foil for plants.

Soon, however, Denny and Peter felt hemmed in. They took the opportunity to acquire more land behind the house – and it was not long before the downsizing failure became apparent. Now the garden surrounds the house and is about 2 hectares/5 acres in extent. Not small, then, but no hurdle for Denny. Her first horticultural mentor was her mother. Later, Denny attended the late Rosemary Verey's garden design course at Barnsley House in Gloucestershire. 'She was a bit of a dragon but she enthused us all so much,' Denny says of the celebrated garden designer revered, in particular, for her ornamental potager.

OPPOSITE Enlarging the garden has allowed for these deep double borders in warm hues, with crocosmia and purple-leaved elder facing persicaria and bronze fennel.
BELOW LEFT This is the third garden that Denny and Peter Swete (here with Norfolk terrier Rafa) have made together, all in Essex.
BELOW RIGHT The garden shed is Denny's outdoor home.

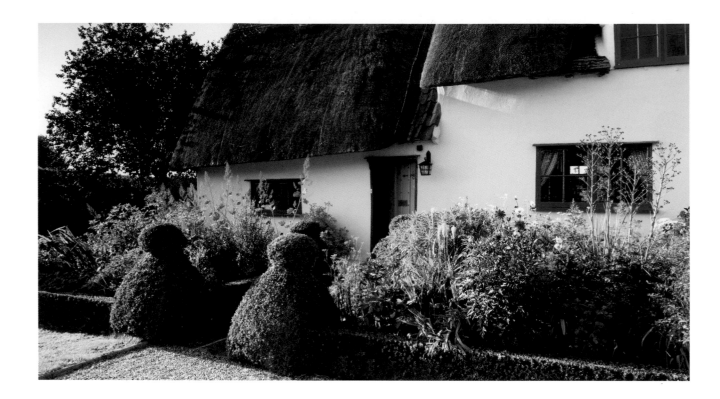

Having gone on to study at Writtle University College, in Chelmsford, Denny now designs gardens for other people.

In Denny's view, box, yew and holly are hard to beat for hedging because they look wonderful in the winter when all around is either dormant or drab. Even more importantly, they provide a framework for the garden. The Swetes' first set of borders, in front of the house, are box-edged, complete with shapely box corner-pieces. Within this formal boundary Denny has chosen plants that provide seasonal interest and rise to a great height. When the planting here is in full swing in summer, it is not unusual for the bench at the top of the path to disappear amid the swell of leaves and flowers.

Exotic pots

Containers add to the lush feel, and are placed to soften the buildings around the central gravelled entrance. Pots full of exotic-looking eucomis, *Gladiolus murielae*, agapanthus and parahebe thrive outdoors in summer before returning to the greenhouse to overwinter.

Once the extra land behind the cottage became available, Denny designed two large borders filled with shrubs and perennials to line a rectangular lawn. Beyond this point, the closely cut lawn continues through gun-metal grey gates to a small swimming pool. As pools are notoriously

difficult to blend into a garden, the Swetes painted the interior of theirs grey, and in winter it looks just like an ornamental pond. Denny's pride and joy, though, is her decorative vegetable garden (a smaller version of the one she left behind at Shore Hall) while Peter, who takes care of the grass, trees and watering, is in charge of the pond on the east side of the garden.

Denny's colour palette has changed from the pinks and blues of earlier gardens, to now embrace orange, yellow and hot red. She creates repeated sweeps of colour from foliage and flowers, usually planted in groups of five, seven or nine. The dark foliage of elder and berberis makes good backing for bright pink dahlias, roses and persicaria. Crocosmia, eryngium, rudbeckia, *Verbena bonariensis* and fennel are key elements in high summer. Cardoons, shrubs and clematis on iron obelisks provide height.

ABOVE Rotund topiary forms resembling pawns from a chess set greet callers-in at Tinkers Green Farm.
RIGHT Slate-grey paintwork on gates, benches and railings, as well as the pale yellow of the house walls, provide a foil to vibrant planting. Favourite dahlias include fizzy pink 'Orfeo' and the classic red 'Bishop of Llandaff'.

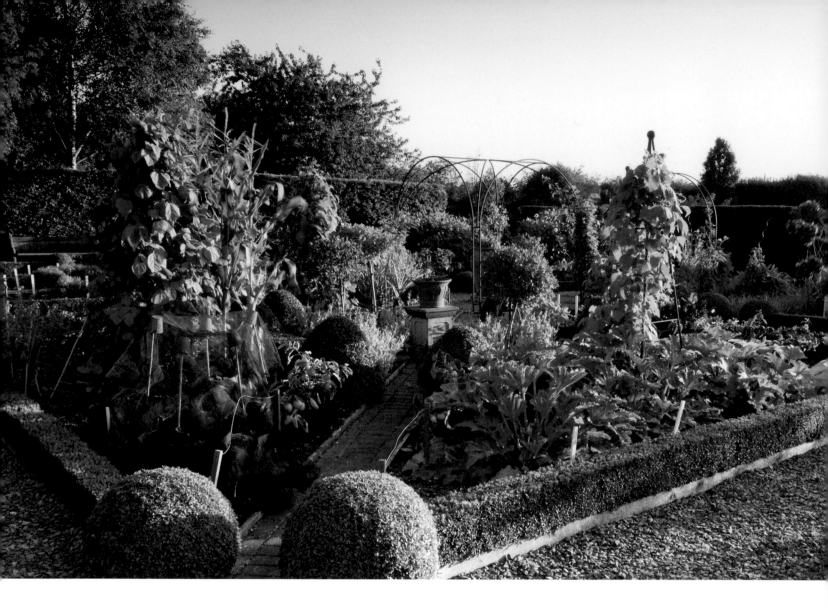

Kitchen Garden

As much as Denny enjoys designing with plants, she loves growing food, especially any new or unusual vegetables. Tiny currant tomatoes (*Solanum pimpinellifolium*) are a favourite at present. The Kitchen Garden is divided into four quadrants, with box-edged borders and a central arch. One section is devoted to a serious cut-flower garden, with narcissi, tulips, cosmos, nigella and dahlias blooming in succession. The bicoloured white and carmine dahlias here are those that Denny has grown for many years, known as 'York and Lancaster'. The whole Kitchen Garden is enclosed by a relatively young yew hedge, which in time will provide the shelter so vital in much of East Anglia.

Trees in the landscape

Although there were some mature trees already in the garden when the Swetes arrived, they have added more, including quince, medlar and other fruit trees, as well as a grove of birch underplanted with purple-leaved cow parsley (*Anthriscus sylvestris* 'Ravenswing'). They have also planted oaks on the gently rising land of 'the rampart', a mound Peter created using spoil from the swimming pool. The oaks were all grown from acorns, mostly brought from Shore Hall.

Ever since Peter and Denny have gardened together, trees have been important to them as a way of planting for the future. Here in the garden at Tinkers Green Farm they are a stone's throw from their first two homes, and in their 'borrowed' landscape are the trees they planted on these two properties, now maturing well and giving them pleasure from not too far away.

ABOVE The Kitchen Garden is enclosed by a sheltering yew hedge, while the inner beds are box-edged. Evergreen structure, used throughout the garden, comes to the fore in winter.
OPPOSITE ABOVE A cutting garden, glasshouse and beehive have their allotted space.
RIGHT Rhubarb forcers echo the large terracotta urn behind.

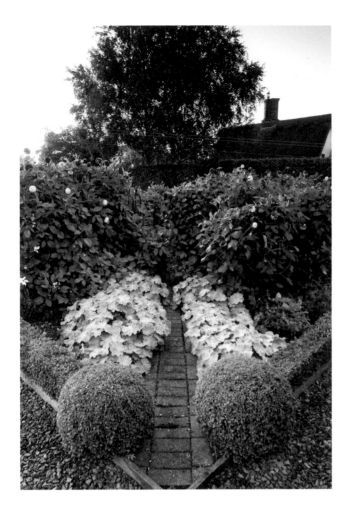

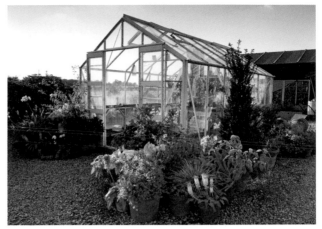

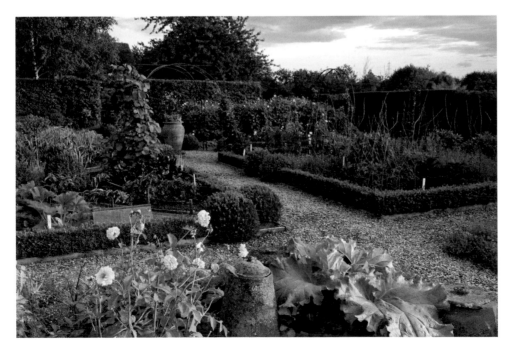

*One quadrant
is devoted to a
serious cut-flower
garden, with
narcissi, tulips,
cosmos, nigella and
dahlias blooming
in succession.*

18
Ulting Wick
Ulting, Essex

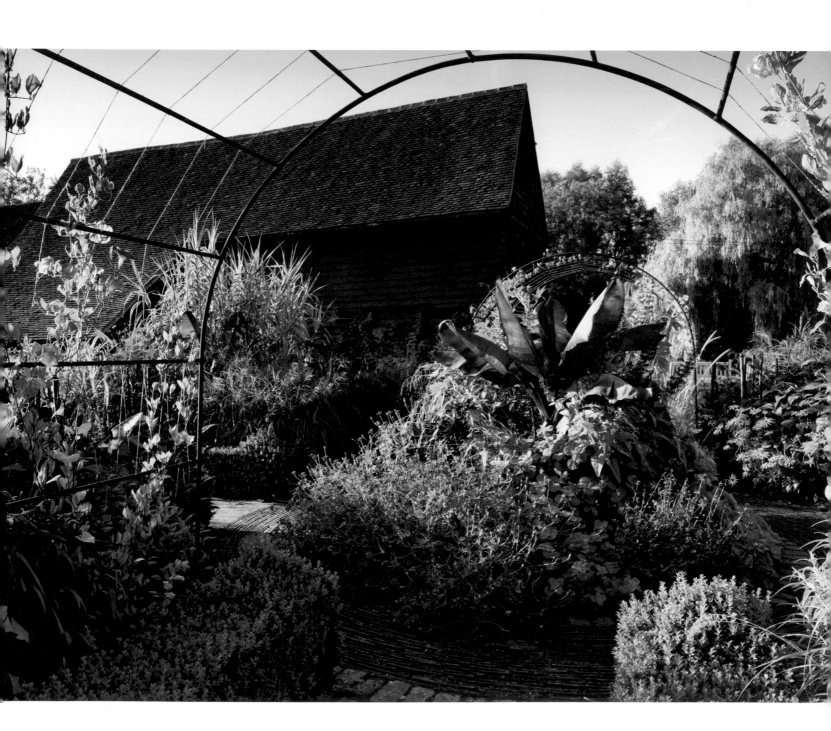

ULTING WICK is reached along one of those rather secretive lanes typical of rural Essex, and is the home of Bryan and Philippa Burrough. Adjacent to and complementing their sixteenth-century house are three imposing, black wooden barns. The area loosely enclosed by these listed barns was a cutting garden for a time, and then a kitchen garden, before finally finding its identity as the Old Farmyard. These changes reflect Philippa's journey as a gardener, her willingness to experiment, and the emergence of her own distinctive style.

Painting with plants

The barns were Philippa's starting point when she set out to make a garden, and remain a source of inspiration. Their size, tar-varnished walls, and the varying pitches of their roofs make an ideal framework for the plant artistry at which Philippa excels. Her deft and intuitive use of colour is matched by a thorough knowledge of plants and an exuberant determination to seek out new varieties. She has ample scope to try different combinations, as the planting in the Old Farmyard changes twice a year: it dazzles in spring with thousands of tulips, while in high summer it luxuriates in hot colours and lush foliage.

All of this still lay ahead when Bryan and Philippa married in 1995. At the time they were living and working in London. A year later they became commuters, having moved to Ulting Wick, where they were faced with the usual renovations that an old country property presents. There was also an existing 4.5-hectare/11-acre garden to maintain, with mature trees, pond and stream, island beds, and a collection of rhododendrons and other shrubs.

Philippa dutifully edged, mowed and pruned – until it struck her how much she disliked the shrubs she was taking care of. This was a pivotal moment, as was the restoration of the black barns. Philippa saw their potential to form the heart of a new garden, one that would be truly hers.

Beds were grassed over, shrubs uprooted, and the rubble, hoggin and compacted soil of ages removed from the former farmyard. Philippa stopped working in the City following the birth of the couple's second son in 1999 and began devoting more time to the garden. It is now her main

occupation. Bryan is the perfect foil to Philippa's creativity. With his support and encouragement, the garden has opened to the public for the past 14 years in aid of the National Gardens Scheme. Bryan is also the exemplary mower of the extensive lawns and woodland paths.

Today, the way in to the Old Farmyard leads through an archway of rambling *Rosa* 'Goldfinch' in which, delightfully, a goldfinch nests. Once past the rose arch there is no option in high summer other than to join butterflies and bees along a path lined with effervescent *Verbena bonariensis* and *Gaura lindheimeri*. The main space within is divided by brick paths into four box-lined beds. A large copper pot marks the junction of the paths. Each season's planting begins with that central pot, described by Philippa as the 'nerve centre' of the garden.

Whatever the season, soft pastels are not an option. The barns dictate strong saturated tones that bounce off and intensify their dark walls, and Philippa is not afraid of colour. 'I am more afraid of not using it,' she says.

LEFT In summer, the copper at the centre of the Old Farmyard often vanishes under a layer of exuberant planting. Bold, bronze-leaved *Ensete ventricosum* 'Maurelii' provides a focal point for this scheme.

RIGHT *Rudbeckia fulgida* var. *sullivantii* 'Goldsturm' and *Dahlia* 'Orange Cushion' turn up the heat.

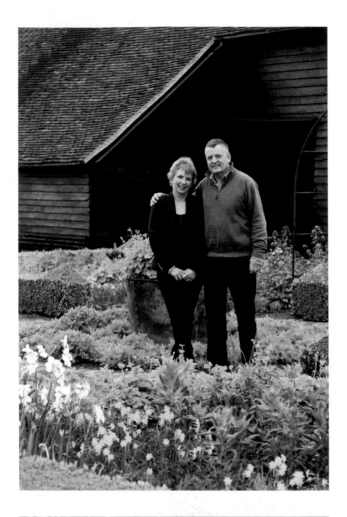

'In some parts of the garden I actually need to put in more green plants and texture, to divide the colour up.' Philippa is aided by head gardener Neil Bradfield, who spends four days a week developing the garden with her. They think ahead, take cuttings, pot up the copious self-sown seedlings and seek out new plants for the ever-changing spring and summer displays.

Decisions, decisions

It is usually June when they knuckle down to planting the annuals, tender and exotic perennials. All the pots come out of the greenhouse and are set on every available surface of grass, gravel and brick before being placed in position. Rather than working from a fixed plan, Philippa and Neil make decisions on the day, moving pots around in the beds until they are satisfied. Difficult, shady spots are dealt with first, though, to ensure success. The bananas, important focal plants, are placed with care, especially as they are almost too big to move around. The dusky foliage of *Ensete ventricosum* 'Maurelii' is a perfect match for the barns.

The scheme is never the same two years running because Philippa would find that dull. There are some fixed points, however: the bamboo-like *Arundo donax*, miscanthus and paulownia (which when pollarded produces giant leaves) are left to overwinter in the box-edged quadrants. These are what Philippa describes as the stationary 'middle peaks'. Staking is done as the planting goes in, using branches cut from the Burroughs' own hazel coppice. These are hidden by the time the plants reach maximum height.

Unravelling the garden follows four months later. By mid-October the flowers have faded and tender plants need to be moved under cover before the first frosts. 'We tunnel routes in through the vegetation and strip the annuals out,' says Philippa. Tree dahlias (*Dahlia imperialis*) are left *in situ* but all other dahlias are lifted and overwintered in one of the barns.

ABOVE LEFT Bryan and Philippa Burrough stand in front of one of the black Essex barns that are so central to the garden's story.
LEFT Dark timber is the perfect partner for stylish planting at every level.
RIGHT A brick path leads into the Old Farmyard past *Verbena bonariensis* and *Gaura lindheimeri*. Beyond this, there is colour all around. Flowers are many and varied, from trusty dahlias to new finds such as yellow-flowered *Nicotiana glauca* (top left). Texture and detail are worked in, including feathertop grass (*Pennisetum villosum*) and succulent aeoniums.

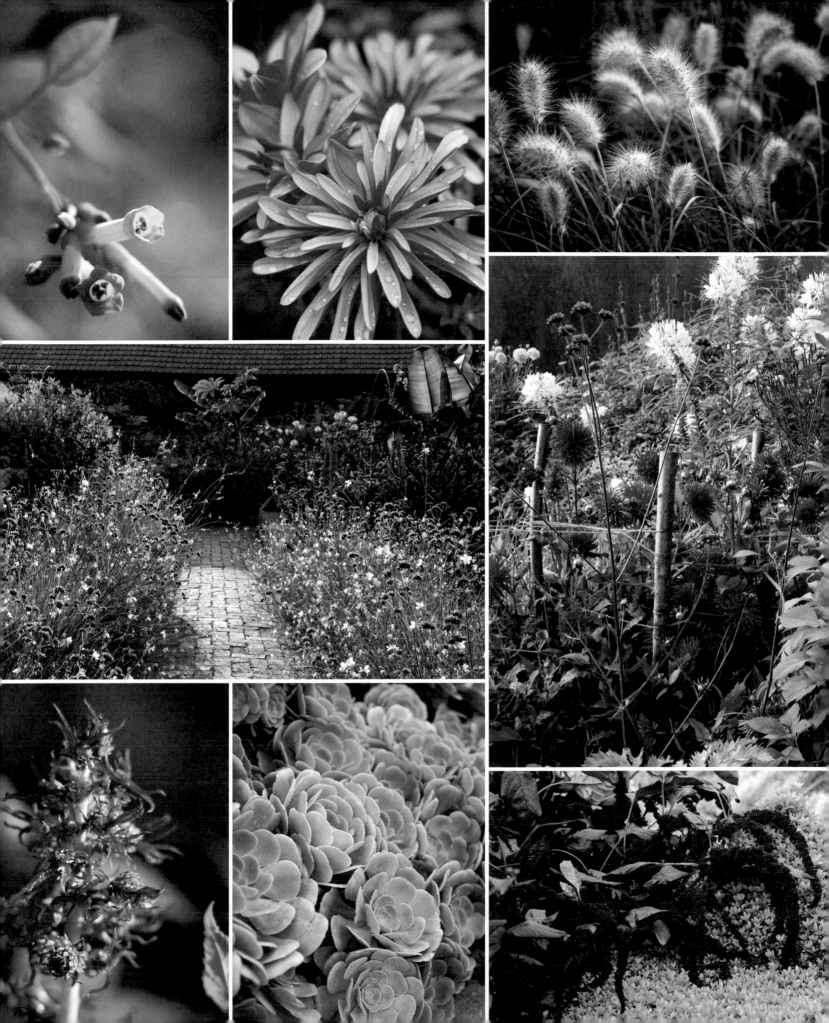

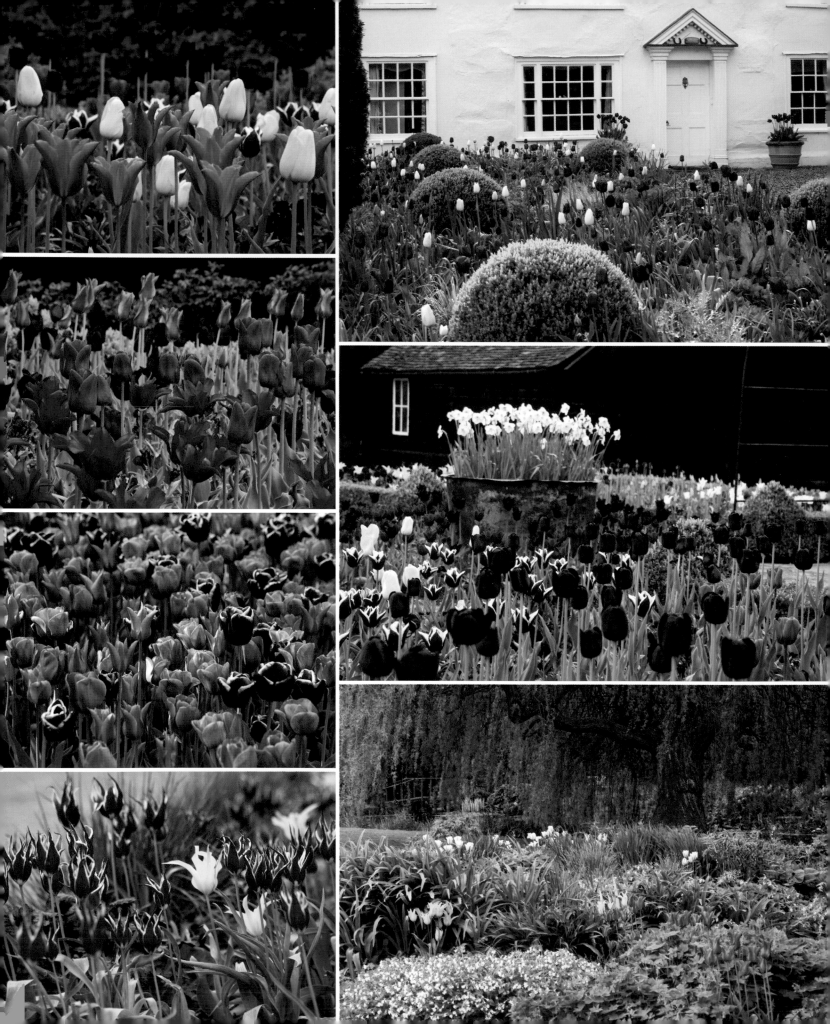

Philippa's holiday reading, if she can tear herself away from the garden, is likely to consist of the latest bulb catalogues. By the end of August she will have placed her orders for up to 10,000 tulips. These are planted as late as possible in a bid to keep the tulips disease-free. Another safeguard is to 'rest' each area in turn by excluding tulips for a period of three years.

Weaving with bulbs

Late November is the magic moment when the new displays for spring take shape. Again, no plan is made on paper. Instead, Philippa and Neil weave bands of bulbs in and out among the early showing perennials with textural foliage. These include *Alchemilla mollis*, pincushion sedums and long drifts of *Geranium phaeum* 'Samobor'. *Stipa tenuissima*, in burnt-sugar tones, combines well with fiery tulips such as 'Ballerina' and 'Cairo'.

In previous years the low-lying drifts of tulips have emphasized the beauty and scale of the Old Farmyard barns. But since resting tulips out of the scheme in recent years, Philippa and Neil have developed a free-flowing style with more height and texture. Honesty and dame's rocket (*Hesperis matronalis*) are among the mixed spring plantings.

Never-ending quest

Continually on the lookout for new and unusual plants, Philippa keeps track of the ideas people share on Twitter. The summer season is particularly challenging, as she explains: 'There are only so many plants that can give me the high-summer jungle look and can stand being carted

OPPOSITE In spring, the dazzling array of tulips at Ulting Wick is a heart-lifting sight. While the main display is concentrated in the box-edged beds of the Old Farmyard, tulips are also used for different effects in front of the house and by the weeping willow tree.

BELOW Saturated colour is the key to Philippa's spring schemes, and every year she falls in love with yet another irresistible tulip.

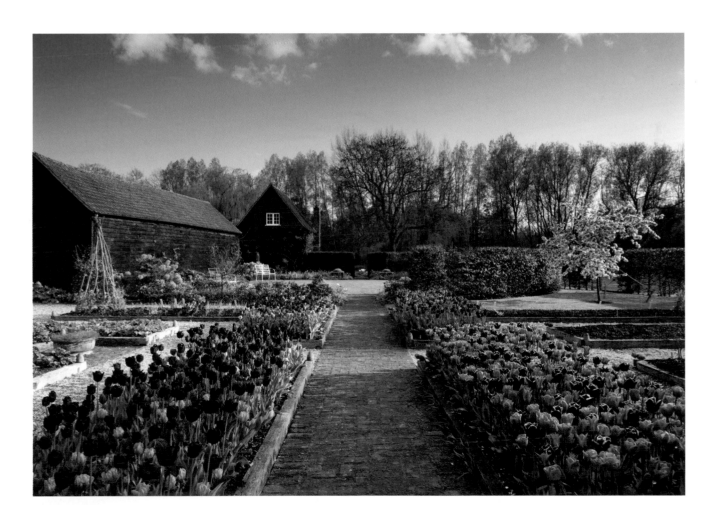

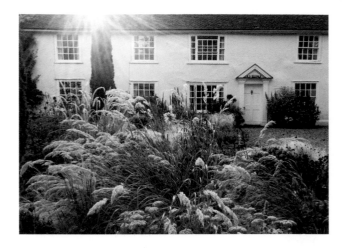
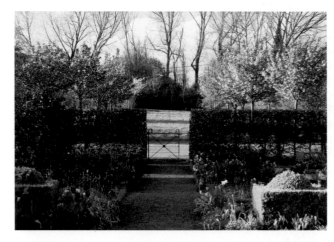

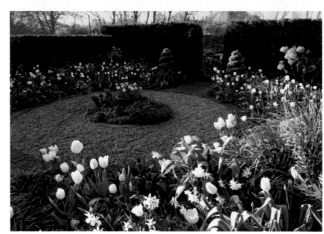

A leisurely walk by the pond leads towards the perennial wildflower meadow.

in and out, as well as coping with the garden's dry conditions.' Lately excitement has been mounting over a statuesque tree tobacco (*Nicotiana glauca*), which grows to 3.5 metres/12 feet and produces primrose-yellow flowers against grey foliage. Keeping it company is the equally dramatic South African lion's ear (*Leonotis leonurus*), with whorls of orange flowers.

White Garden

The Old Farmyard is high maintenance and demands attention constantly, but this has not stopped Philippa developing a suite of other gardens to enjoy. Leading on from the Kitchen Garden is the Pink Garden, created in 2004. Here, spring displays of purple and pink tulips including 'Barcelona', 'Queen of Night' and 'China Pink' precede its late summer peak, when vibrant asters and striking dahlias bloom. The adjoining White Garden is an intimate space in restrained shades, featuring box topiary.

Moving away from the barns, there is a change of pace and tone. A leisurely walk by the pond leads towards the perennial wildflower meadow developed in 2010. Doubling back behind the Kitchen Garden is the woodland, planted with native trees, limes and an avenue of *Prunus* 'Kanzan'. Each year Philippa adds yet more snowdrops and flowering bulbs to increase spring interest.

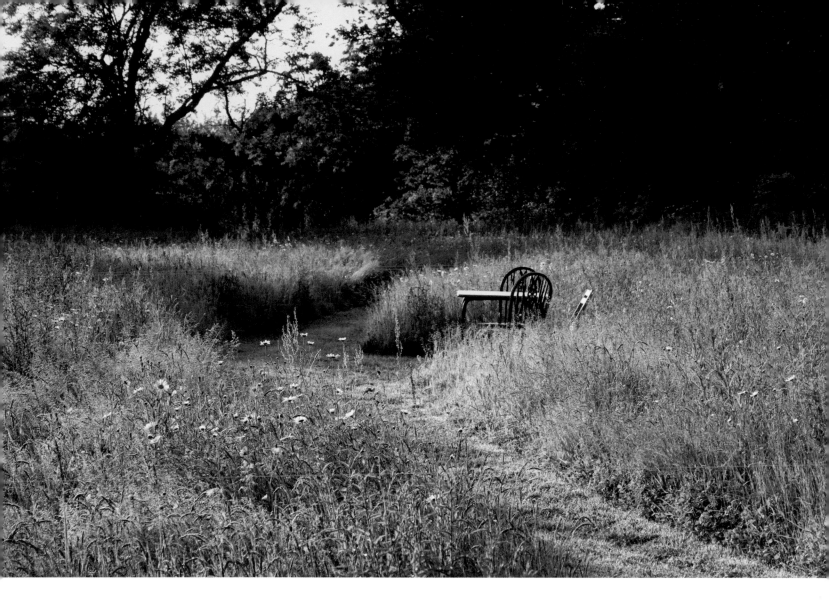

The front garden has proved tricky. After previous plantings failed to cope with the heat, this area was replanted as a dry garden, using drought-tolerant salvias, grasses and nepetas. Irish yews and box balls from an earlier layout provide rhythm and a structural counterpoint to the flowing lines of perennials. Fortunately for Philippa the gravel alongside the front garden is a wonderful nursery for seedlings, many of which are used in her trademark zingy colour schemes.

Over the years Philippa has gained confidence as a gardener. Her experimental approach has blossomed, as has her playful and painterly way with colour. So, rather than arriving at an end point, the spring and summer plantings continue to evolve. Philippa and Neil keep a record of how their schemes perform, as well as any pleasing plant associations that arise by accident. Of course, experimentation means having the courage to fail on occasion. Philippa takes this in her stride: 'It is a great joy when it works, and if it doesn't then I shrug, make a note, and do something else the following year.'

OPPOSITE The varied gardens at Ulting Wick offer changes of pace (clockwise from top left): grasses, salvias and nepetas thriving in the heat of the front garden; flowering cherries by the Kitchen Garden; the simplicity of the White Garden; and seats on the riverbank.

ABOVE Beyond the clamour of summer colour, the wildflower meadow provides a tranquil place to sit and let your thoughts wander.

19
Wickham Place Farm
Wickham Bishops, Essex

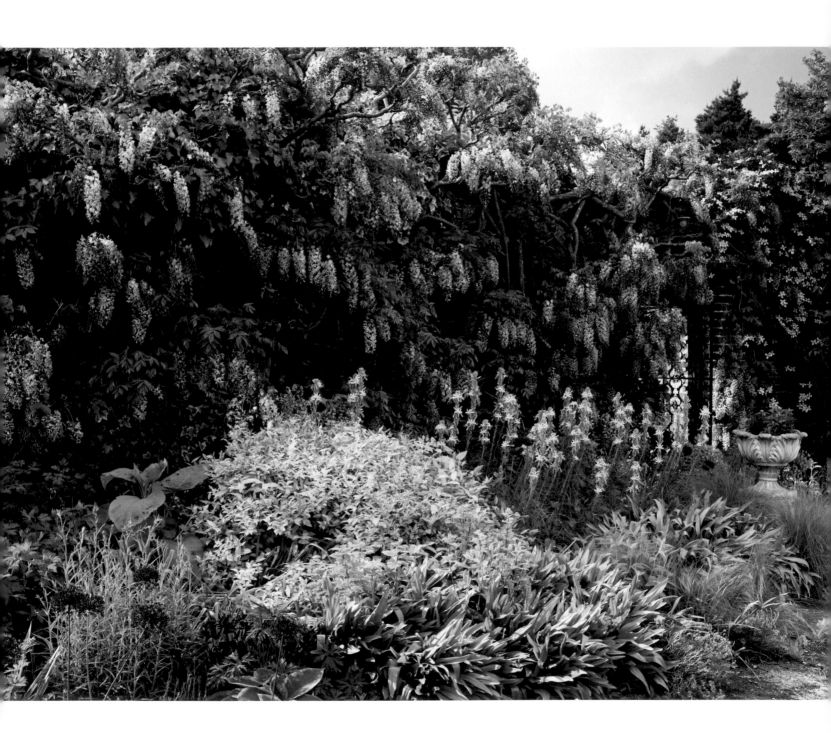

JUDITH AND TERRY WILSON are looking at the garden with new eyes. Or rather, from a different vantage point. They have recently renovated a coach house on the northeast corner of their 0.8-hectare/2-acre walled garden and moved there from the gardeners' cottages on the southwest corner. 'We used to wake up to views of cascading wisteria,' says Judith, 'which was always special, but I have gained a lot of pleasure from creating new views over the coach house garden.'

Not only has the outlook changed, but the building project opened up fresh areas for planting. A hot, south-facing stretch of grass has been converted into a gravel garden of silver and spiky drought-tolerant species, while the sunny terrace near the coach house itself has been given a Mediterranean feel. A new border of 45 by 3 metres/148 by 10 feet set against the high, north-facing wall required some skilful plant selection, due to a troublesome combination of gravelly soil, shade and encroaching rabbits and deer.

Garden rescue

Judith began her long association with Wickham Place Farm in 1987. The main garden here is enclosed by walls dating from 1706, and would originally have been a kitchen garden supplying the 'big house' next door. From 1948 to 1952 this area served as a cattle farm, until rescued and redesigned as an ornamental garden by Judith's predecessor. Sadly, though, his creation eventually slipped into decline and by the time Judith arrived the garden was completely overgrown. This presented her with a huge challenge, one that took her far beyond her previous experience of gardening.

She describes this period as 'like learning a new language'. She read books, listened to experts, and took advice from her former neighbour Helen Robinson, who at that time still owned Hyde Hall, now run by the Royal Horticultural Society. In the end, Judith simply had to plunge in. Clearance was the first step, followed by an enormous amount of pruning. The wisteria resembled heaps of tangled trunks, the yew hedges were seriously out of shape, and ivy covered almost every wall. The best technique for the ivy was to slice through it with a chainsaw, then use spades to prize it away from the sides of the walls.

The hard-pruned wisterias, originally planted in the 1950s, did not look as if they would ever flourish again. With new wiring in place on the walls, however, the plants responded to all Judith's training, nurturing and patient tending – to become the glory of the gardens in summer.

There are at least five wisterias, the longest being a *Wisteria sinensis* of 73 metres/240 feet covering one entire side and the full 3-metre/10-foot height of the garden wall. The Japanese wisteria (*W. floribunda* 'Multijuga', also known as 'Macrobotrys') covers both a gazebo on a south wall and a large pergola behind it on the north side. It has soft mauve, trailing racemes up to 1 metre/3 feet long, with an unusual but delicious, almost musky fragrance.

Planting in layers

Several decades on from those pioneering early days, Judith is skilled in planting design, propagation, composting and pruning. Within the walled garden she constantly refines the re-established mixed and herbaceous borders, nurtures an ancient mulberry tree, and clips into shape wonderful, complex box features. Sweeping lawns, huge shrubs, a pool terrace, two ponds and a nursery complete the picture. Judith only grows what does well on the gravelly, hungry soil. She is not keen on orange flowers, nor annuals, preferring to create a permanent structure of trees and shrubs, and then add in layers of perennials and bulbs.

As there is only a small greenhouse, all stock for sale is grown outdoors. Judith is convinced this makes plants stronger: 'I know if they survive here – we do have severe frosts – they will survive in other gardens.' She advises

OPPOSITE Alliums and asphodels flower alongside the beautiful *Wisteria sinensis* that covers both sides of the garden's western wall.
ABOVE Pools, lawns and shrubs are quiet but essential elements of the walled garden. In the background is a gazebo engulfed by Japanese wisteria.

anyone planning a new border to start buying plants as early as possible and pot them on so they have time to develop a good root system. 'Then when you actually plant them into their new positions,' she says, 'they hit the ground running and have a really good chance of establishing.'

For many visitors the superlative wisteria is the garden's high point, but there are also quieter pleasures well worth seeking out. One of these is a lily-of-the-valley pavement near the gardeners' cottages. Decades ago someone must have planted these shade-lovers close to the north-facing house walls. Over the years they have multiplied and spread under the paving, popping up in between the Yorkstone slabs of the terrace to form an unexpected and highly fragrant feature in May.

Woodland walks

For Judith and Terry, however, most compelling of all is the secluded woodland north of the garden. Planted in the 1950s for timber, the 4.8 hectares/12 acres of woodland

had a 'nurse' crop of Scots pine protecting the final crop of oak and beech. About a thousand of the trees were lost in the Great Storm of 1987, resulting in a huge amount of debris to clear. In the aftermath, as the Wilsons began to learn about managing woodland in a sustainable way, their appreciation of it deepened.

Their first impulse was to replant, until they discovered that for the woodland's long-term health there needed to be still fewer trees rather than more. Terry now undertakes tree thinning every winter, this being one of his roles in the horticultural life of Wickham Place Farm. Due to the demands of work, his involvement in the day-to-day gardening is limited. Judith, on the other hand, is taken up with gardening much of the time, assisted one day a week by Thady Barrett, an accomplished propagator.

Early on, Judith began to experiment with plantings in the woodland, not all wild or woodland natives, but barrowloads of garden surplus that she introduced to see if it would survive the browsing rabbits, muntjac deer and badgers. Some of these 'sacrifices' were eaten immediately, others lasted only until the winter food shortage. But plenty have multiplied happily in various spots: monkshood, primroses, wood anemones, leucojums, bluebells, snowdrops, lily of the valley, colchicums, day lilies and hellebores. Geraniums, ferns, dicentras and rhododendrons have since made the journey into the woods.

The strong attachment the Wilsons feel for the woodland is bound up with its role as a habitat for all kinds of creatures – tawny owls and goldcrests being two favourites. The woodland is also a place of particular sights and sounds. 'In autumn, we like to sit on a log bench and listen to the leaves rattling in the wind,' says Judith. She and Terry share a lot of 'downtime' in the evenings and at weekends, time when perhaps they ought to be gardening but instead walk in the woodland or gardens and simply enjoy what they have created. They recommend the same to all garden-makers, of plots large or small, for at moments like this, Judith says, 'we would rather be here than almost anywhere else in the world.'

LEFT Judith and Terry Wilson feel a strong sense of attachment to the woodland, situated near the main garden.
RIGHT Seeing the massive wisteria so magnificently draped in bloom, it is hard to believe that 30 years ago the garden's walls were smothered in ivy and the wisteria lay in tangled heaps. Borders and pondside plantings have likewise been rejuvenated.

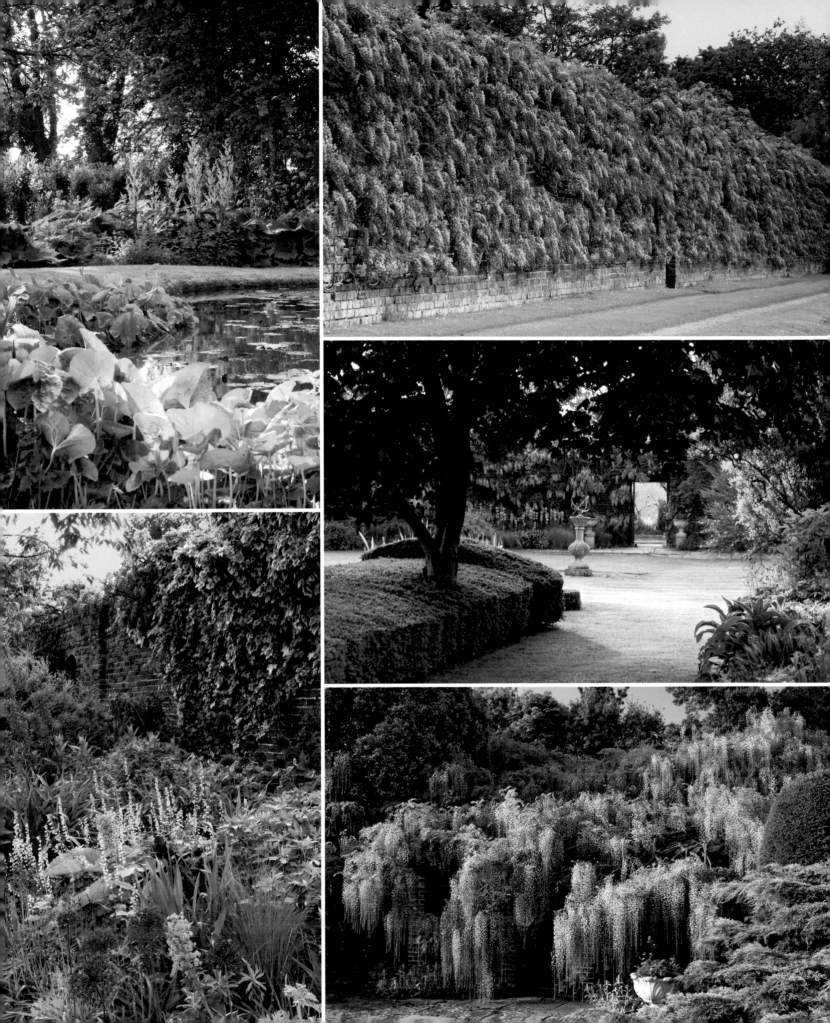

20
Winterton Lighthouse
Winterton-on-Sea, Norfolk

HERE, ON THE MOST EASTERLY POINT of the Norfolk coast, the weather is significant for seafarers and gardeners alike. In *A Tour Through the Whole Island of Great Britain* (1724–6) English novelist Daniel Defoe was well aware of the dangers to shipping close to Winterton Lighthouse, noting that there were at least four lighthouses along the coast above Yarmouth to assist mariners. In *Robinson Crusoe* he set Crusoe's first experience of shipwreck at Winterton. Fortunately for current owners Sally Mackereth and Julian Vogel, life at the lighthouse – come sunshine or sea fret – has all the attributes of a safe haven.

Panoramic views
Positioned a long way back from the sea and high up, the lighthouse looks out over a valley of rolling dunes. The view is breathtaking. Sally and Julian bought the building 12 years ago, and with their combined design sensibilities (Sally is an award-winning architect and interior designer, while Julian is a publicist working in fashion and design) they transformed a dilapidated old tower into a seaside retreat. They come here to escape their rushed working lives in London, relax with children Lola and Oscar, and potter in the garden.

The lighthouse had been without its lantern room for decades by the time Sally and Julian took it on. However, by adding a new dome with 360-degree views across land and sea they have succeeded in recreating the silhouette typical of a lighthouse. The original paraffin-burning lantern was sold at auction in the early twentieth century and now graces a lighthouse on one of the Abaco Islands in the Bahamas.

Once work on expanding the living quarters at the base of the tower was under way, the couple turned their thoughts to the space outdoors. Julian is the gardener in the family but, not unexpectedly, Sally has strong views on structure. They wanted to create a bold garden that would wrap around the building and yet not compete with it for attention. Having worked in the past with Chris Moss, an award-winning garden designer based in London, Sally knew he would be the person to approach. 'I think about shapes – solids, voids, mass – and shadow and light,' says Sally, 'and Chris does too, but in relation to plants.'

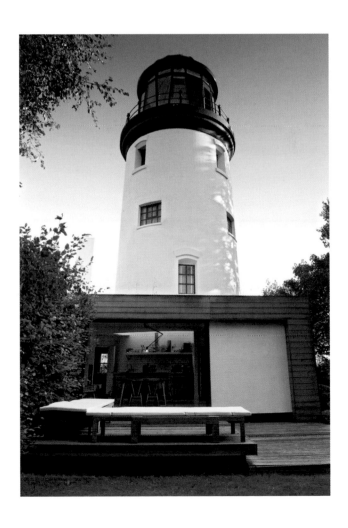

LEFT Timber decking extends the living space and forms a transition between indoors and out.
RIGHT A new glazed dome replaces the original lantern room, removed in the 1910s. Maps show some form of beacon on this spot since the sixteenth century.

green sanctuary began to take shape, surrounding the tower on three sides.

Although the site and the lighthouse itself were not compatible with a cottage-garden look, the planting was to be understated and natural in style. As with all coastal gardens, the salt-laden wind was a limiting factor. An additional challenge was the sandy soil. Luckily, Julian and Sally have good friends in Alan Gray and Graham Robeson along the coast at East Ruston Old Vicarage (see pages 24–9). 'One of their viewpoints is through to our sister lighthouse at Happisburgh,' says Sally, who has learned that whatever thrives at East Ruston will also do well here.

She and Julian had firm views on plant selection. They wanted architectural plants. They wanted a succession of interest from foliage, bark and flowers. They also wanted plants that largely could look after themselves, as they did not want to be working in the garden every spare moment. Notwithstanding, Julian is always impatient to find out what has burgeoned, bloomed or faded in his absence: as soon as the family arrives for the weekend he rushes out, torch in hand if necessary, to inspect.

Tones and textures

The garden has a distinctly lush feel. Plants mingle in curved or linear borders, and rise out of beds with an edging of masonry painted black to match the livery of the lighthouse. Silver, mauve and every shade of green imaginable are the dominant colours throughout. There is no room for terracotta or hot oranges. Although foliage provides the main impact, flowers and seed heads in season offer surprise bursts of colour and additional texture. Dark-leaved *Sambucus nigra* 'Black Lace' combines with the deeply cut foliage of green fennel, ferny thalictrums, burgundy-coloured astrantias, indigo nepeta and violet blue geraniums such as 'Rozanne'. The silvery tones of weeping pear and *Melianthus major* add touches of brightness.

The kitchen and living room in the box-shaped extension at the back of the lighthouse are the focus of family life, which spills out at times through bifold doors on to a 'floating' hardwood deck. The doors frame a view into the garden, and the deck offers extra space for entertaining and relaxing. There is also an unencumbered lawn for play or sitting out.

The lighthouse is in effect semi-detached. The cottages next door were once the lighthouse-keeper's home, but now form a separate property. The old route connecting the tower and cottages has been sealed off – it would otherwise lead through what is currently the family's

Finding the flow

When Sally and Julian first took stock of the 0.2-hectare/ ½-acre site they were pleased about the mature trees on the perimeter, but overall found the garden to be 'scrappy' and lacking cohesion. With Chris, they reworked the space as a series of rooms. The area at the front, for example, felt like an extension of the front door and is so sunny in the morning that it makes a perfect place to sit out. It also frames the entrance to the tower. Together the three of them agreed the basic structure and planting schemes for the new garden – and a secret

ABOVE Julian Vogel and Sally Mackereth both had strong views on the garden that surrounds their seaside retreat.
OPPOSITE With its restrained range of colours, including every possible shade of green, the garden makes a statement without vying for attention with the lighthouse. Drama comes from the interplay of textures, such as feathery fennel, jagged *Melianthus major* or the sinuous leaves of *Crambe maritima*.

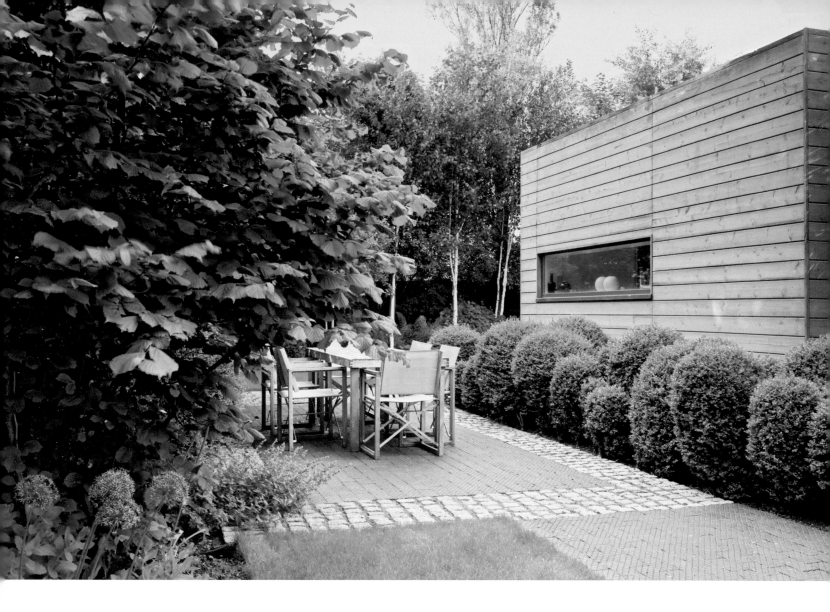

*The lighthouse's
original paraffin-
burning lantern
had long since been
sold at auction
and shipped to the
Bahamas.*

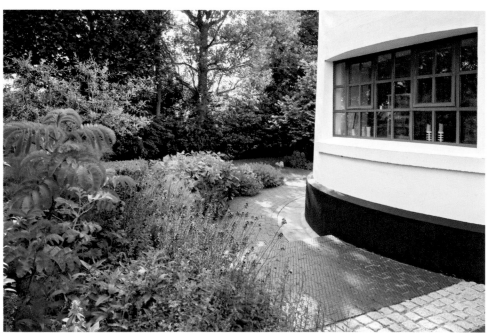

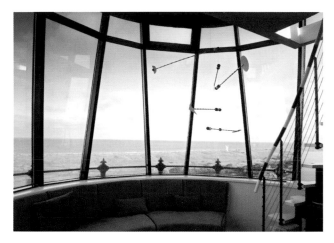
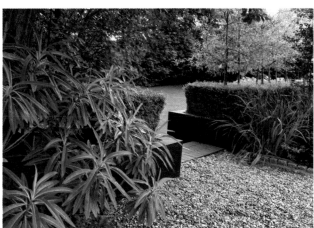

bathroom. As the cottages overlook the lighthouse garden, though, there is a short run of beech hedging to provide some privacy. Ingeniously, the hedge is stepped back from the walls and openings are cut out opposite the cottage windows in order to allow light through for the neighbours.

Carefully arranged evergreen and deciduous hedging, as well as lines of shrubs, make this small garden appear much larger than it is. Textures of hazel, box and beech are laid across each other to great effect, often making play of geometry. Near the gravelled garden entrance is a low, rectangular block of clipped box, out of which rise the stilt-like silvery grey trunks of several aligned weeping pear trees.

There is one box hedge that does not quite match the others. It runs alongside the timber-clad kitchen extension designed by Sally, masking the junction where the new wooden structure meets the ground, and she claims it is her sole contribution to the garden. But this is not simply a functional hedge, as its cloud-like contours reveal. 'I love the sculptural impact of topiary,' says Sally. 'There is so much control involved in shaping plants.' Cutting this hedge is strictly her job, and no one else's: 'It's so satisfying to walk alongside it, glass of wine in one hand and my Jakoti shears in the other.' It would seem that Winterton Lighthouse has brought out her inner gardener.

OPPOSITE ABOVE Sally enjoys clipping the box hedge into irregular bobbly shapes.

OPPOSITE BELOW A curving path follows the shape of the lighthouse.

TOP LEFT AND ABOVE LEFT Changes in hard landscaping materials add interest: gravel crunches underfoot at the entrance, leading to a path of grey setts and darker paviours.

TOP RIGHT AND ABOVE RIGHT The view from the top of the lighthouse across dunes to the ever-unpredictable sea is matched in beauty by the view inland towards the church at Winterton-on-Sea.

21
Wood Farm
Gipping, Suffolk

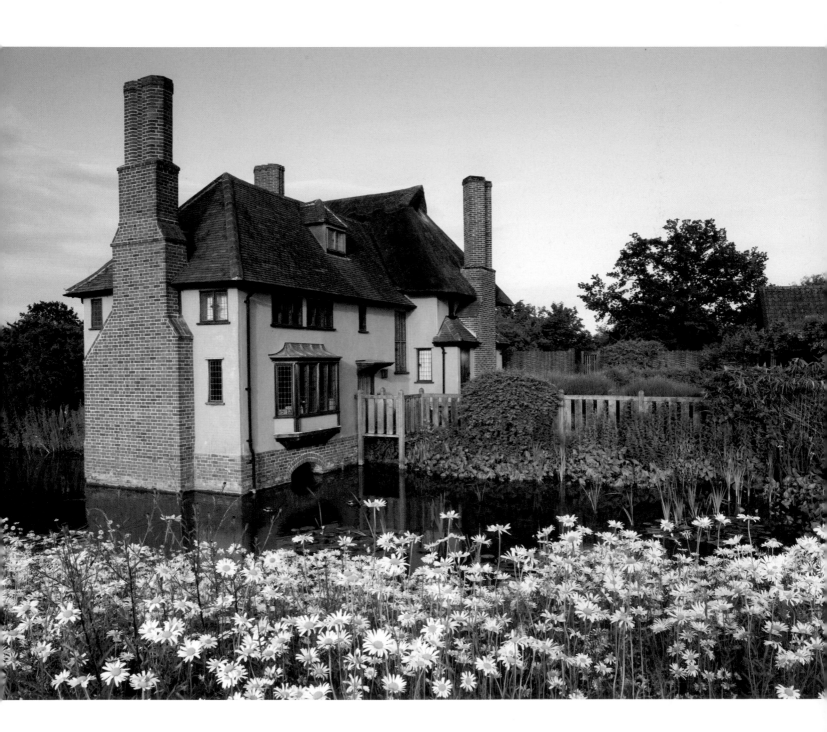

THE MUSTARD-YELLOW WALLS of Wood Farm – a 500-year-old Suffolk farmhouse – form a strong block of colour for a floral backdrop. Fittingly, the two separate but complementary garden features laid out on opposite sides of the house match it for strength: the mass of white-and-yellow ox-eye daisies in the meadow behind, and the many purples and blues in the cottage-style front garden.

Emily and Rob Shelley bought Wood Farm in 1995. They set about renovating the house and extending it in size, with the help, in 2000, of local architect Rodney Black. Emily recalls that there was no garden to speak of when they arrived – just a few trees, a climbing rose and the moat-like pool of water that curved against the back and side of the house.

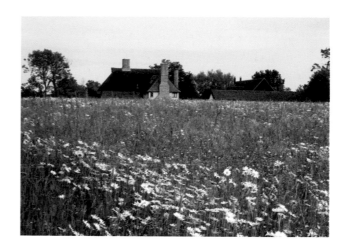

Making the meadow

Emily had always longed for a meadow filled with wild flowers, for the romance of it and also because she is passionate about wildlife. In 1999 the Shelleys had the chance to purchase the agricultural field behind their house, and with it the possibility of creating Emily's 'field of dreams'. It was a long haul, as the 3.2-hectare/8-acre meadow has taken around 12 years to fully establish, and has required determination and plenty of hard manual work along the way.

Having acquired the field, the Shelleys turned for advice to Emorsgate Seeds, a Norfolk-based specialist supplier of wildflower and grass seed. As the field was clay, they took the meadow mixture recommended for this type of soil. Wild flowers make up 20 per cent of the mixture, with seven species of grass, including meadow barley, common bent and sweet vernal grass, making up the remaining 80 per cent. In spring, cowslips are the first flowers to appear. Later come ox-eye daisies, meadow buttercups, red clover, yarrow, lady's bedstraw, ragged robin and common sorrel.

When Emily started this project she was young and new to meadow-making. She spent many hours hand-weeding the thistle seedlings that arrived in that first year, as she continued to do over numerous following years. Perhaps she would do things differently now, but it was worth every effort in view of the results. From late April through to the end of June, the meadow flows towards the house like a floral river. The play of light, colour and texture is heightened by the movement and buzz of the insect life the meadow attracts. The Shelleys regularly see swallows swishing and diving for insects, as well as a barn owl that works the field edges.

OPPOSITE AND TOP Ox-eye daisies lap right up to the moat-like body of water by the house. The meadow, a haven for insects, later takes on the russet hues of sorrel.

ABOVE Emily Shelley, pictured in the meadow she has created with such conviction, lives at Wood Farm with her sons and husband Rob.

Fastigiate yews, as yet small, rise above the floral base notes.

A succession of colours plays out in the meadow each year. In spring the vibrant green of the grasses dominates. Later, the meadow is washed over with a layer of white and yellow from ox-eye daisies, bird's-foot trefoil and buttercups. Later still the russet foliage and seed heads of sorrel come to the fore. Whichever shade is uppermost, all work well against the strongly coloured walls of the house.

Every spring, when it is time for Emily and Rob to make the first mow of the season in other parts of the garden, they decide on the shape and position of the paths they will mow through the meadow. There is always a margin all the way around the edge, between the meadow and the hedgerow. This is an enjoyable loop for walking and birdwatching.

The meadow originally lacked a hedge, having long ago been stripped out, so the Shelleys decided to replace the boundary as their millennium project. Their elder son Charlie oversaw activities, when awake, from the safety of his large Silver Cross pram. Emily planted for all she was worth – blackthorn, dogwood, field maple, hawthorn and oak, along with dog roses. At night Rob worked by the light of the moon to fit hedge guards, since Emily was convinced that rabbits were out there, just waiting for the cover of darkness to nibble her fledgling hedgerow.

The meadow's annual cycle comes to an end in late June, when it is cut as a hay crop by a neighbouring farmer. As the hay is fed to animals, it must be kept free from harmful ragwort (*Senecio jacobaea*). So from early spring onwards Emily checks the site thoroughly, digging out and burning even the smallest scrap.

Natural charm

While the meadow is splendid for its summer season, once cut it is completely over. Aware of this late summer gap, Emily thought about what she could do with the blank space in front of the house. In 2012 the Shelleys' architect laid out a curving pattern of paved paths, by which he also defined a series of spaces for planting. Emily set about amending the soil and filling the meandering beds to create an informal cottage garden rich in plants attractive to bees and butterflies.

Random and relaxed are Emily's keywords for the front garden. And the plants have joined forces to create the desired look. Mounding plants, such as lavender, do their bit by wandering across path and bed edges, while sweet peas cling to supports to offer a light and frothy hedge. Fennel, poppies, lupins, alliums and irises make a play for the centre of the borders, while fastigiate yews, as yet small, rise above the floral base notes, soon to provide height to the relatively low-growing mix of plants.

The cottage garden is hedged with a line of softly curving yew that acts as a rich green backdrop for the colourful, free-flowing flowers. The spires of indigo nepeta, bright blue cornflowers and spheres of white and purple alliums are particularly effective against both the yew and house walls. Formally clipped box plants are used to punctuate the softer elements of planting. These mounds and cones are destined to take the shape of animals and birds in due course.

Emily is fortunate to have the help of gardener Guru Sharma in bringing her plans to fruition. A former mountain guide from Nepal, he trained in horticulture at Otley College, near Ipswich. An important task the pair tackle in spring is to move plants that have formed over-large blocks into gaps elsewhere in the borders. Many of the plants here were given to Emily by her mother and mother-in-law from their own gardens. Both women have been a source of inspiration and advice. Emily has also garnered precious tips from conversations with 'old-school' gardeners, and she sticks to the rule never to clip box trees before the Epsom Derby Day (in other words, the first Saturday in June).

When she thinks back to pulling thistles in those early years, Emily has a feeling she was the source of many a joke in the farming community. Maybe so, but the meadow now looks just as she hoped it would and her hard work has more than paid off. What's more, Emily's kitchen garden supplies fresh produce to the pub in nearby Stowupland. This new turn of events happened when the pub was threatened with closure, and the Shelleys decided to step in and buy it. That surely was a welcome local initiative.

As summer progresses, the front garden builds to a crescendo. Silver spires of Scotch thistle, richly coloured irises and bright blue cornflowers mix and match with sugar-pink lupins, diascias and sweet peas. Repeated mounds of lavender and box cones lend rhythm to the relaxed planting, which is defined by an underlying structure of paths.

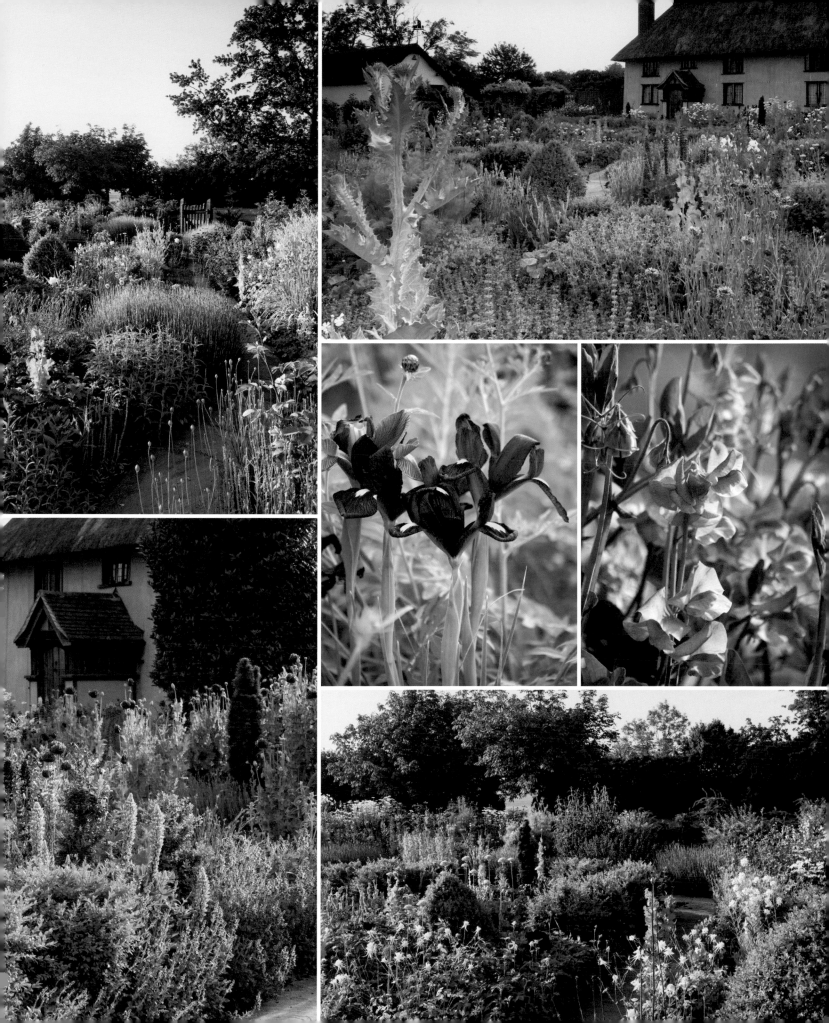

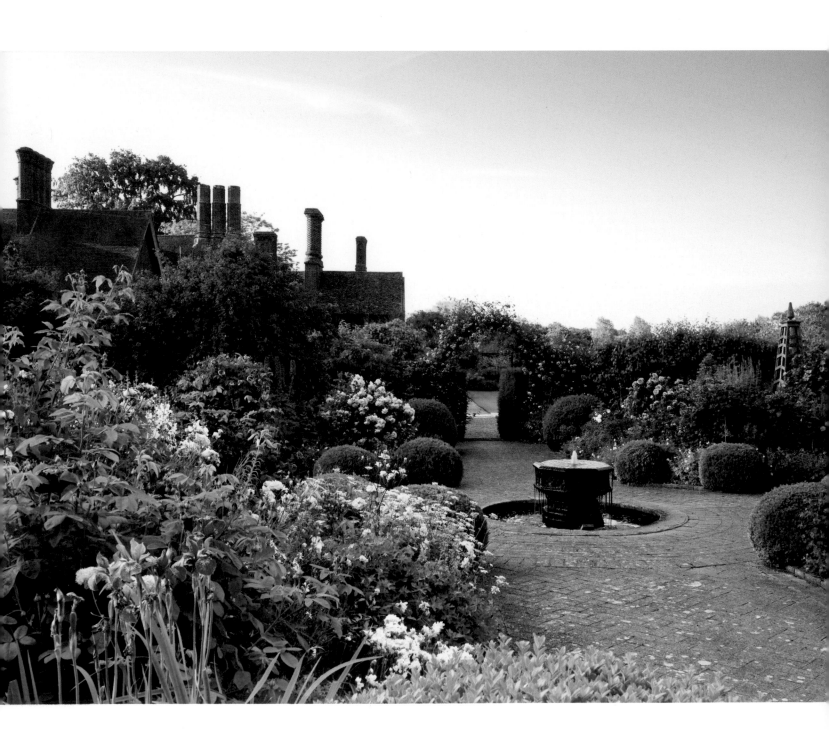

22
Wyken Hall
Stanton, Suffolk

CARLA CARLISLE is forthright about her dislike of the way many beautiful old English houses are cluttered and obscured by driveways running right up to the entrance, where parked cars mar their lovely facade. It was a flaw she was determined to correct at Wyken Hall, her home since 1986. She sold the diamond brooch her husband Kenneth had given her for her fortieth birthday and used the proceeds to redesign the approach to the hall.

It was quite a transformation. The front door now opens on to a formal quincunx of five interlocking brick circles inset with a band of local flint, in a pattern that was inspired by a Gertrude Jekyll design. Each brick ring surrounds a circular box-edged bed with tiered topiary, where forget-me-knots, tulips or salvias bloom in season. The central circle holds a blue ceramic fountain by potter Clive Davies.

Fusion of styles

This Tudor manor house in rural Suffolk has been in Kenneth's family since 1920, when it was bought by a cousin, Frank Heilgers. The distinctive red ochre limewash applied to the hall two decades ago resembles the 'Suffolk pink' of Elizabethan times. Kenneth's interest in the garden at Wyken dates from the late 1970s. He was fortunate, he says, to inherit a framework of flint walls and magnificent old trees. The changes he introduced have been enhanced by the couple's joint ventures since Carla came to live here. Together they have put a modern and distinctive mark on the garden. Soon after their marriage they also planted a vineyard on a south-facing slope, which produces around 12,000 bottles a year. As Carla observes: 'We are two people from different lands who brought out the best in this ancient plot.'

Evocative details

Carla, food writer, entrepreneur and *Country Life* columnist, hails from Mississippi and claims that she is no gardener. Before Wyken, her horticultural credentials mainly consisted of planting rows of rosemary, lavender and tomatoes. That may be so, but her contribution here over the last 30 years shows wit, imagination and an enviable instinct for colour. There are also one or two

hints of her American roots. The entrance and west front of the house are the backdrop for a quirky 'Southern-style' verandah, with large rocking chairs brought from Mississippi and painted in the dusty blue colour Carla chose for Wyken's garden furniture.

The walls and windows at the front of the house are hung with a curtain of plants to provide an element of privacy. A row of trained 'Spartan' apple trees makes an effective blossoming, then fruit-laden screen. This keeps the house slightly removed from visitors' line of sight without impeding the view from the windows. The house looks out over fields, where sheep, llamas and a single Red Poll cow enliven the landscape for much of the year. What Kenneth describes as a 'poor man's ha-ha' keeps the animals out of the garden. It consists of a post-and-wire fence set in a deep ditch, is invisible from the house and allows an uninterrupted vista.

Lying between the pasture and more formal garden features immediately around the house are various areas

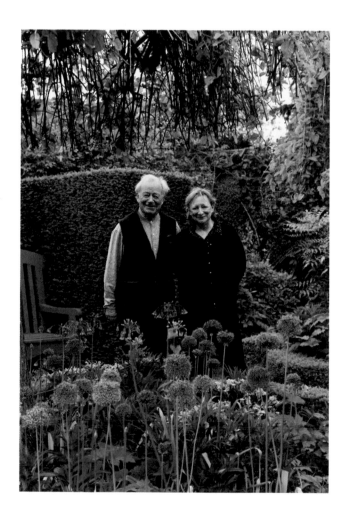

LEFT The Rose Garden holds over 60 varieties, including *Rosa* 'François Juranville' trained across the entrance arch.
RIGHT Kenneth and Carla Carlisle have added fresh and distinctive elements to the garden around their Elizabethan manor house.

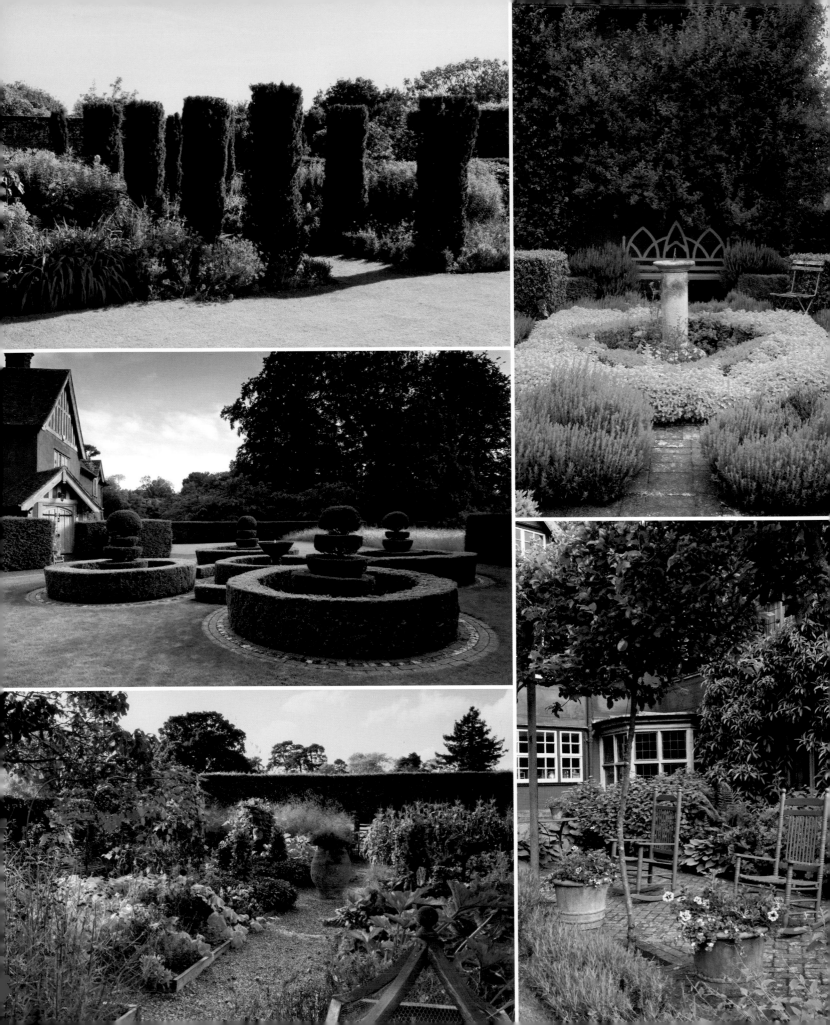

of looser planting, such as the Winter Garden and Woodland Garden. These provide a display of winter colour (from hellebores, *Sarcococca* species and *Daphne bholua*), a collection of spindle trees (*Euonymus* species) for autumn foliage and berries, and the fragrance of early flowering shrubs such as *Viburnum* × *bodnantense*.

To the north of the hall is a kitchen garden, an old orchard where chickens, Norfolk Black turkeys, guinea fowl and peacocks wander freely, and a tranquil graveyard in memory of generations of family pets. Moving on to the more private gardens behind the house, the mood shifts to one of drama, scent and colour. The first of these, the Red Hot Border, is at its high-octane best from July to September, when sunny-coloured flowers, foliage and grasses shine.

Carla was the instigator of this razzle-dazzle scheme – as she says, 'Southerners believe that something a little vulgar in the garden cuts the sweetness and adds some muscle to the design.' But it was Kenneth who sought out the required colour variations of crocosmia, achillea, dahlia and geum, and combined them with bright annuals such as tithonia, sunflowers and nasturtiums. Backed by the old flint wall and punctuated by sky-rocketing Irish yews, the hot border offers a colourful counterpoint to the calming green of the croquet lawn and its two 'grazing' sheep, the work of sculptor Willow Legge.

Further round on the east side of the hall, there are three interlocking gardens devised and presented as a gift by friend and landscape designer Arabella Lennox-Boyd. These formal features, including a herb and knot garden, replaced what Kenneth describes as a 'muddled' area close to the house. Among the fruit trees here are apples 'Spartan' and 'Ashmead's Kernel', while ornamental varieties include weeping white mulberries (*Morus alba* 'Pendula').

'We are two people from different lands who brought out the best in this ancient plot'
CARLA CARLISLE

OPPOSITE Sober, monochrome spaces alternate satisfyingly with more detailed garden features, as these vignettes illustrate (clockwise from top left): the hot borders with columns of Irish yews; a ring of golden marjoram in the Herb Garden; espaliered 'Spartan' apples screening the house; the Kitchen Garden and its grid of timber-edged beds; and a quincunx of topiary by the front door. BELOW On the lawn beyond the Parterre Garden, with its clipped diamond lozenges of teucrium, are two ever-grazing sculpted sheep.

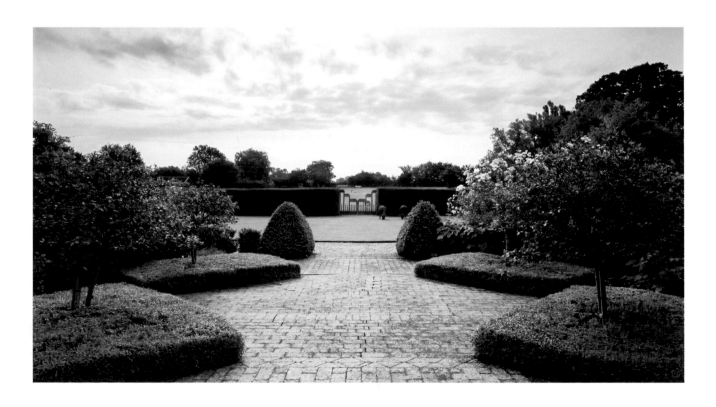

Pastel shades

It is hard to believe that the adjacent Rose Garden was once an orchard. It was first altered in 1979, being one of Kenneth's initial projects for the Wyken gardens. Now divided into four generous quadrants, with borders lining the russet brick walls, it is packed with old-fashioned roses, perennials and woodlanders such as bluebells, foxgloves and oriental poppies. At the centre, where the paths meet, there is a font-like water feature that sits in a circular pool of water.

Kenneth acquired his roses from two Norfolk rose specialists, Trevor White and the late Peter Beales. Early favourites included 'Hebe's Lip', 'Cardinal de Richelieu' and 'Fantin-Latour'. The collection has grown over the years, and now holds around 60 different varieties. Near-invisible metal structures support the more vigorous roses, while climbers rush up wooden obelisks and cover a wooden pergola similar to one at Bodnant in North Wales (where Kenneth was born and spent his early childhood).

The pastel shades of the roses are matched by the hues of delphiniums, astrantias, artemisia, alliums and Jacob's ladder. Espaliered pears line the south-facing wall of the Rose Garden, leaving space at their feet for irises to bake in the sunshine. In addition, annuals and fragrant shrubs such as mock orange (*Philadelphus*) provide colour and scent.

BELOW One of Wyken's peacocks is poised beneath a blue wooden pergola covered in climbing *Rosa* 'Blairii Number Two'. The pergola is modelled on one at Bodnant, in Wales.

OPPOSITE Kenneth's preference is for old roses, and the garden would not be complete without deep wine-red 'Cardinal de Richelieu', mauve 'Reine des Violettes' or pale pink 'Madame Grégoire Staechelin'. Delphiniums and other soft-coloured perennials add to the romance.

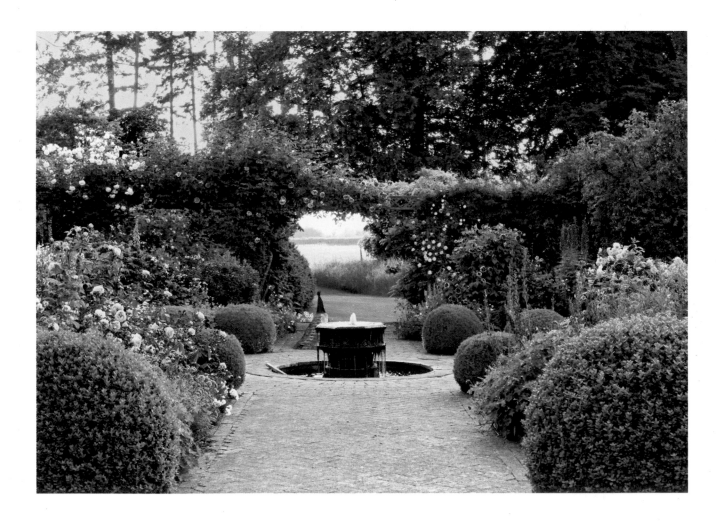

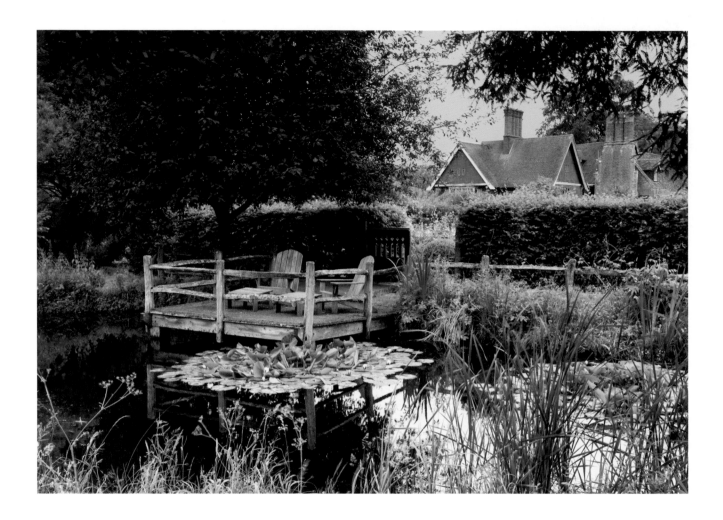

On the wild side

Beyond the Rose Garden, the planting relaxes into a freer, more natural style. Here, a deep and tranquil pool is bordered by an oak jetty with two Adirondack chairs, inviting a moment's pause. This expanse of water was created by lining an old clay pit. In the Dell Garden, a wildflower meadow spreads out beneath a stand of 40 Himalayan birches (*Betula utilis* var. *jacquemontii*). In spring, before the grass is dotted with daffodils, the white-barked birch trunks are scrubbed clean with soapy water. Later, fritillaries, summer snowflake (*Leucojum aestivum*) and yellow rattle (*Rhinanthus minor*) surface and bloom. The walk southwards away from the house sweeps past a copper beech maze planted in 1991 in memory of Kenneth's mother.

For those who want to wander further, there is scope for a stroll across fields and through woodlands to the vineyard that yields Wyken's award-winning wine (which is served at the Leaping Hare, the restaurant run by the Carlisles from within a converted sixteenth-century barn). The Wyken estate – ancient, certainly, but not frozen in time – is managed in a decidedly innovative way. There is a sense of energy at work behind the scenes. Similarly, the country garden that anchors Wyken Hall in the surrounding landscape is a lively combination of classic charm and originality.

ABOVE Moving away from the house, the garden changes in style as it forms a transition towards the surrounding landscape.
RIGHT The Dell Garden's Himalayan birches are scrubbed in spring to heighten the effect of their grouped trunks. Beneath, bulbs are followed by wildflowers and grasses.

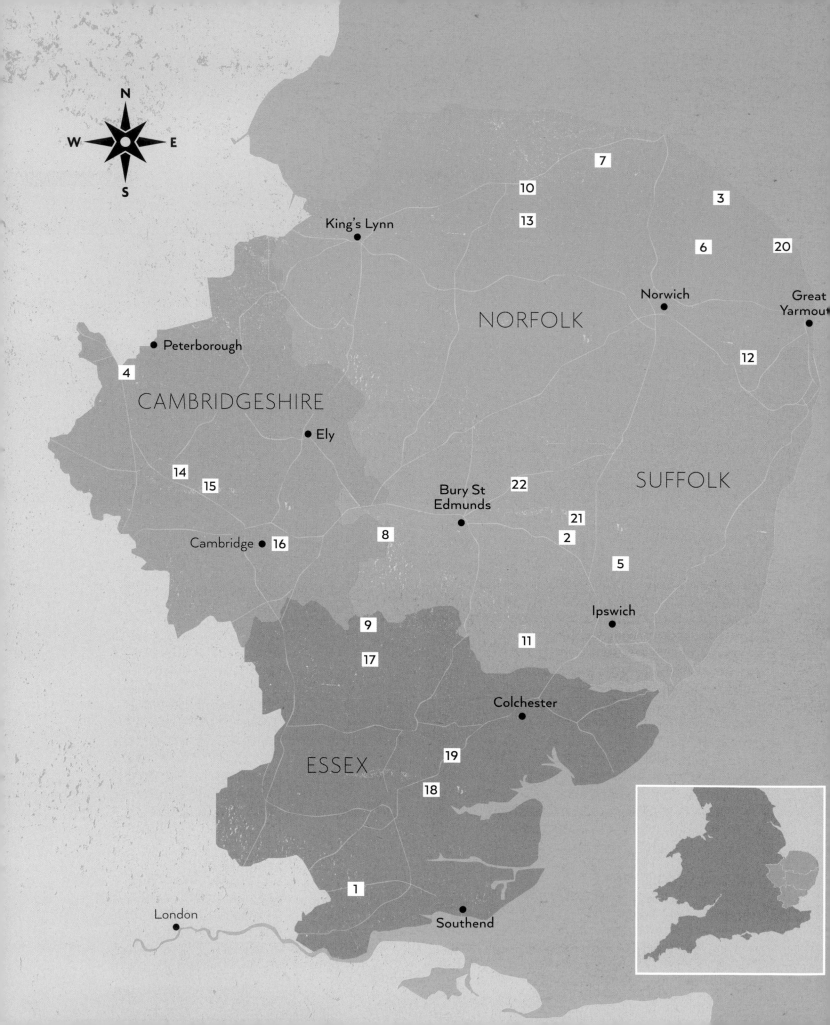

NORFOLK

SUFFOLK

CAMBRIDGESHIRE

ESSEX

King's Lynn

Peterborough

Ely

Norwich

Great Yarmouth

Bury St Edmunds

Cambridge

Ipswich

Colchester

Southend

London

7

10

3

13

6

20

4

12

14

15

22

21

2

8

16

5

9

11

17

19

18

1

Garden opening information

At the time of publication 21 of the 22 gardens open to the public at some time during the year, or by appointment. Please check opening times on the website or with the garden owner before travelling. The garden at Winterton Lighthouse does not open.

1
Barnards Farm
Brentwood Road, West Horndon, Brentwood, Essex CM13 3LX
Open to the public on selected dates April–September under the National Gardens Scheme (www.ngs.org.uk).
Website: www.barnardsfarm.eu

2
Columbine Hall
Stowupland, Stowmarket, Suffolk IP14 4AT
Open to the public three days a year, usually in May and June, in aid of the National Gardens Scheme (www.ngs.org.uk) and other charities. Also under Invitation to View (www.invitationtoview.co.uk).
Tel: 01449 612219
Website: www.columbinehall.co.uk

3
East Ruston Old Vicarage
East Ruston, Norwich, Norfolk NR12 9HN
Open to the public regularly in the afternoons from March to October.
Tel: 01692 650432
Website: www.eastrustonoldvicarage.co.uk

4
Elton Hall
near Peterborough, Cambridgeshire PE8 6SH
Open to the public for the last May bank holiday (Sun–Mon, 2–5 p.m.) and selected afternoons June–August.
Tel: 01832 280468
Website: www.eltonhall.com

5
Helmingham Hall Gardens
Helmingham, Stowmarket, Suffolk IP14 6EF
Open to the public four afternoons a week during May–September.
Tel: 01473 890799
Website: www.helmingham.com

6
Hoveton Hall
Hoveton, Norwich, Norfolk NR12 8RJ
Open to the public regularly in May and June.
Tel: 01603 784297
Website: www.hovetonhallestate.co.uk

7
Hunworth Hall
Hunworth, Melton Constable, Norfolk NR24 2EQ
Open to the public occasionally in aid of charity.
Contact: henrycrawley53@gmail.com

8
Kirtling Tower
Newmarket Road, Kirtling, near Newmarket, Cambridgeshire CB8 9PA
Open to the public three days a year under the National Gardens Scheme (www.ngs.org.uk).

9
Parsonage House
Wiggens Green, Helions Bumpstead, Haverhill, Essex CB9 7AD
Open to the public usually two afternoons a year under the National Gardens Scheme (www.ngs.org.uk).

10
Pensthorpe Natural Park
Fakenham Road, Fakenham, Norfolk NR21 0LN
Open to the public daily, except 24–26 December.
Tel: 01328 851465
Website: www.pensthorpe.com

11
Polstead Mill
Mill Lane, Polstead, near Colchester, Suffolk CO6 5AB
Open by arrangement May–September for groups of more than ten, in aid of the National Gardens Scheme (www.ngs.org.uk).
Tel: 01206 265969

12
Raveningham Hall
Raveningham, Norfolk NR14 6NS
Open to the public for snowdrops throughout February, then main season April–August.
Tel: 01508 548480
Website: www.raveningham.com

13
Silverstone Farm
North Elmham, Norfolk NR20 5EX
Open to the public occasionally under the Invitation to View
scheme (www.invitationtoview.co.uk) and during lecture days.
Contact: grcarter@easynet.co.uk
Website: www.georgecartergardens.co.uk

14
The Manor
High Street, Hemingford Grey, Huntingdon, Cambridgeshire,
PE28 9BN
Garden open daily (house by appointment to individuals or
groups).
Tel: 01480 463134
Website: www.greenknowe.co.uk

15
The Manor House
Chequer Street, Fenstanton, Huntingdon, Cambridgeshire
PE28 9JQ
Open to the public on selected afternoons in June in aid of
the National Gardens Scheme (www.ngs.org.uk).

16
38 Norfolk Terrace
38 Norfolk Terrace, Cambridge CB1 2NG
Open to the public on selected dates in July under the National
Gardens scheme (www.ngs.org.uk) and for Cambridge Open
Studios (www.camopenstudios.co.uk).

17
Tinkers Green Farm
Sampford Road, Cornish Hall End, Braintree, Essex CM7 4HP
Open only by appointment for groups of more than ten.
Contact: dswete@justgardens.co.uk

18
Ulting Wick
Ulting, near Maldon, Essex CM9 6QX
Open to the public on selected dates in April–June and
September under the National Gardens Scheme (www.ngs.org.uk).
Also by appointment for groups (minimum 15).
Tel: 01245 380216
Website: www.ultingwickgarden.co.uk

19
Wickham Place Farm
Station Road, Wickham Bishops, Witham, Essex CM8 3JB
Open only by appointment to groups of 15 or more.
Contact: info@wickhamplacefarm.co.uk
Website: www.wickhamplacefarm.co.uk

20
Winterton Lighthouse
NOT open to the public

21
Wood Farm
Gipping, Stowmarket, Suffolk IP14 4RN
Open to the public one afternoon a year, usually in June, under
the National Gardens Scheme (www.ngs.org.uk).

22
Wyken Hall
Wyken Road, Stanton, Bury St Edmunds, Suffolk IP31 2DW
Open to the public Sunday–Friday afternoons from 30 March to
the end of September.
Tel (shop): 01359 250262
Website: www.wykenvineyards.co.uk

Index

Folios in *italics* refer to captions.

Acknowledgments

I would like to thank all the garden owners and gardeners for their generosity in sharing with me the stories of their gardens and the way they garden. I would also like to thank Beth Chatto (www.bethchattogardens.co.uk) both for her foreword and for her writing about, and appreciation of, plants and gardens.

It has been a delight to share the secret garden journeys with Marcus Harpur, who has taken such wonderful images of the gardens that we both know and love in East Anglia.

At Frances Lincoln I would like to thank Helen Griffin for her original encouragement and for commissioning this book. Andrew Dunn and Laura Nicolson have taken it forward with great aplomb, but in particular I would like to thank designer Anne Wilson and copy editor Sarah Zadoorian. They are a wonderful duo, who made certain the book looks terrific and that every detail is as it should be. *Barbara*

The photography in this book is dedicated with love to my children, Connie, Millie and Rupert. I take credit for the photography, but not for the imagery. That is entirely due to that which we celebrate – the creativity and dedication of the owners and makers of the gardens herein. Photographing gardens is about being in the right place at the right time, but it is also about the good times involved in visiting many gardens and meeting the wonderful people who made them. Gardening is an act of generosity and hope, and so I thank all those owners who have given us hospitality and shared in that spirit. This book was the inspiration of Barbara Segall, who made it happen, and who has just been the perfect friend throughout. *Marcus*

We would both like to thank Åsa Gregers-Warg, head gardener at the Beth Chatto Gardens, for the portrait photo of Beth Chatto on page 7.